# FROM THE GROUND UP

Published by Preface 2012

10 9 8 7 6 5 4 3 2 1

Copyright © U2 Limited 2012

First published in Great Britain in 2012 by Preface Publishing

20 Vauxhall Bridge Road
London, SW1V 2SA

An imprint of The Random House Group Limited

www.randomhouse.co.uk
www.prefacepublishing.co.uk

Addresses for companies within The Random House Group Limited
can be found at www.randomhouse.co.uk

The Random House Group Limited Reg. No. 954009

A CIP catalogue record for this book is available from the British Library

ISBN 978 1 84809 368 3

Designed by AMP Visual.com
Printed and bound in China by C&C Offset Printing Co. Ltd

# FROM THE GROUND UP

## U2360° TOUR
### OFFICIAL PHOTOBOOK

WITH WORDS BY **DYLAN JONES** AND FEATURING
PICTURES BY **RALPH LARMANN**

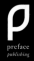

preface
*publishing*

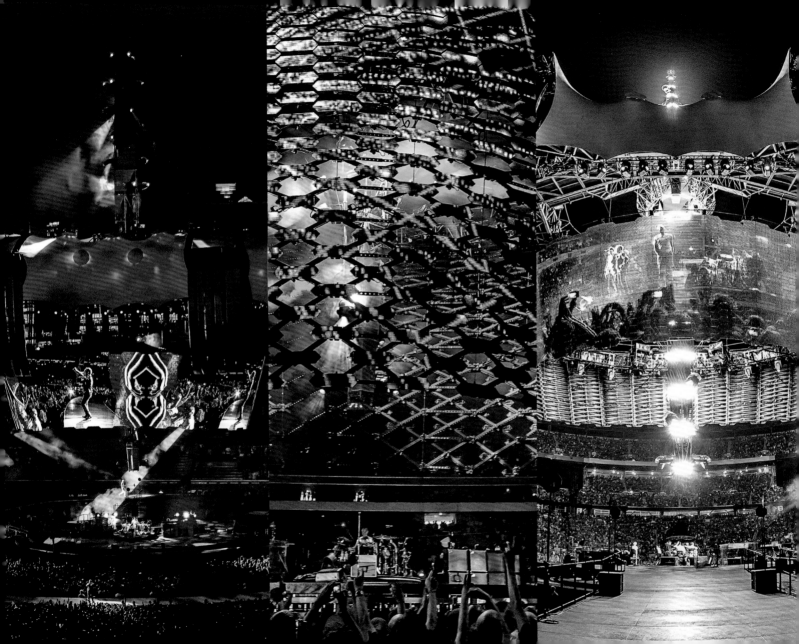

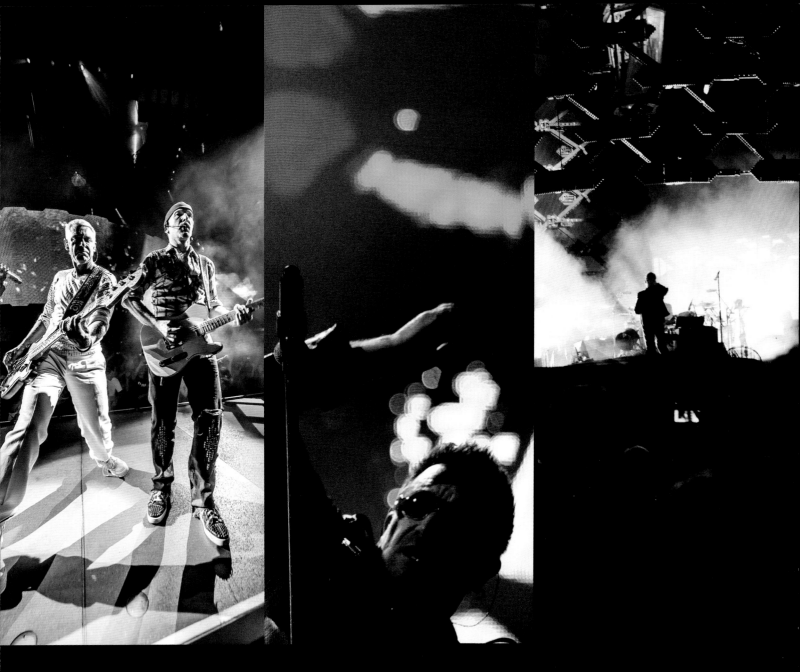

CONTENTS

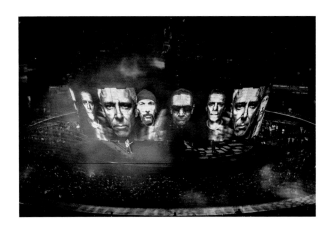

# THE 360° STORY
## – *Paul McGuinness*

**For a number of years U2 had been thinking about how to design a set which would create an 'in the round, 360 degree experience for outdoor shows', which of course would be spectacular but which would also be transportable enough to tour.**

In the summer of 2008 a small team was convened to try and make this a reality. Willie Williams, the designer behind U2's tour stages from the early days, set about the problem and with the band and Mark Fisher came up with a design which is certainly vast and groundbreaking, but is also breathtakingly beautiful and a triumph of practicality, allowing fans in all parts of a football stadium an unequalled experience.

The story of the 360° tour is as epic as the numbers, from the seven million people who bought tickets to the logistics of moving three identical sets around continents each one taking 150 trucks to transport. Above all it was an epic experience led by the music and the show. This is the story of U2's biggest tour to date and biggest tour of all time.

**PAUL McGUINNESS**
**MANAGER, U2**

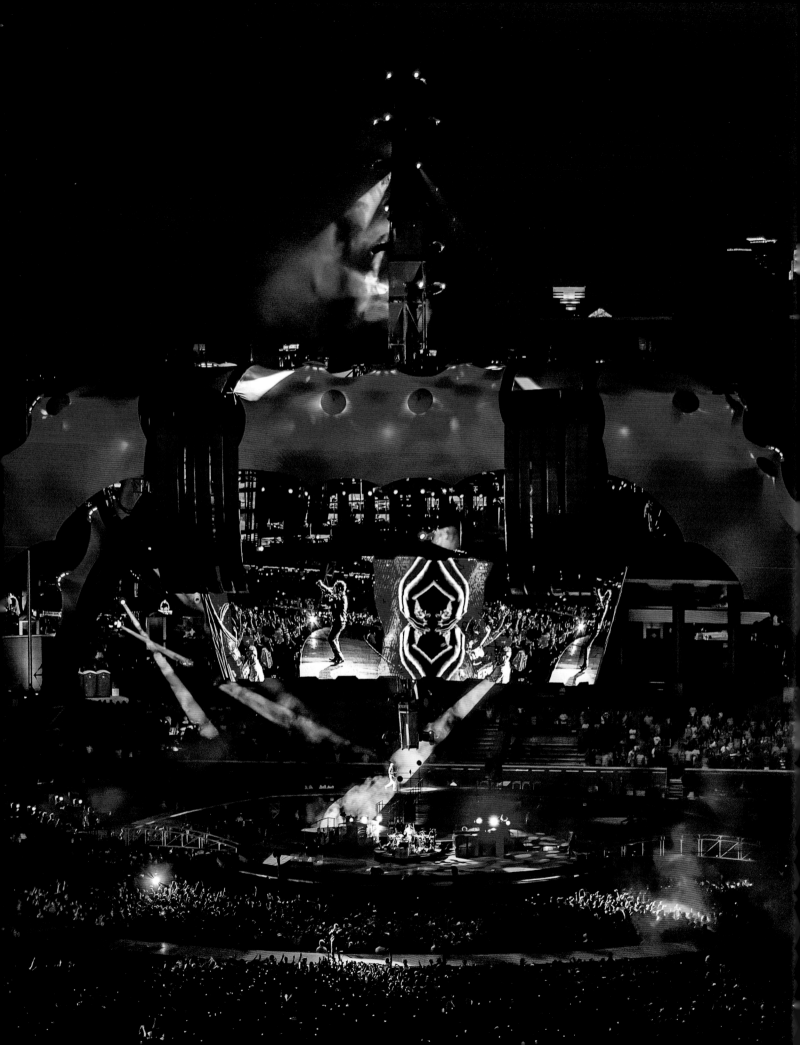

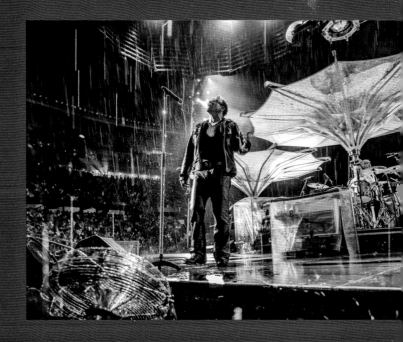

# WHAT U2 DID NEXT: THE GREATEST SHOW ON EARTH?

## Introduction

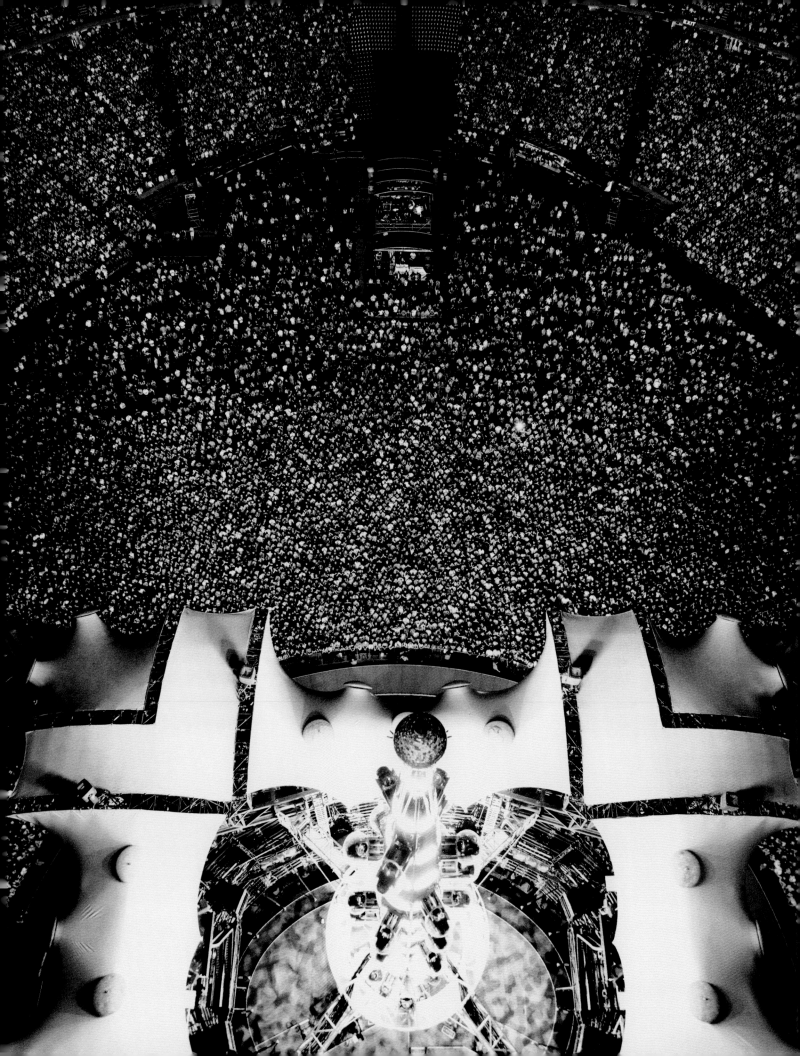

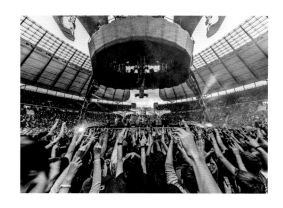

# 'WE'RE DOING THE SAME THING, IT'S JUST THE WRAPPING IS DIFFERENT'

## – *Larry Mullen*

*(On the trappings of the PopMart tour in 1997)*

For at least the last twenty years, U2 have been in the business of 'Big'. As far as their live performances stand, their only rivals in terms of scale and ambition are the Rolling Stones, but even they were unceremoniously pushed into second place by U2's 360 show. Not only is it the highest-grossing tour, at $730m, in history, it was also a tour that has been seen by over seven million people.

Thursday, 23 June 2011: Bono parted the grey cotton curtains and walked slowly – deliberately – almost John Wayne-style, down the aisle. Since his back operation a year ago, you were always looking for signs of wear and tear, but tonight he just looked like any leather-trousered rock star off for a bit of an evening stroll on his plane. Except that it was 4.30 in the morning, and everyone on the plane – band, management, a skeleton crew, guests (there were always guests) – had had to make a decision after the show they'd just played, at the M&T Bank Stadium in Baltimore (supported on this leg of the tour by an enthusiastic Florence and the Machine), as to whether to go to bed for an hour following the after-show party back at the hotel, or carry on through. It had been roughly a 50/50 split, with those who had stayed up, nodding in their seats, trying to allow the alcohol to send them off; and

those who had grabbed their forty winks (you can't squeeze any more out of an hour) trying a little too hard not to appear sanctimonious. Bono himself had stayed up, huddled down in one of the Intercontinental's many generic function rooms, his taut frame surrounded by a small posse of friends and assistants. 'This must be the right place,' said Paul McGuinness on the other side of the bar, casting his custodial eye over the proceedings. 'The singer's here.'

There was a fair bit of turbulence, so the Fasten Seat Belt signs were flashing intermittently, but Bono walked purposefully, carefully clutching the headrests as he went. In truth he had something of a pimp roll, not unlike the one used by Bradley Whitford's Josh Lyman in the earlier episodes of *The West Wing,* and tonight it was in full effect as he walked the length of the chartered jet, asking for glad tidings and glasses of wine as he went – 'Are you drinking? Ah, good … So am I …' His walk was so pronounced, I almost expected him to be wearing spurs.

U2 had broken into the very last leg of their North American tour to charter a United jet to take them, in the middle of the night, all the way from Baltimore, Maryland (where they had played, a whole year after they were originally supposed to) to Cardiff, Glamorgan, where they would be taken by helicopter – a sixteen-person helicopter, no less ('Ah, I always like some executive napalm in the morning,' Paul McGuinness would say) – to the carefully manicured Royal Crescent Hotel in Bath, and then, f-i-n-a-l-l-y, after a year of gossip, apprehension and general media brouhaha, on to Glastonbury. Because of Bono's injured back, the band had been forced to cancel their appearance the year before, along with sixteen further shows

in the US, and there was a palpable sense of expectation on the plane. Expectation and something that smelled a lot like fear. This second, self-inflicted interruption was costing the band over two million dollars, although it wasn't the money that was really the issue; there was a sense that U2 had a point to prove, and they needed Glastonbury to be much more than a success, they needed it to be something approaching the epic. What they certainly didn't need was anything approaching failure, not when they were so near the end of the crusade. On this particular three-day weekend they were playing on the Friday, with Glastonbury favourites Coldplay appearing on the Saturday (it would be the fifth time the band had played the festival), and – appropriately, it was felt, including by the band – by Beyoncé on the Sunday, coming in at the end like the cavalry, in full Las Vegas splendour, no doubt in bright, braided finery. Using a festival sound system and old-fashioned technology, with a generic, sub-standard lighting rig, in the middle of a field of potentially grumpy and uninterested non-U2 fans was always going to be a risk, but there was such momentum about it that after a while there was nothing the band could have done but turn up and dig in.

'We know Glastonbury is going to be a battle, and we think it's one we can win,' said Bono on the plane that night, with a careful sense of sincerity. 'Cancelling Glastonbury was awful, and we've never felt so bad about cancelling anything. The insurance companies usually make a fortune off of us because we never cancel, we just don't. So cancelling that leg of the tour in 2010 that included Glastonbury was a horrible feeling of defeat. As a side issue, U2 exists outside of the music industry as a sort of vacation event. People make plans to see college mates, they

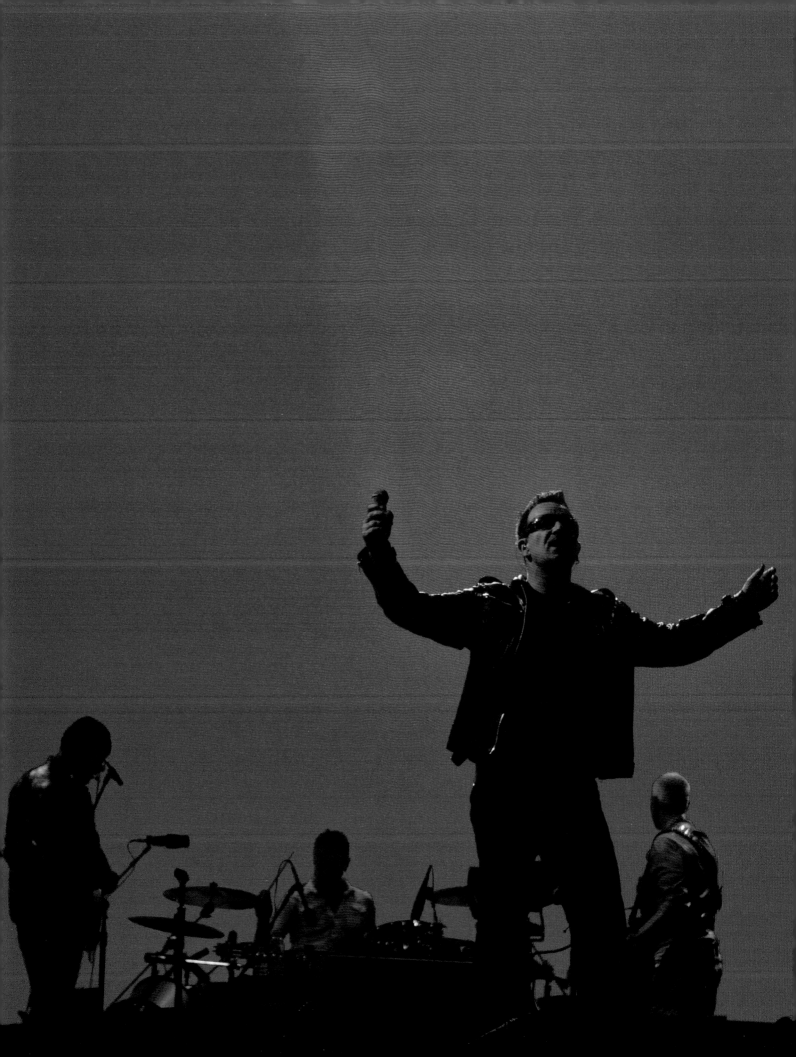

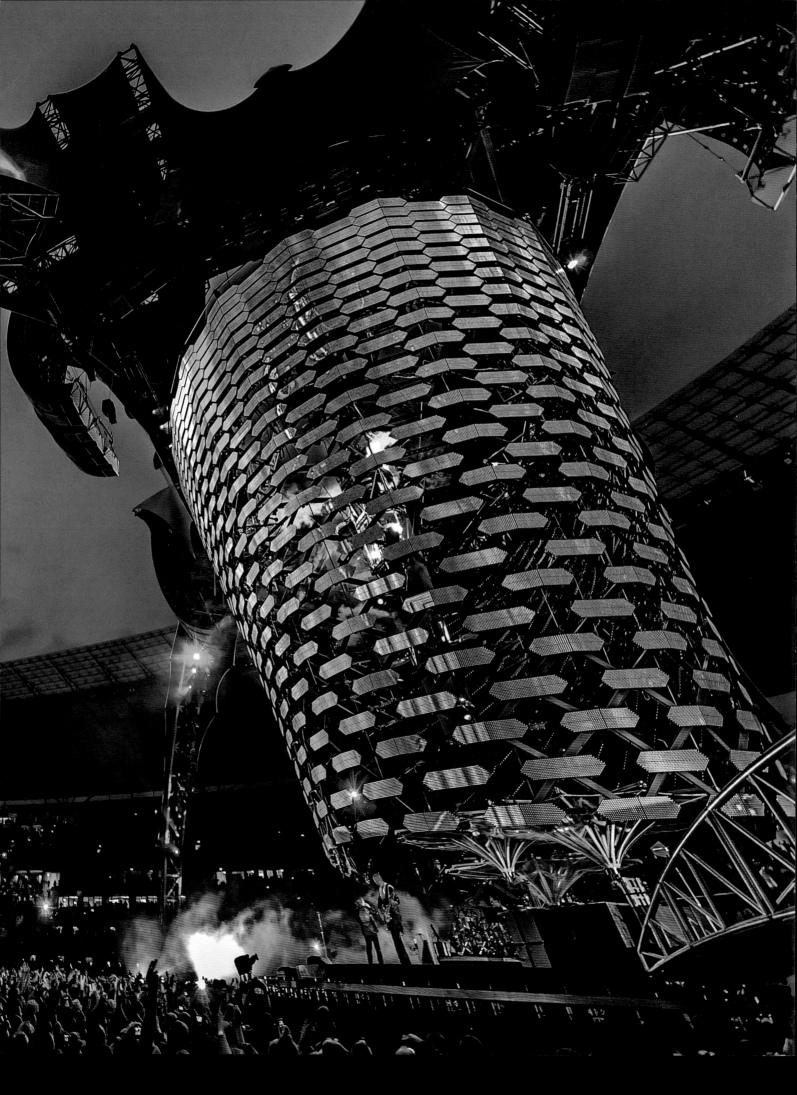

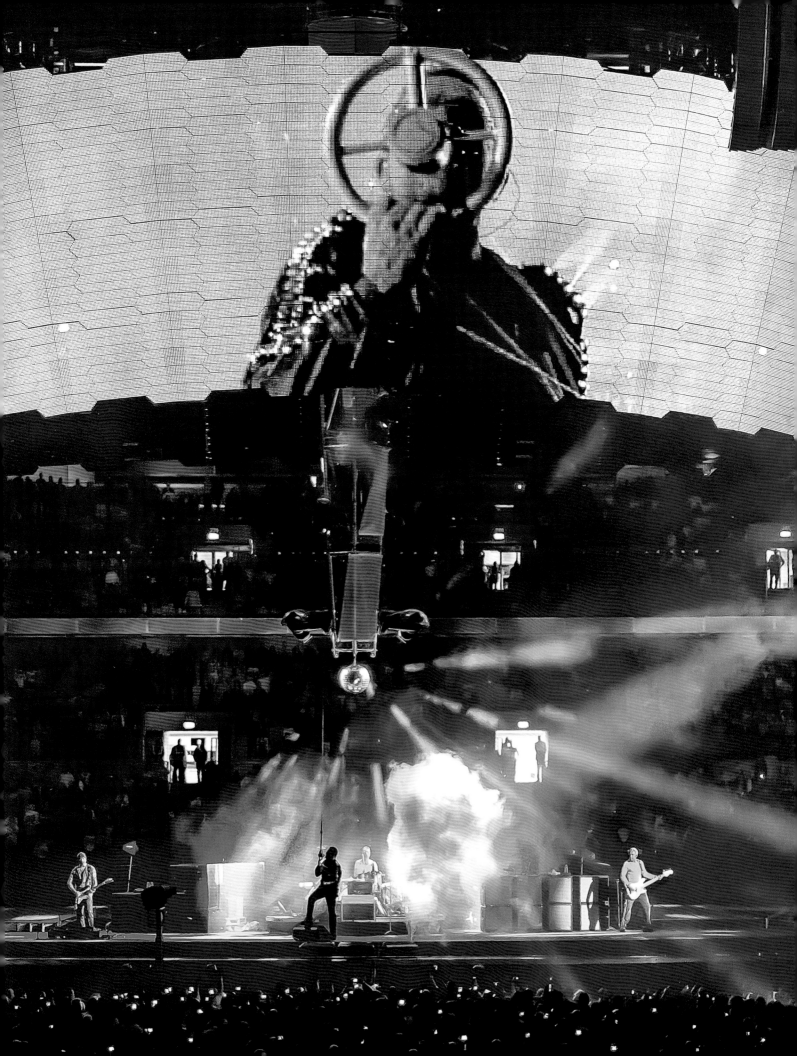

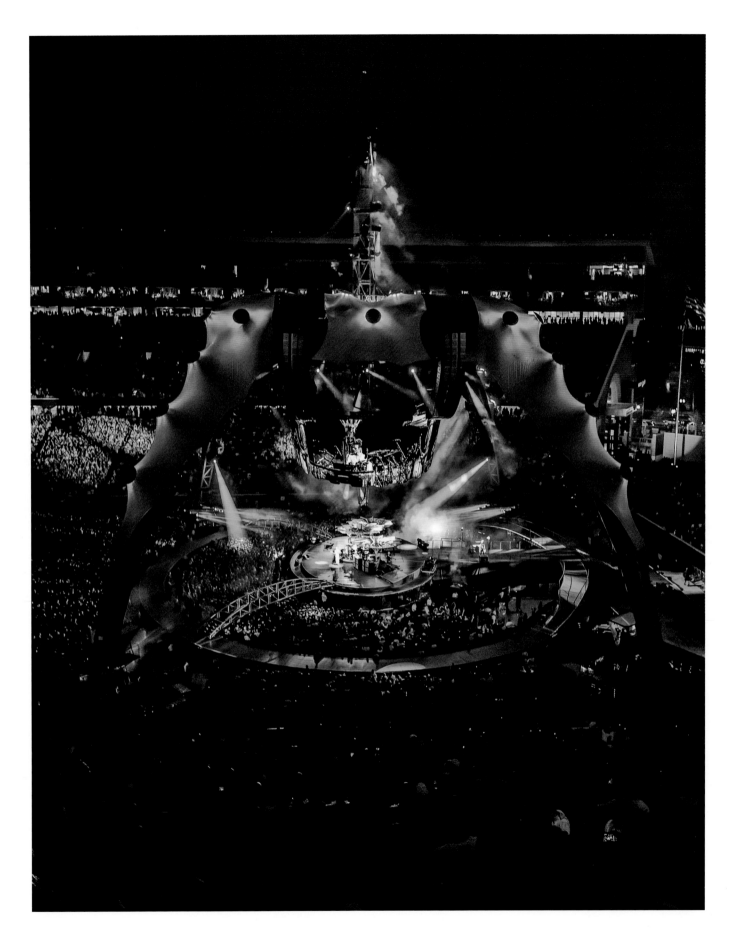

build vacations around our gigs, we know that, and this was a big blow to them as well as us. We hated cancelling the tour, and interrupting it, as we felt as though we'd let everyone down. Because this is the sort of thing that U2 just doesn't do. People book trains, planes, hotels, and I know it was a huge blow when we cancelled. Usually when someone cancels a tour, you can expect thirty or forty per cent of people to ask for their money back. When we cancelled I think something like two per cent of the ticket holders asked for their money back, which is kind of amazing. We didn't need to remarket the tickets, as people just put them in drawers and waited.

'So Glastonbury this time around is incredibly important for us. We want to open ourselves up and play for people who aren't that familiar with us, who might have paid their money to see someone else. In the early days of U2, back in the clubs, we went out of our way to try and play to as many people who didn't know our music as possible, as we wanted to convert as many people as possible. We didn't care where we played, as long as there were going to be people in the audience. Of course there weren't always people in the audience, and often there were very few people at all, but it always seemed like a mission. And we still want to touch people, we still want to connect.' Which is what they'd just spent the best part of two years doing – attempting to connect. Their 110-date 360 tour was not only the biggest tour ever staged by a rock band, not only the most technologically innovative, and not only the most expensive, but also it would eventually gross more money than the Rolling Stones' 2005 extrava-ganza, A Bigger Bang, and by the end of their two years on the road, the band would have performed in front of a staggering seven million people (which

is like playing to everyone in Honduras, although not all at the same time). Initially designed to support their 2009 album, No Line On The Horizon,

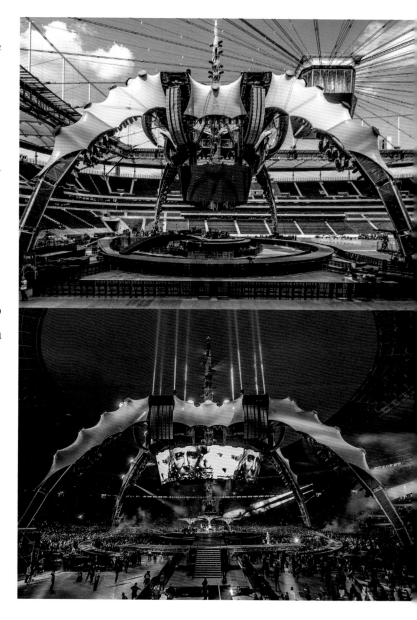

the tour had taken on a life of its own, one that looked as though it might dwarf everything else the band had ever achieved. This was the three-birthday tour, starting in the summer of 2009 and eventually finishing in the autumn of 2011, taking in North America, South America, Russia, Europe, Australia and most points in between. In their quest to

redefine the stadium spectacle, and to provide what had become known as their intricately managed sense of intimacy – intimacy on a grand scale – the anthropomorphic wonder of 360 had ticked boxes the band weren't sure even existed. This was the largest stage set ever built, with the largest and loudest sound system ever built for a rock 'n' roll tour. This grand intimacy also reflected the binary nature of the U2 noise, the Al Pacino-style gear change from a whisper to a boisterous scream in the crash of a cymbal.

While the album hadn't captured the Zeitgeist like those before it (the album's signature single 'Get On Your Boots' was originally disowned, but the live version became a band favourite), the tour was certainly the most extravagant thing they'd ever attempted. It was the most extravagant thing any band had ever attempted. This was bigger than Pink Floyd, bigger than Metallica, bigger than everyone. Playing inside a massive architectural wonder, a 200-ton arachnid, a nomadic behemoth nicknamed, much to the band's consternation, 'The Claw' (resembling the Theme Building at LAX, and originally inspired by a design that Bono originally tried to describe on his kitchen table in Dublin using three old forks and a grapefruit), and featuring a 100-ton steel construction using a cylindrical 500,000-light LED screen display conceived especially for the show, videos beamed from NASA's International Space Station, a light show not seen in a rock show before, and the sort of extravaganzas usually reserved for Olympic ceremonies, Bono, the Edge, Adam Clayton and Larry Mullen Jr. put on their version of the greatest show on earth. Exactly one hundred and ten times.

This was hyperreality disguised as a giant Christmas bauble, the postmodern rock show to end

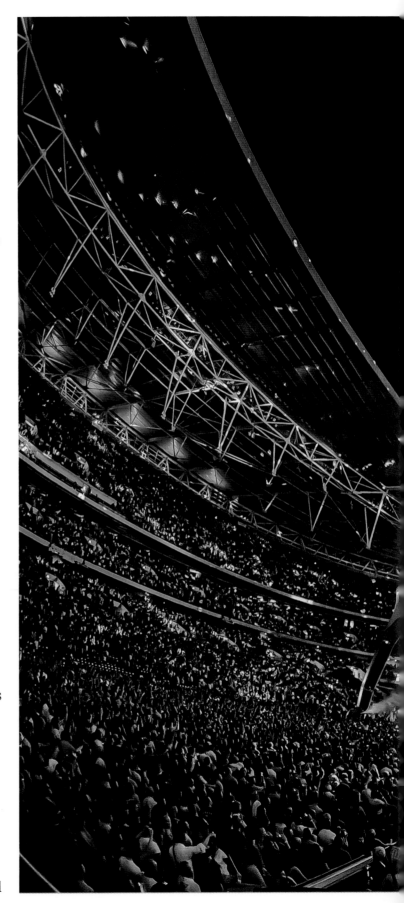

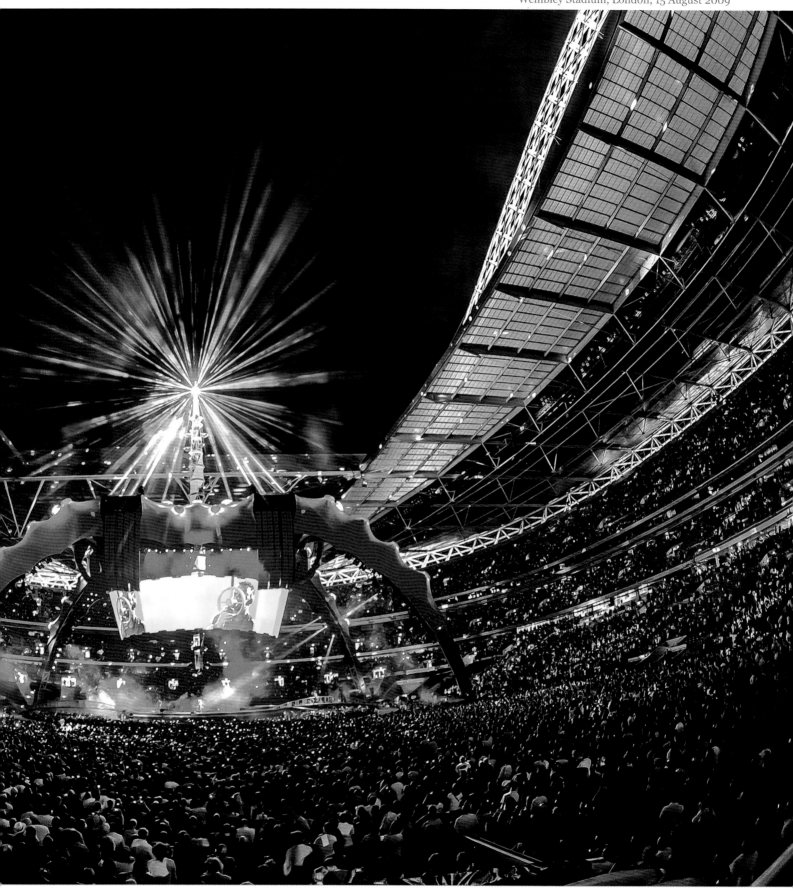

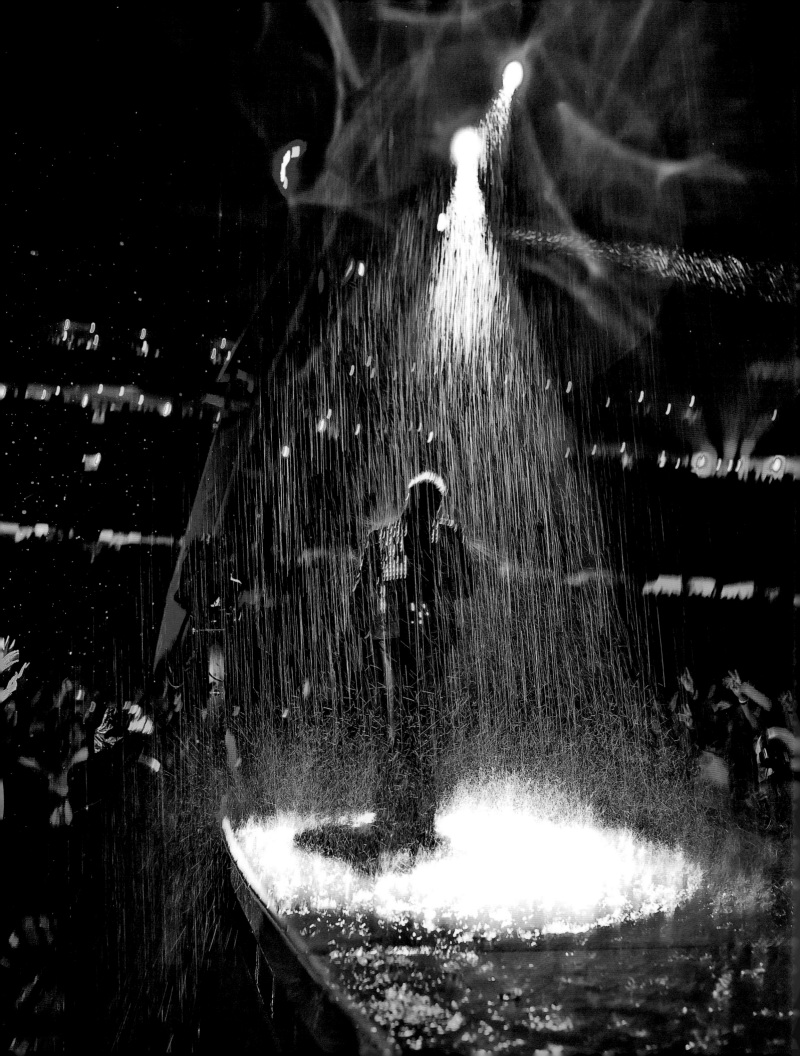

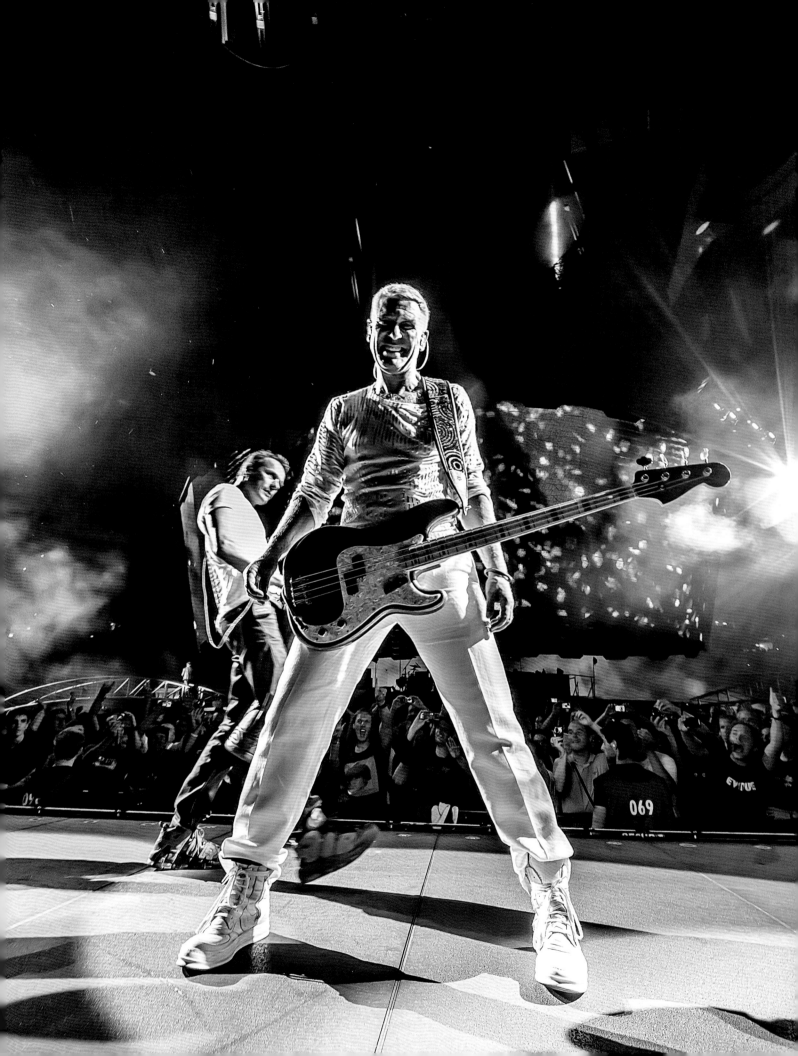

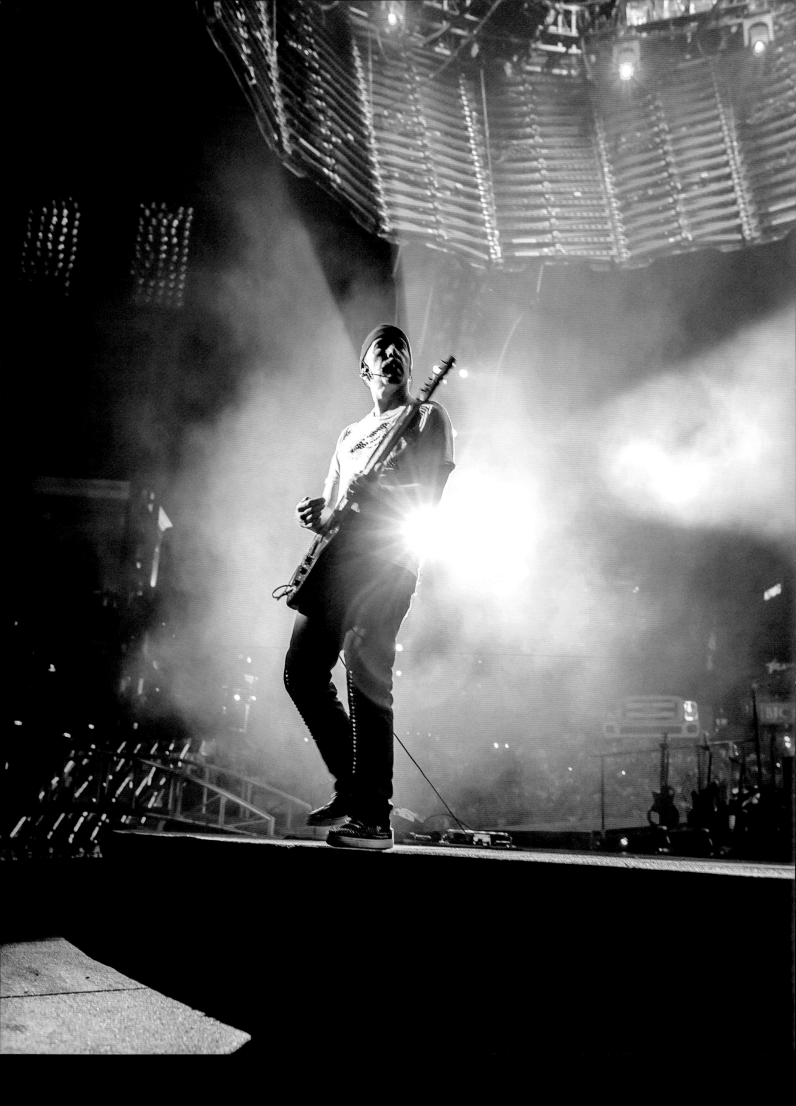

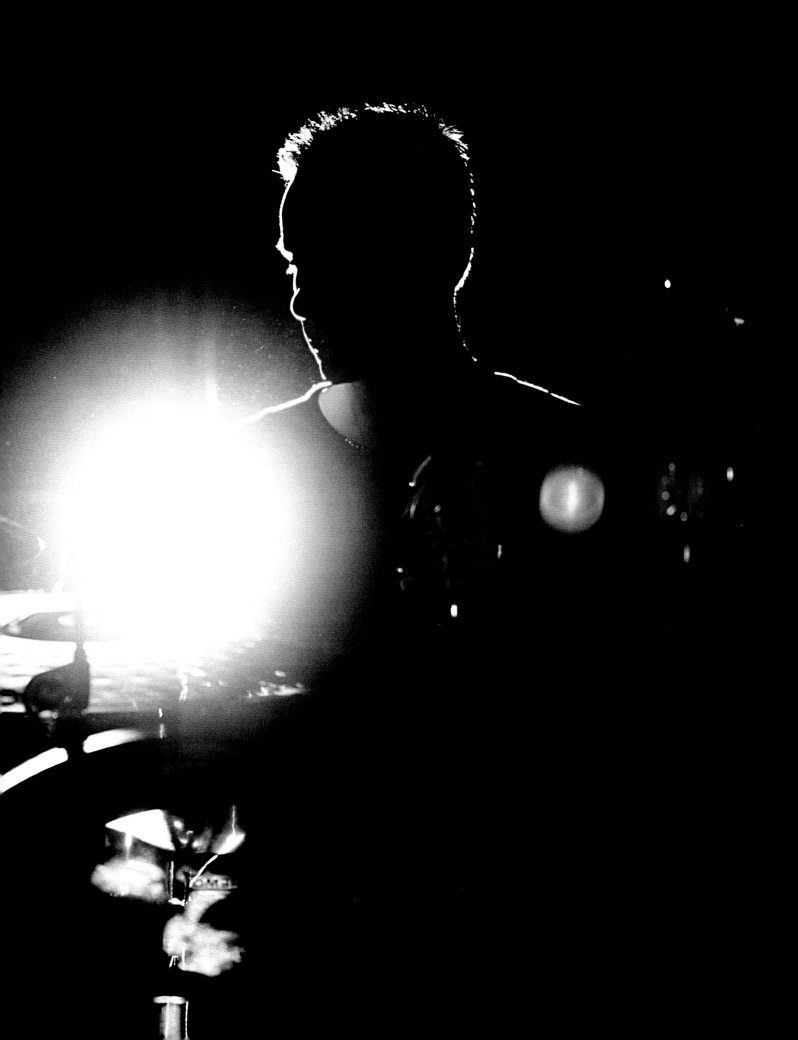

them all, a kaleidoscopic spectacle free of irony.

Rarely had a band had to compete so heavily with its own stage for attention. Each night their own city of blinding lights – which, the first time I saw it, reminded me of being lost for the first time in Tokyo, made me remember how I felt sitting in the front row watching *Tron* – flickered into action, and – like a Transformer – turned itself into an orbital spacecraft, before taking off into a journey of continuous sensation. If their innovations had

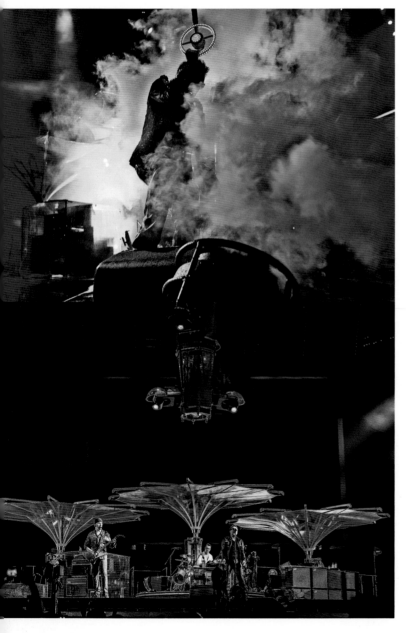

previously become industry standards, it is difficult to imagine anyone replicating this: the art of possibility disguised as a theme park. This was a show that could harness the heroic bombast of their anthemic Eighties, the mock decadence of their dark disco decade, and the full-circle dynamism and pop-smarts of the Noughties, and all points between and beyond.

'There's definitely a sense that we're the only people prepared to spend this kind of budget on a show,' said Adam, a few weeks previously. 'I think we probably spend more dollars than the Stones do on production. But you know, when you see the effect that it has on people, the fun and the pleasure that a challenging production gives the show, it's kind of worth it. Metallica always do something interesting, but they're on a different scale. But this time, with 360, certainly once we'd figured out you could go into a stadium and do it on our terms, it kind of gave us a lot of room to play around. Everything about it – the shape, the size, the cylindrical screen – was a game changer ... The screen was based on the helix, the office toy. The way the screen opens and closes, that's a whole new thing, and we're all enormously proud of it. You have to find ways to make the songs touch people more, to disorientate people so they're more open to being touched.'

'Yeah, connecting' said Bono, not for the last time. 'We go out of our way to do that. Why wouldn't we? Why wouldn't we want to impress ourselves on everyone we meet? Punk was all about the guy on top of the speaker stack or in the middle of the crowd who gets on stage, and that's what we're about. We're about community.'

He'd said this before, and it always had a ring of truth; Bono acknowledges that his obsession with

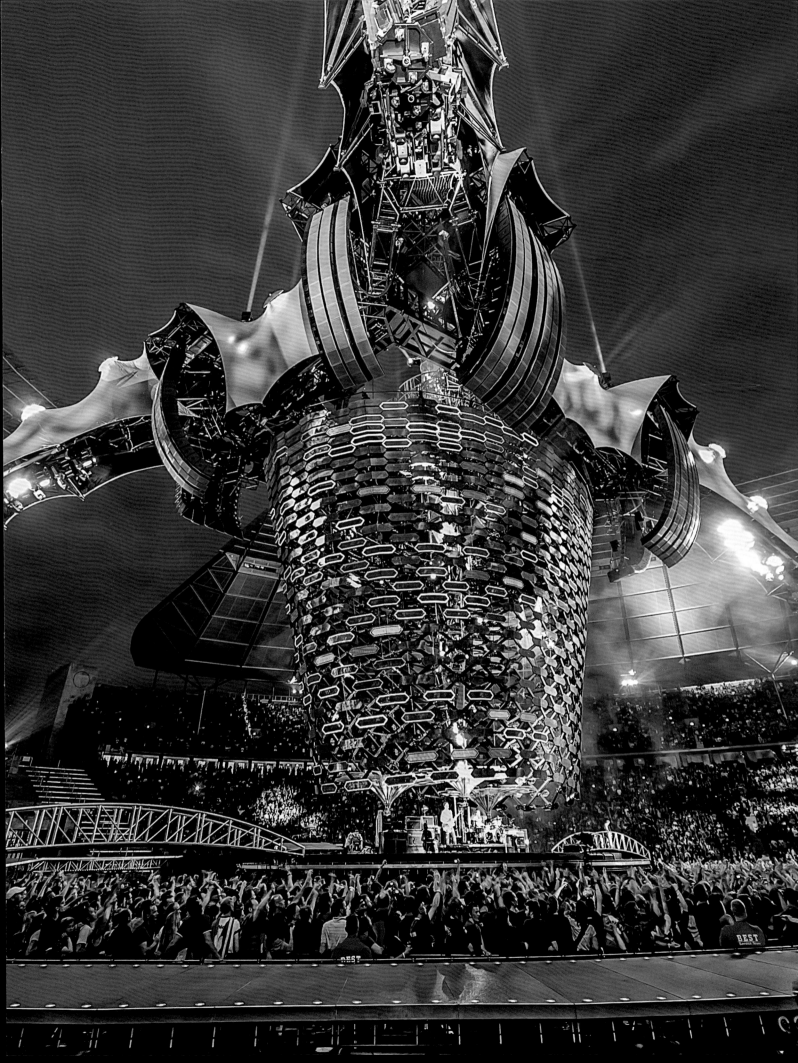

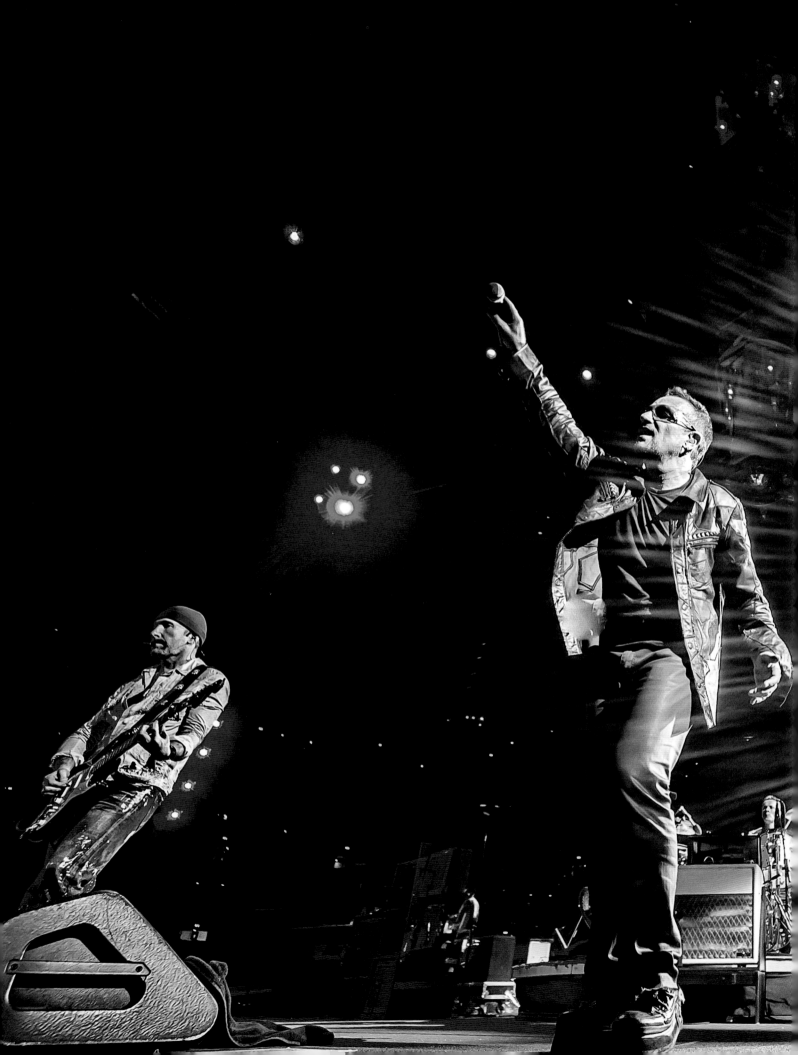

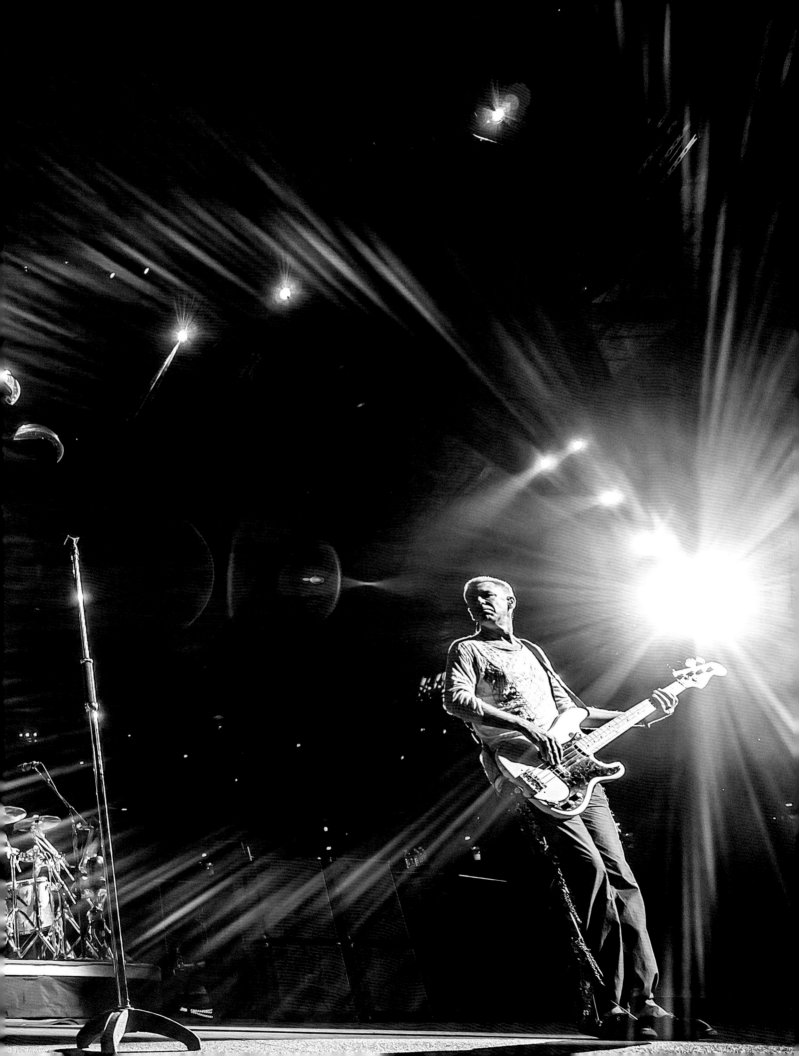

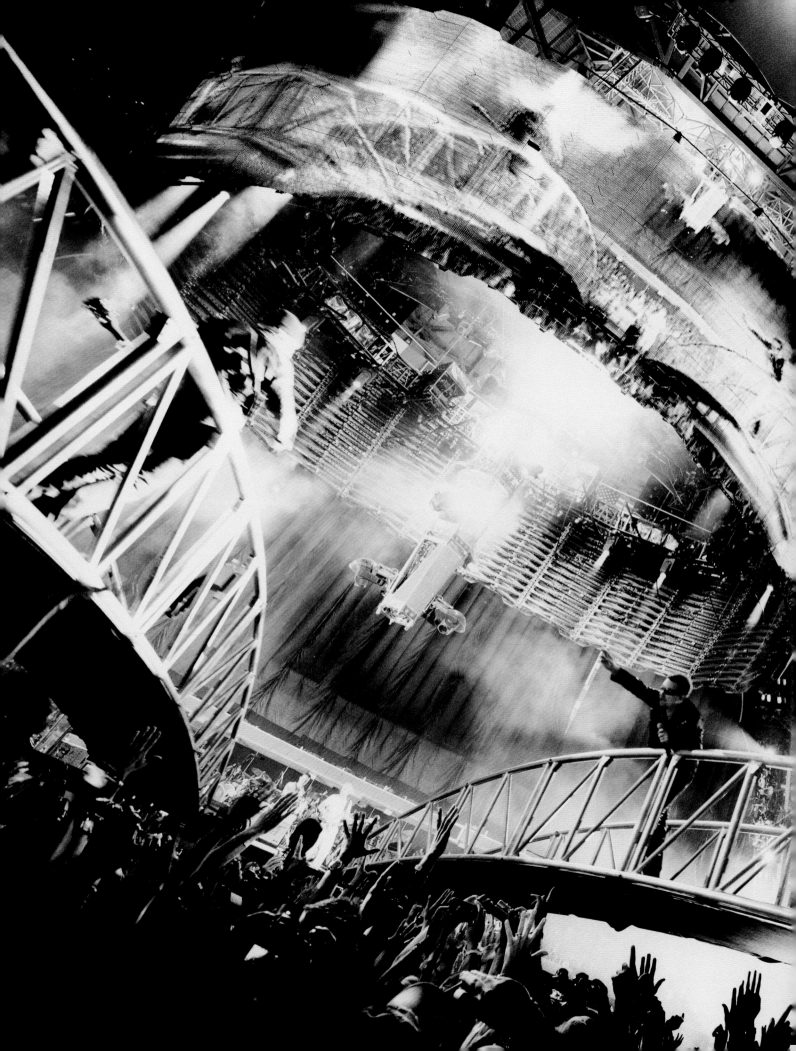

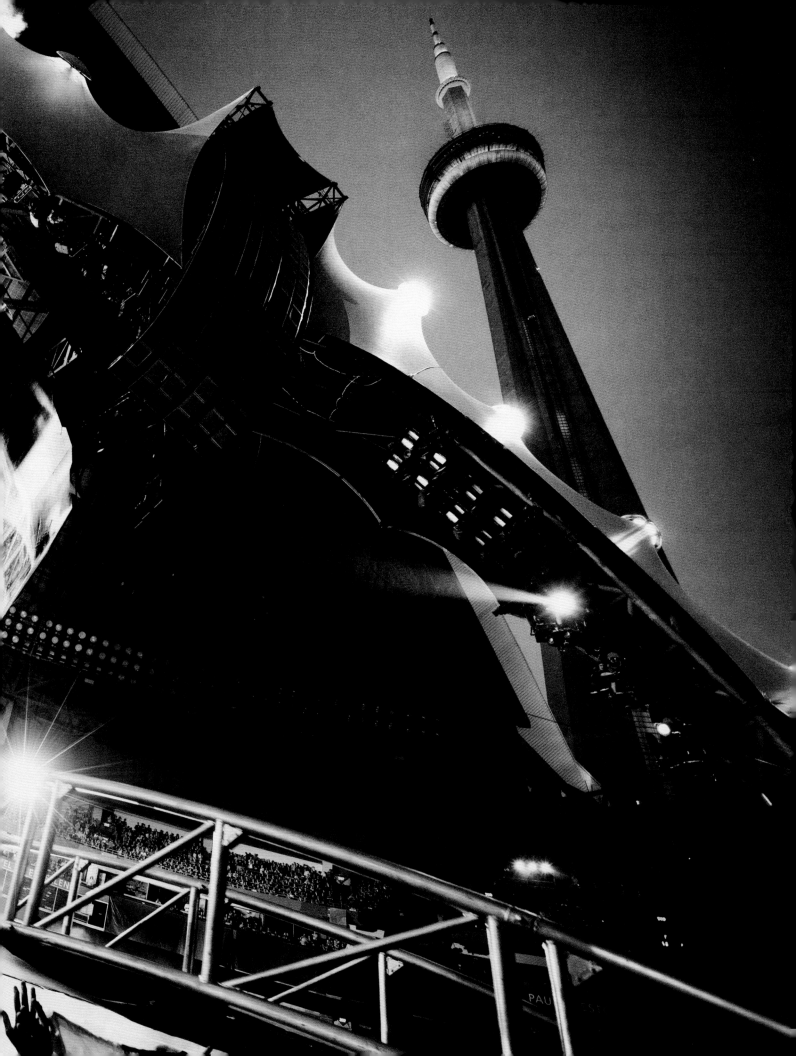

inclusiveness is one of his defining characteristics. Bono once described himself as having the instincts of a perennial suitor, a rock and roll travelling salesman who almost sees it as a matter of pride to be able to sell his wares to the most reluctant customer. In this particular case, he wanted to woo Glastonbury, and he wanted to woo the crowd on their own terms. Which is just as well, as there was no other way he was going to achieve it.

'Bruce Springsteen once told me that he hated doing television, because it enabled people to edit what you do, or turn you down. It gave other people control. For us it's been festivals, as we simply don't do them, and for thirty years we've only played to people who like us, so this is something completely new.' He'd actually been speaking to Springsteen just a few days before, as Bono had called him after the sudden death from a stroke on 18 June the E-Street saxophone player, Clarence Clemons (at the Baltimore gig, he had dedicated 'Moment of Surrender' to Clemons). 'He said he's been even more upset than he thought he'd be, and how hard it is to conceive of the band without Clarence. I mean what would they sound like? How can you have Bruce without Clarence, right?' He talked a little about the R&B influences in various Springsteen songs and then spontaneously burst into the chorus of 'Girls In Their Summer Clothes', the breezy pavement song from Springsteen's 2008 album Magic, as bodies under blankets shuffled in their seats, woken from their slumber.

In 1967, with almost extraordinary prescience, Ellen Willis – who would go on to become the music critic of the *New Yorker*, wrote these words in *Cheetah*, which at the time was a serious competitor to *Rolling Stone:* 'The tenacity of the modern publicity apparatus often makes artists' person-

alities more familiar than their work, while its pervasiveness obscures the work of those who can't or won't be personalities. If there is an audience for images, artists will inevitably use the image as a medium – and some images are more original, more compelling, more relevant than others.' In the forty-five years since Willis wrote them, these words, these sentiments, have described everyone from Bob

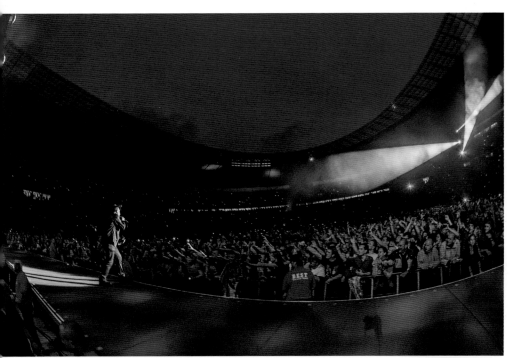

Dylan to Lady Gaga, everyone who has tried to build a personality rather than actually disclose one. But while U2's image couldn't be more indelible, and while Bono's personality has been broadly drawn and interpreted for him for over thirty years, I've always had the sense that they have fallen over themselves to communicate their version of authenticity, however embarrassing that sometimes has been. U2 have spent over three decades building an edifice, yet they've always been at pains to show us the wiring, to tell us how they got to where they think they are at any given point. U2 have spent

their career telling us not just why they do what they do, but how, too. Whether we've been interested or not. All those soaring anthems don't come out of nowhere, you know.

Back in the Eighties, when the band were still in their Joshua Tree pomp – what I remember referring to affectionately as The Dark Side Of The Joshua Tree, Born In The Joshua Tree or the revenge of the gatefold sleeve – in order to connect with the stadium audience, Bono would fling down his microphone, leave the stage and disappear into the crowd, mingling with them, laying his hands on them, embracing them and helping to wave their flags (most of which had his name on). He attempted to become 'as one' with as many members of the crowd, and there was always a sense that if he (and indeed they) had had the time, he would have embraced every single person in the audience.

In a way, with 360, and in particular with the spectacular invention that will forever be known as 'The Claw', he was able to touch everyone at once.

Peering through a pair of designer sunglasses that he never appeared to take off (he started wearing shades with a vengeance during the Zoo TV tour in 1992, and hasn't looked back since), Bono tipped his head to Adam, who was making his own way down to the back of the plane – accompanied, as always, by his huge, benign smile and a cup of tea – to chat with Sharon Blankson and the rest of her wardrobe girls, and continued his deconstruction of

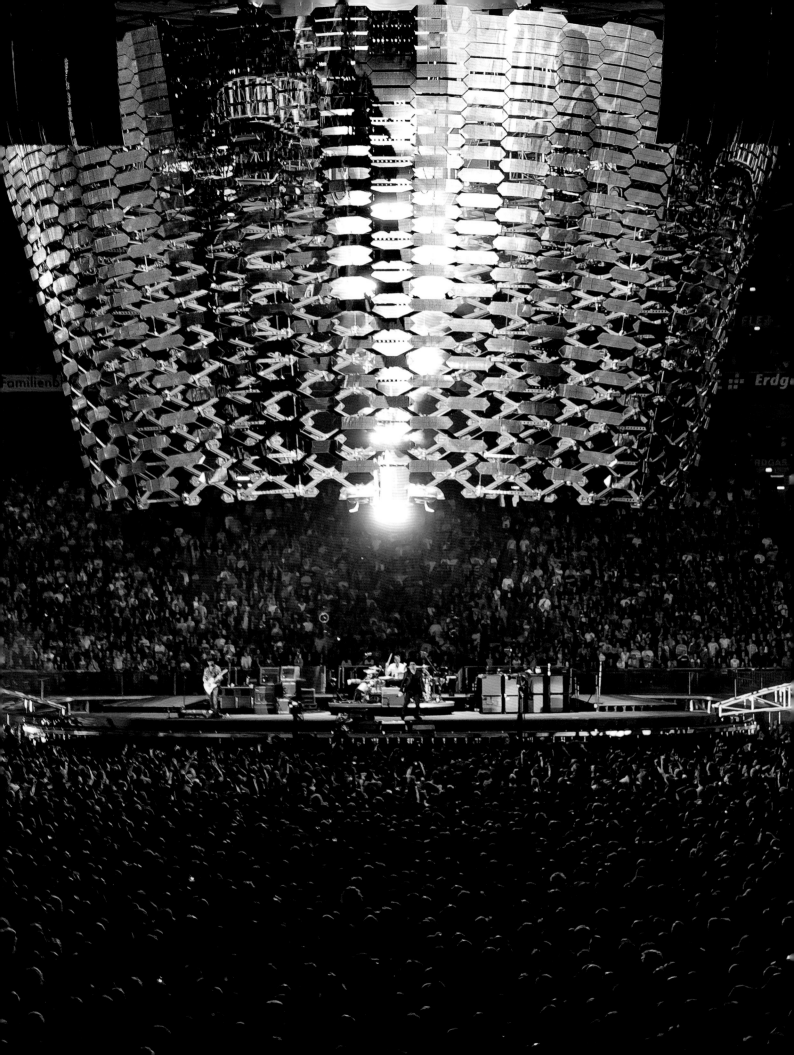

the 360 tour.

Suddenly, at the back of the plane, a pillow fight broke out, as half-a-dozen crew members started throwing their blankets and pillows around – playfully at first, almost incidentally, but then fervently, and with a keen sense of competitiveness. It was hostile for a few minutes, then everyone collapsed in laughter. No winners, no losers.

'Yes, it's a long tour, but it's only 110 dates,' said Bono, screwing his face up at the tartness of the wine. 'And let's face it, come on now, BB King would play 110 dates in a summer, and not a very long summer at that. We were all getting very Irish and very macho about it, but it's not that big a deal. However it is an achievement to play to seven million people. In 110 shows. I think the two positives of this tour have been joy and intimacy. Oh, and some badass attitude.

'This tour has allowed us to step back, evaluate, write songs, and think about what we might do next. It hasn't driven us into the ground, hasn't driven us crazy – although it's driven us a bit crazy recently, to be honest – but it's been a way for us to do this thing we do properly.

'After two years, three birthdays, a back injury and a hell of a lot of heartache, we're finally coming up with something that we're proud of. We hope that people have found something in our music they feel is important enough to take us with them. Because we're not there for any other reason.'

And what had the last two years taught him? What were U2 compared to what they were before they embarked on this folly of all follies?

'We've managed to get out from under the hammer each time ... but it's only sensible to think the hammer is coming down any minute now ... Time's up ... We've dodged our fate for too long for

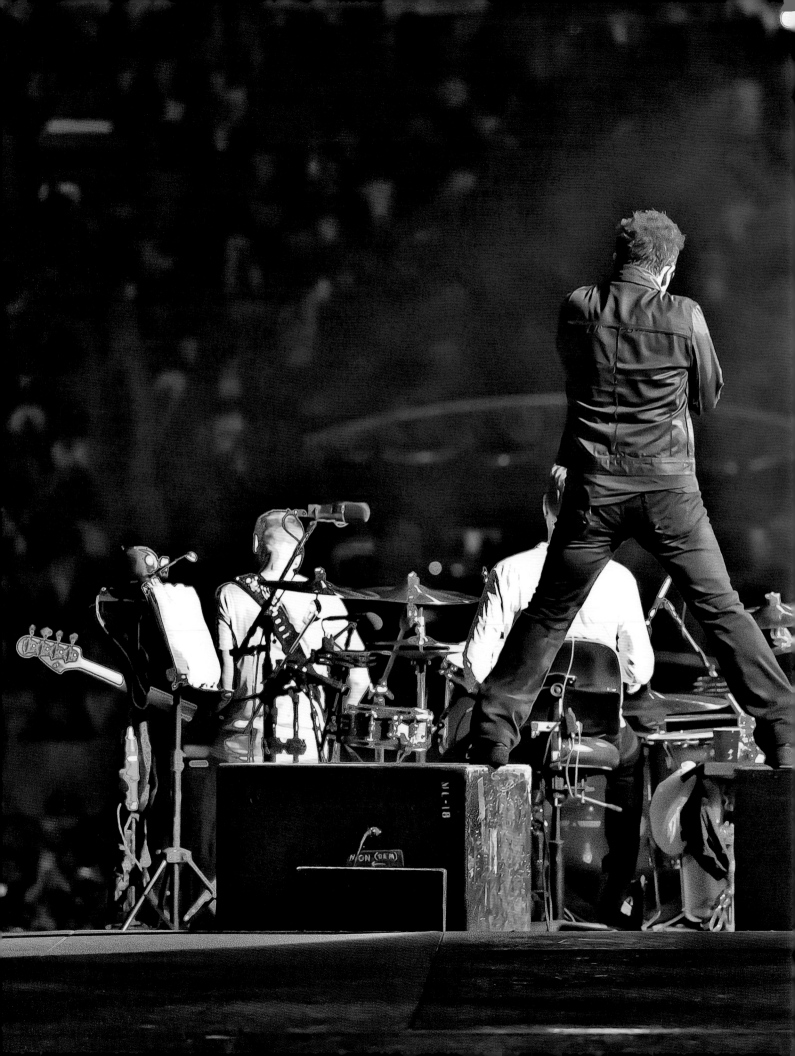

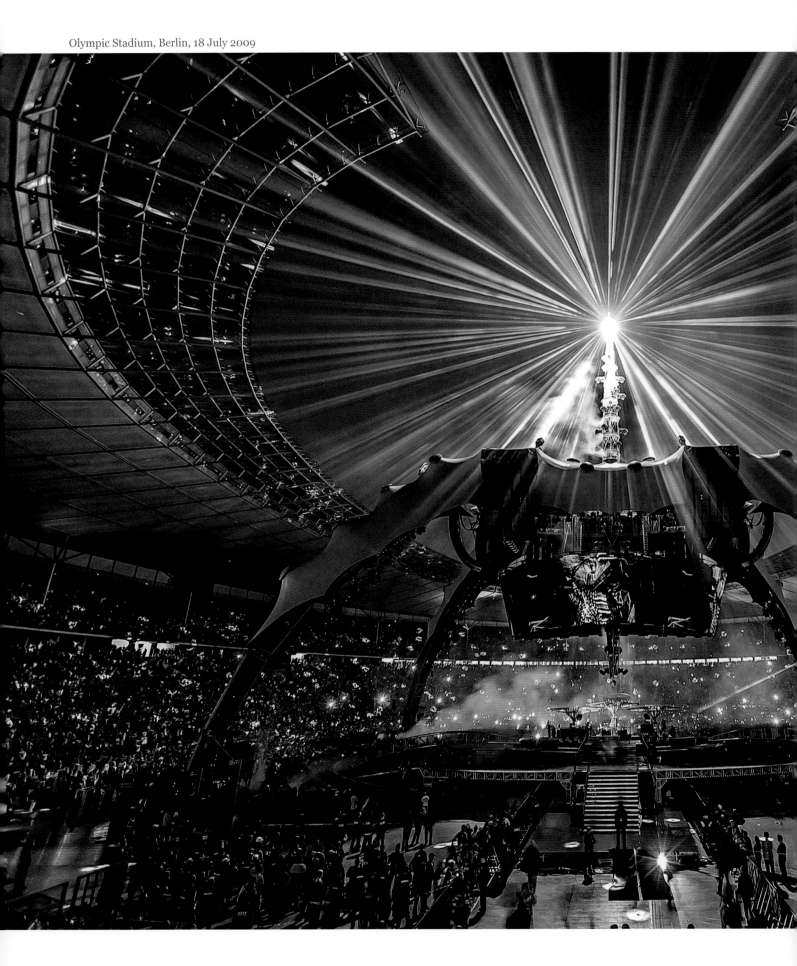

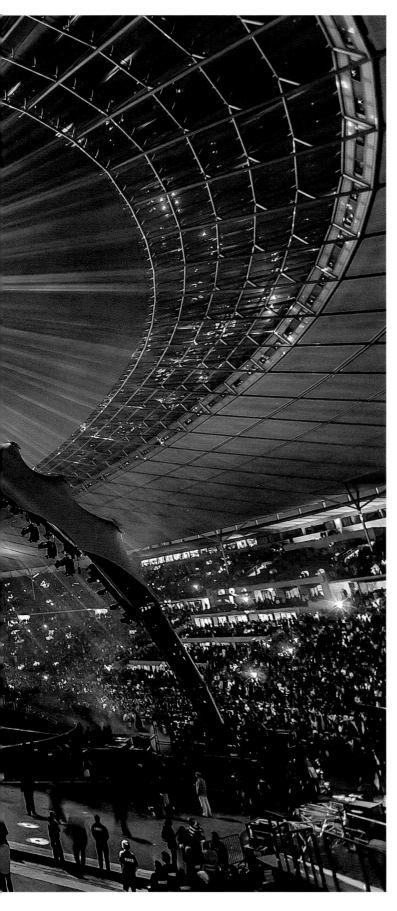

it not to! But it's been fun ... we've made some great music on the run from this eventuality. But that hammer, that sword of Damocles is hanging right there ... waiting ... We are not under any illusion ... this might be it for us. I hope it isn't ... it's great fun and we're getting really good.'

And with that he pimp-rolled back to his berth, glass in hand, the weight of his world on his leather-jacketed shoulders, and the prospect of an attritional rain-soaked performance at Glastonbury just a few hours way ... It was going to be a long, cold, rather bumpy night.

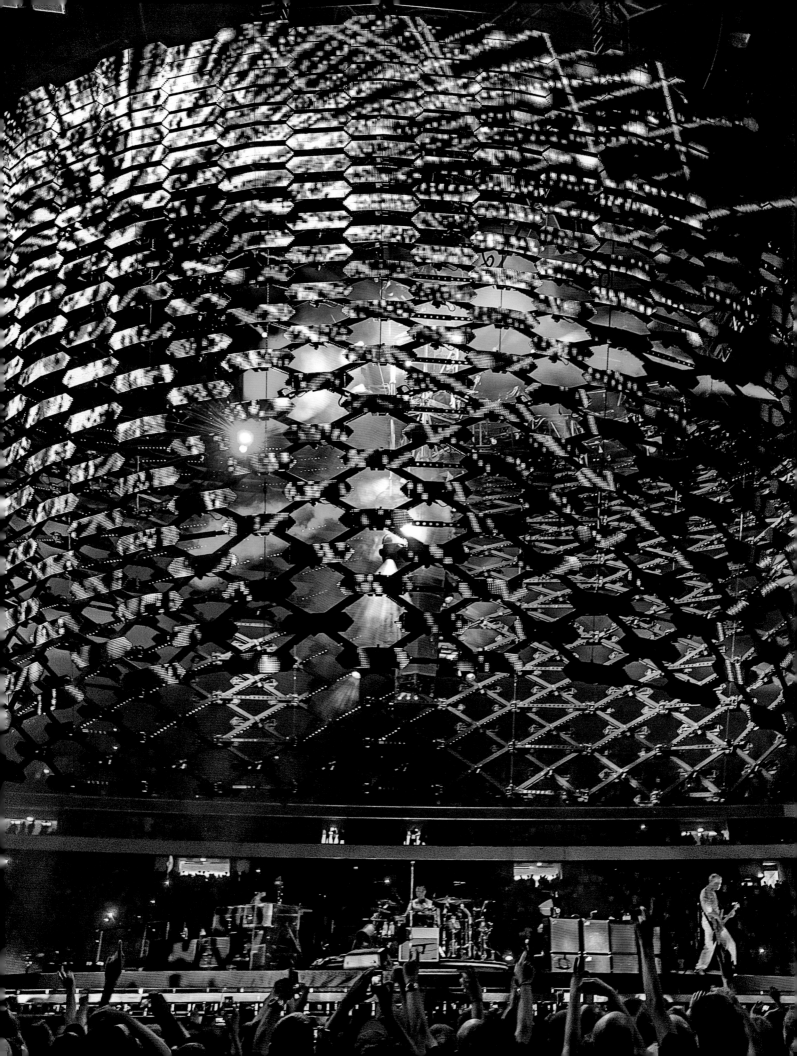

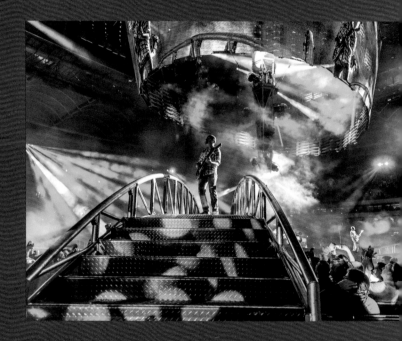

# DESIGNING 'THE CLAW':
## A SQUID AS BIG AS THE RITZ

## Chapter One

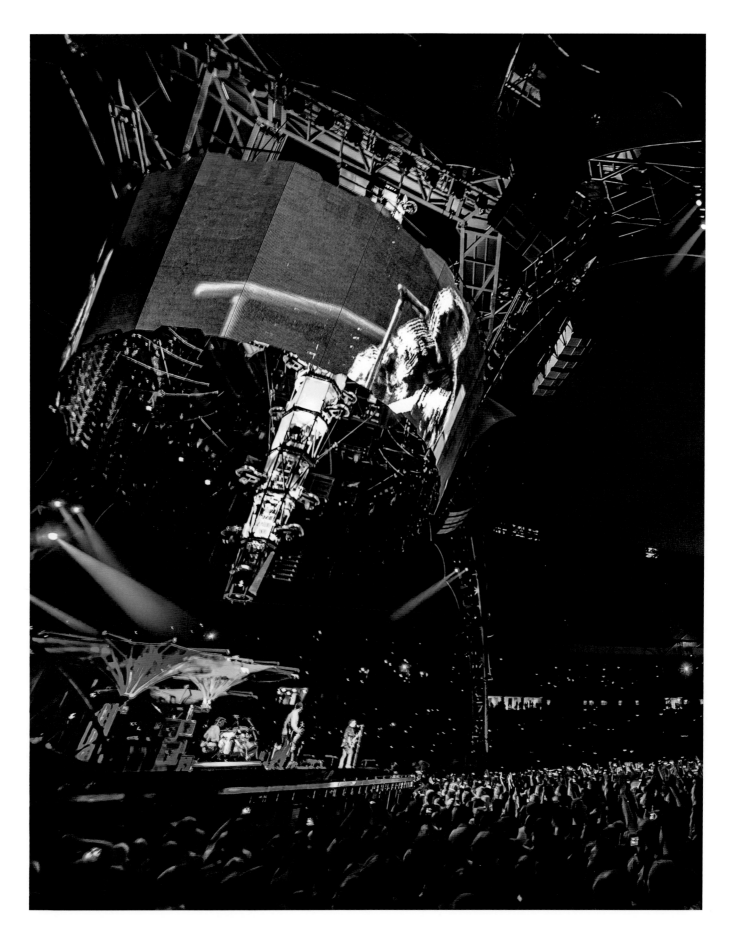

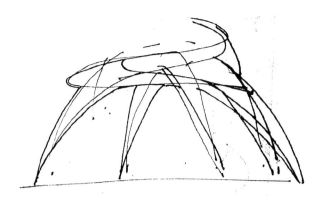

# 'THIS IS OUR MASTERPIECE. IT'S THE CULMINATION OF EVERYTHING I'VE EVER DONE WITH U2'

## *– Willie Williams*

**As the last leg of the Vertigo tour drew to a close in Honolulu in December 2006, Bono and the band's production designer Willie Williams were already considering what they would do to follow it up, and what the next U2 show might look like. With the aid of some forks and some forbidden fruit, and inspired by the Theme Building at LAX, they set to work.**

It all started with a grapefruit. U2 tours tend to begin on the last day of the previous tour, and so it was in Hawaii on 9 December 2006, on the last day of the Vertigo tour. The band were in Honolulu, where they were due to play the Aloha Stadium that night. For most of the day, Bono had been hanging out with Willie Williams, the show director who has worked on every U2 tour since 1982, chatting about where – philosophically – he thought the band should go next. As the band were still on tour, Williams could walk around the stage after soundcheck visualising what it might look like the next time they went out.

'After soundcheck that day, I walked around the stadium with Bono and the guy's saying, "You would be standing here, the leg would be where the bin is over there," and it was such a helpful thing for him to be able to stand and imagine what it would be like to be onstage. Because, you see, when you're

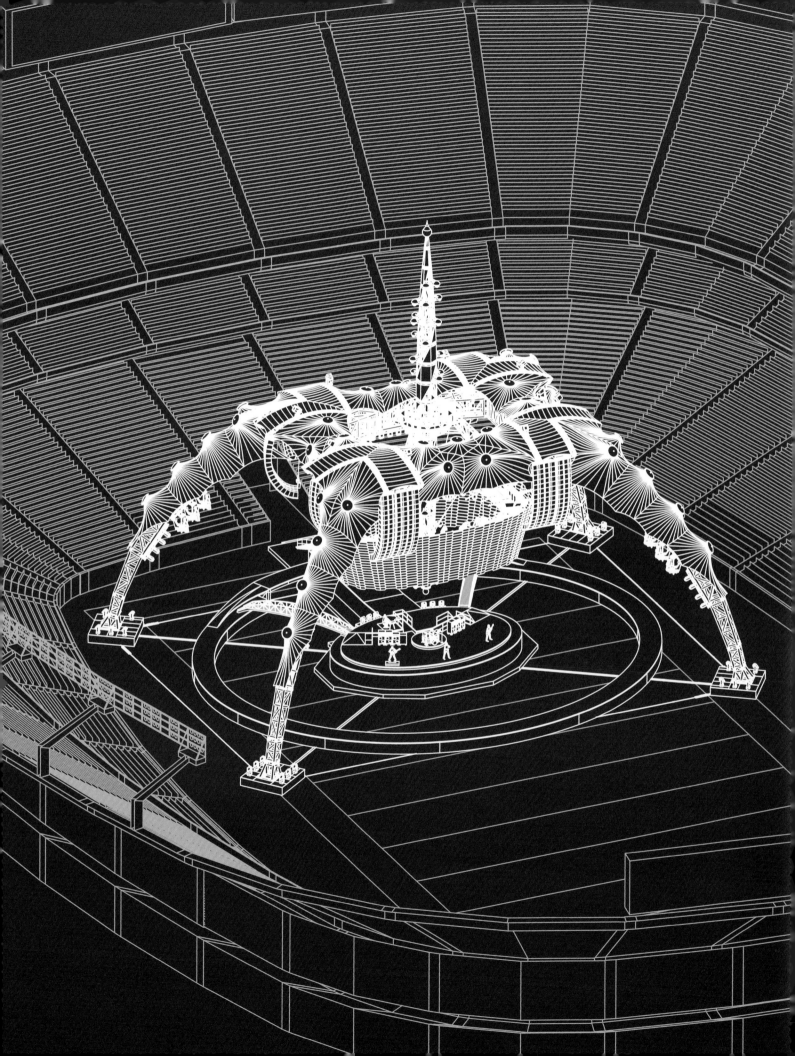

standing on the 360 stage, the structure completely disappears – all you see is people.'

Bono had this idea about intimacy. About micro and macro, about building something big that would make everyone 'out there' feel bigger, about building something enormous that would touch people in a way they'd maybe never been touched by a stadium show before.

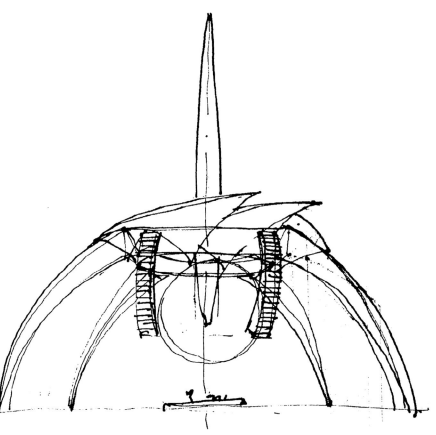

The original sketch for 'The Claw, a virtual spaceship bound for a stadium in a town near you soon ...

It was typical Bono. A grand gesture. Some would say folly. A big headache.

'The first idea was: can we move the stage out from the back wall, close to the centre of the pitch?' said Edge. 'What does that look like? Because clearly you have to support everything with some sort of structure, and if so, what is that going to look like? How is it going to affect sightlines? How

are we gonna deal with the lighting and the PA, and everything like that? So bit-by-bit, this thing came into focus, and what was interesting was that the solution to all the questions was an object, a singular design element.'

'We knew we were going to go and play outdoors, and we wondered how we could do it differently to everyone else who's ever done it,' said Bono to me one night towards the end of what would turn out to be the most successful rock 'n' roll tour ever. 'How could we conquer the stadiums? How could you create this feeling of "The Garden", where you could build something that was all about excitement and joy, a cycle of enjoyment, the perfect arena for music. And something that we could move around. In the early days, of Elvis and the Beatles, they just bashed it out in an intimate way because there was no PA, there were no lights. It was just a band on stage. But from the mid-Sixties onwards, the stage just started getting bigger, moving away from the audience – the Rolling Stones, Pink Floyd, Grateful Dead, you name them. And it always annoyed me that there was just this one way of doing it. So I thought, what would happen if we didn't have a PA. Everyone wears headphones!'

'U2 had always played arenas in the round and the last two U2 tours have been predominantly indoor-based productions, so it started to feel like it would be a good time to start thinking about doing

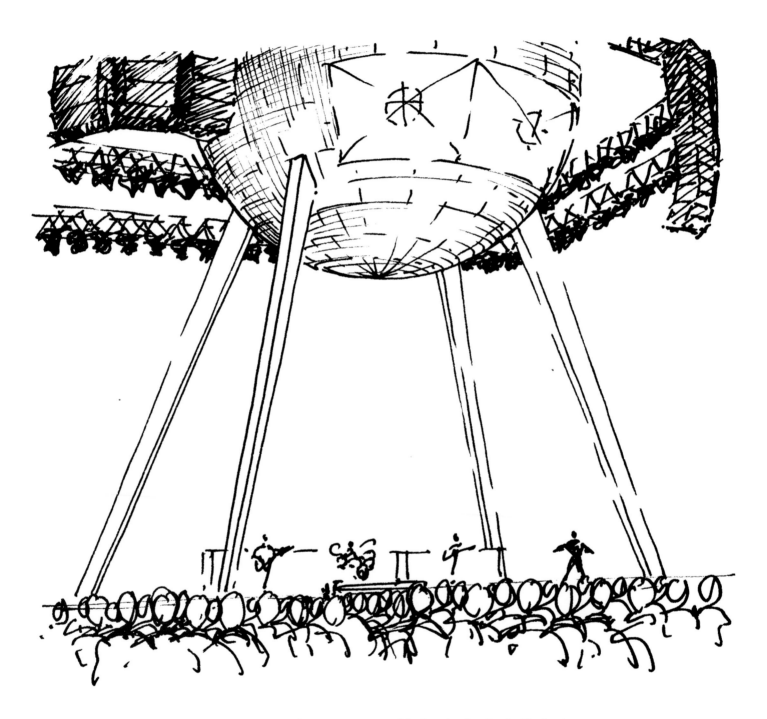

Mark Fisher stage sketch, may 2004 – one of the first sketches for the U2360 stage.

'The stage needed to be different. It needed to be bigger, and better. Then I thought there might be a way,' said Bono. 'So I got these knives and some forks, and a grapefruit, and started mucking around, placing the knives and forks over the grapefruit, trying to build this thing in my head. I did it on the breakfast table, much to the dismay of my family, Who thought I'd lost it.' Bono

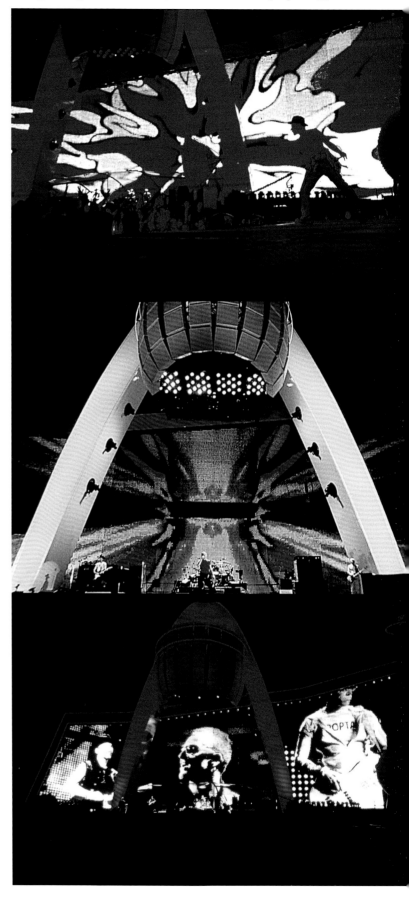

an outdoor tour,' said Edge. 'We hadn't performed outdoors in America since the PopMart tour of 1997 in America. But it needed to be different. It needed to be bigger, and better.

'There was also the issue of the fans, especially the younger ones. We were very aware that with gigs of a certain size, the tickets were being resold at incredibly high prices, which felt wrong. It felt like our fans were being ripped off. But we were also aware that the younger, college-student age fans, couldn't afford these tickets at all. So by doing outdoor concerts, by completely fulfilling demand – which you do in pretty much every city where you play a big stadium – it just kills the secondary ticket market. So we were able to offer thousands of tickets at around $30, and suddenly they're affordable for the younger U2 fans, and then you really see the difference in the crowd.'

'Then I thought there might be a way,' said Bono. 'So I got these knives and some forks, and a grapefruit, and started mucking around, placing the knives and forks over the grapefruit, trying to build this thing in my head. I did it on the breakfast table, much to the dismay of my family, who thought I'd lost it.'

As Bono explained it, I started thinking about the obsessive way that Richard Dreyfuss builds his model mountain in *Close Encounters of the Third Kind,* before realising that what he's building is – frighteningly – actually real.

'Then I went to Willie, to see what he thought,' continued Bono, as though he were describing the process for the first time. 'And then I spoke to Jake [Berry, U2's Tour Production Director], just sounding things out. It might look like this, it might not, but could it happen if we wanted it to?

'I've always been obsessed with the things that

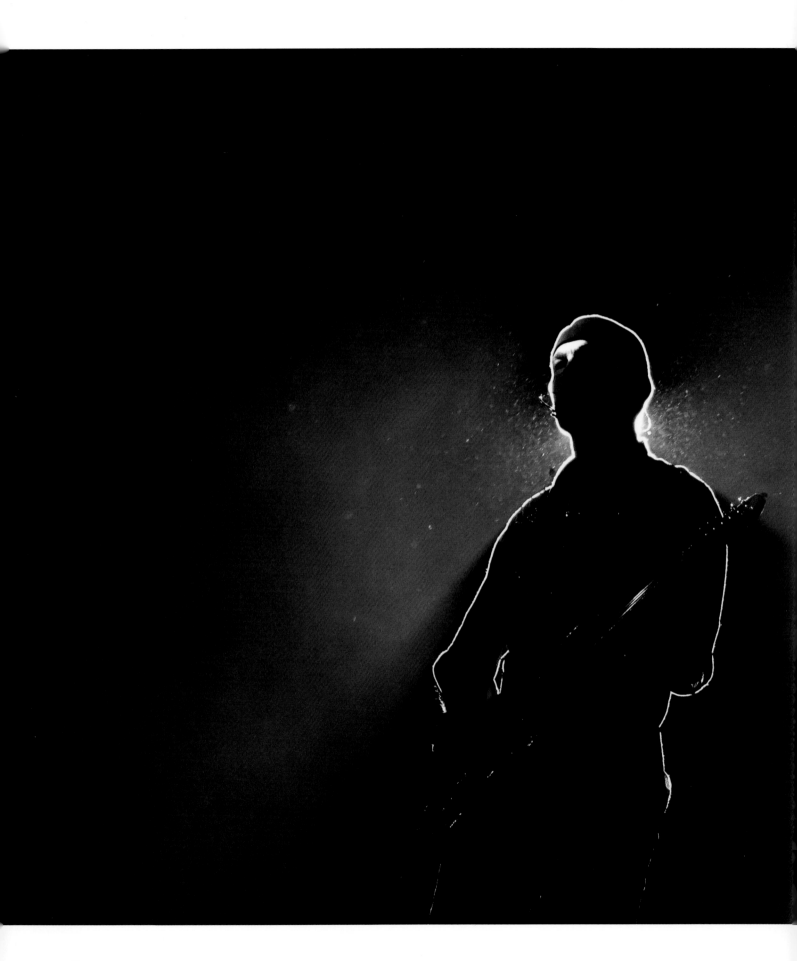

separate you from the audience. I've been in small clubs seeing bands and I've felt a million miles away as there is no connection, no relationship, so it's not always about the size of the venue. It's about how you communicate. That was the breakthrough, realising that. It's not about physical distance, it's about feeling, it's about trying to get in the face of your audience. It's about whether I believe this person. And by the way it's not about soulfulness, it's not about openness. Look at Ian Curtis. He wasn't open, but it was all about, do you believe him? And we did believe him, which made him a great performer.

'Once you realise that, you start looking for things to break down the wall between the stage and the audience, the fourth wall. We invented the satellite stage, as I was always saying to the production managers – why can't I stand on the sound desk, why can't I be closer to the crowd? And Joe [O'Herlihy, who's in charge of U2's sound design] would always say, 'You're not fucking standing on my sound desk.' I wanted to put a roof on him, so I could sing on the sound stage, and now we've got these acoustic monitor earpieces, you can play in any part of the stadium, with no echo or interference. I said, I want a stage here! And so the compromise was the satellite stage. That started in the Nineties. In the Eighties I had to actually get into the crowd, physically grabbing people, to try and get closer to them. And when that wears off you want to do it mentally and start looking for the contraptions and constructions to challenge the fourth wall. That's how Zoo TV came about, and in a way the 360 tour is the follow-through of that.'

As Larry Mullen Jr said once, capturing the U2 methodology in a single bite: 'If it ain't broke, break it.'

'You sometimes see a one-off outdoor stadium show

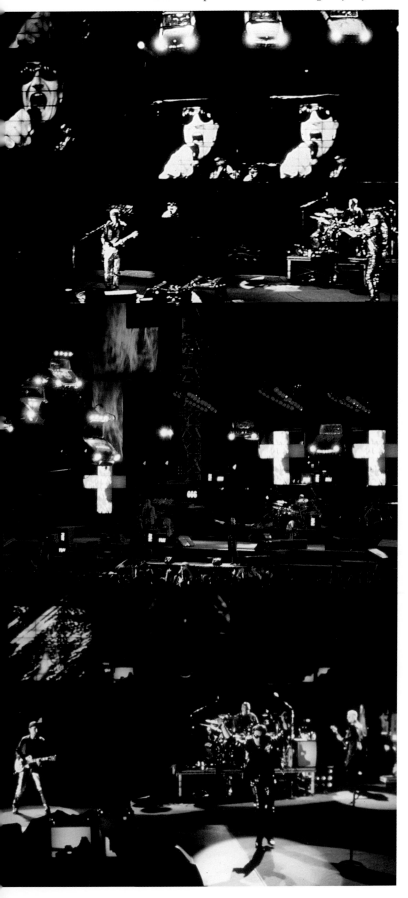

in the round but that stage is a temporary structure and not built to tour,' said Paul McGuinness. 'So there is really only one act in the world that would be big enough to do an outdoor show in the round, and that was U2.'

Paul has been offered some of the biggest bands in the world but has politely turned them all down. This is germane because of the attention to detail this relationship with U2 brings. 'In the Eighties there was a generation of bands who seemed to be our contemporaries, and we thought they would develop in parallel with us; I'm thinking of bands like the Clash, the Pretenders, Queen, Talking Heads and Police. All of them retired or changed into solo performers, or someone died, and none of them really tried to have careers in the way that U2 did.'

After his initial discussions, Willie Williams started talking to the team, and the team in U2's case is always the same. There is Paul McGuinness, tour promoter Arthur Fogel, architect Mark Fisher, LED technology visual expert Frederic Opsomer and tour production director Jake Berry. These men became the conceptual godfathers of 360.

'Bono had been thinking about ways to bring the stage closer to the centre of the field which we thought could aid an intimacy and connection with the people on the upper tiers of the big stands that would be the furthest away from us,' said Edge. 'So he pitched this idea to Willie, who went off to try and make it work.'

Willie's next step was to consult Mark Fisher, who has been responsible for elaborate stage shows used by the Rolling Stones, Elton John, Pink Floyd and pretty much anyone else in the rock world who has a modicum of ambition. After a brainstorming session with Fisher ('He is the architect of my

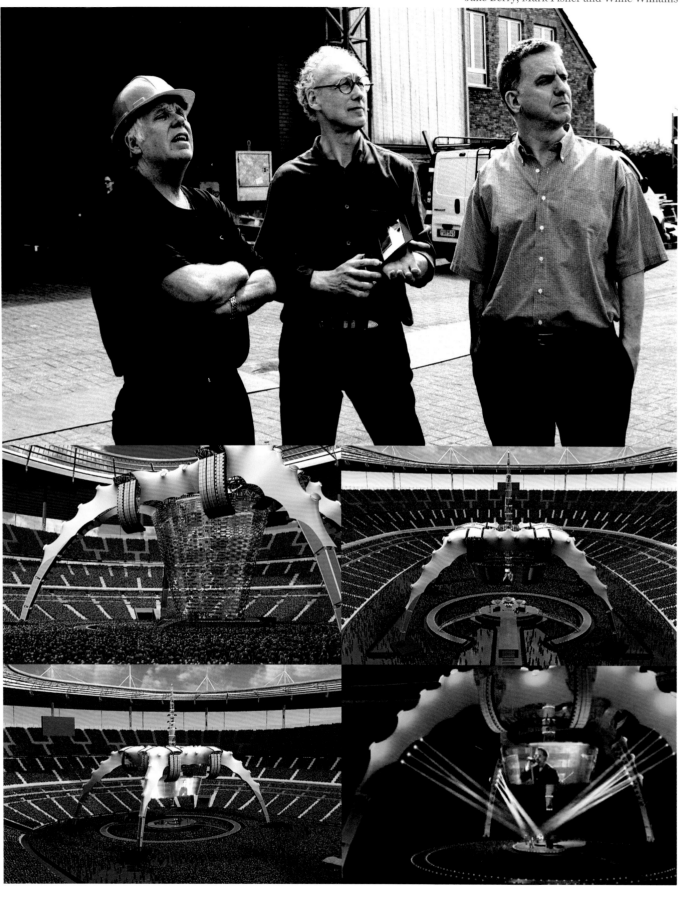

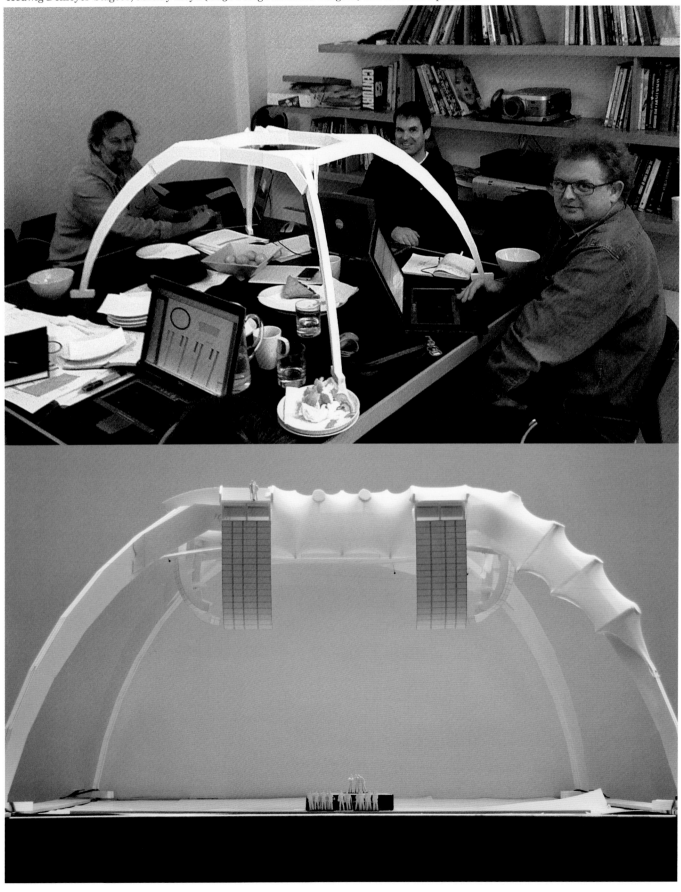

Hedwig Demeyer-Stageco, Jeremy Lloyd (U2360 stage technical designer) and Frederic Opsomer

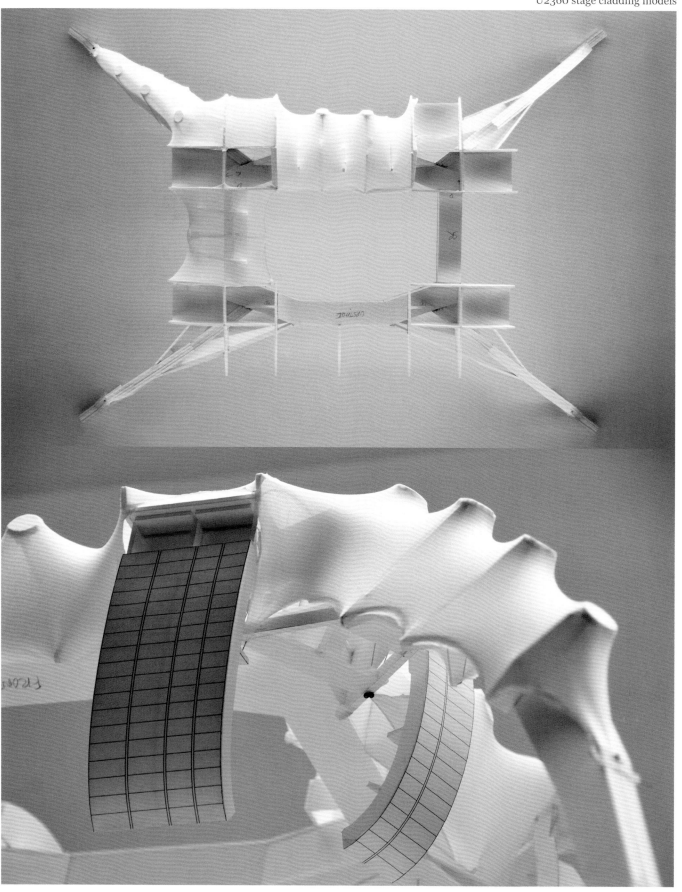

dreams, and he got it in one,' said Willie, 'sending round a bunch of sketches of huge objects standing in a stadium'), the stage for the 360 tour began to emerge – based heavily on the futuristic building at LAX, Los Angeles' famous airport. Which itself looks as though it might have started life as a grapefruit supported by some cutlery.

In Los Angeles at the beginning of the sixties, the messy beat ethos was disappearing, contradicted

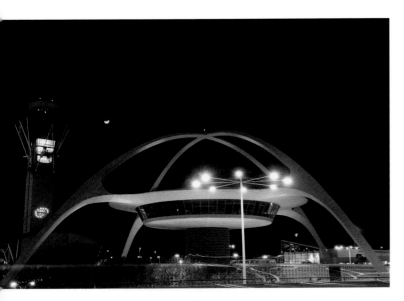

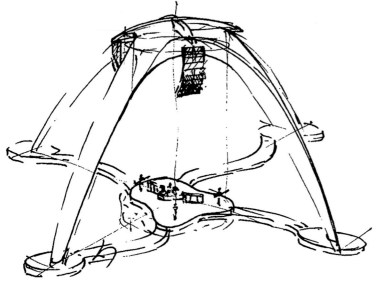

The LAX Theme Building opened in 1961 as a restaurant and observation deck. It was designed by a team of architects and engineers headed by William Pereira and Charles Luckman and is an example of the mid-century modern influenced design school known as 'Googie' or 'Populuxe'.

by the rise in popularity and critical acclaim of mid-century modern design, and, crucially, the election of John F. Kennedy. 'It could be seen in fashion, film, art and architecture,' writes Hunter Drohojowska-Philp in her book *Rebels In Paradise: The Los Angeles Art Scene and the 1960s*. 'The very appearance of the city changed as some of the city's pre-eminent modernist architects used the latest developments in engineering and technology to forge curved and circular buildings that were termed futuristic. John Lautner completed the Malin residence, called the Chemosphere, a hexagonal, glass-sided residence mounted on a pole in the Hollywood hills overlooking the Cahuenga Pass. The Los Angeles International Airport gained a circular glass restaurant suspended between a pair of linked arches, a collaborative effort by four of the city's top architects: William Pereira, Charles Luckman, Welton Becket, and Paul Williams. A serpentine clover leaf of smooth pavement opened to connect the Santa Monica and San Diego freeways.'

And here it was again, only this time it was going to be standing in dozens of stadiums all over the world, a twenty-first-century caravan of love. (At the onset of the planning, environmental consultants were contracted to come up with a plan to offset the environmental costs of the tour.) It was Fisher who came up with the extraordinary template for the stage, a stage that would soon become known as 'The Claw'. It was an enormous structure, meant to sit in the middle of a stadium, which allowed everyone in the audience a view of the band. This was going to be a concert in the round like no other.

'The band was going to be sitting in the palm of the audience's hand,' said Willie.

'The real breakthrough came in realising that

instead of trying to make the structure less intrusive and more minimal,' said Willie, 'what if it was so big that it just became part of the building? Once that was in my head I knew that that was the moment. We could do it.'

'There have of course been a number of 360 degree shows in arenas, obviously on a much smaller scale,' said Arthur Fogel. 'If you've been in the business and experienced some of those shows you had a feel for what that is, but certainly on this level it had never been done. And I'm always in favour of pushing the envelope in any number of ways, and when pushing the envelope creatively, which this surely did, and logistically and financially, to me that's the exciting part of the business.

'I think it's easy to keep doing the same old, same old, but this was really ground breaking and challenging and fun.'

Fogel is the Chairman of Global Music and Chief Executive Officer of Global Touring at Live Nation, which looks after the U2 tours. His relationship predates this, and he actually started working with the band in Canada, promoting their shows in 1981. He would end up being on every date of the 360 tour, and had been at pretty much every gig since he took over the world touring responsibilities in 1997, on the PopMart tour.

'People often ask me what I do when they see me at a show, and the answer is, "Hopefully nothing." My role is really that of an executive producer, and if everyone is doing their job properly – which they do – then I don't have to get involved. The plan is the key, and probably where I have the most value is in the months before the tour

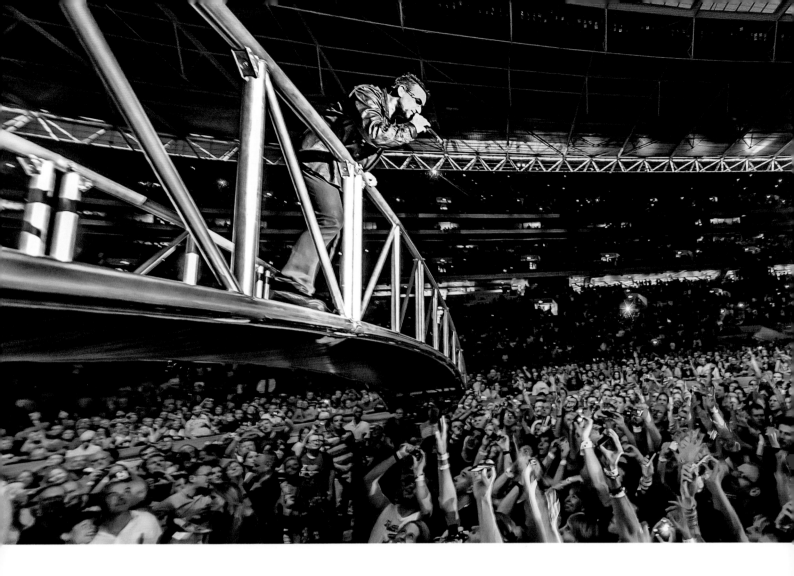

commences, putting all the pieces in place in such a way as to minimise people coming up to me at shows and having issues. So I think that, for me, that's the most critical part of the whole process, coming up with the right plan, putting it together well in advance, having a great team and then seeing it executed, hopefully with minimal drama.

'The first question really was about the capacity, as there's really nowhere to hide with unsold seats in a 360 production. And of course the one thing you don't want to experience is creating a production that opens up more seats that go unsold, both aesthetically and financially. So for me that was the toughest decision, whether I had the confidence to say to them, "Yes, we will sell the tickets." But I absolutely felt we could achieve it. And then of course after that first meeting in New York, I kind of went away and said, "Shit, is that true? Do I really believe that?" Because surely the last thing I want is to put anyone, particularly this band, in an embarrassing situation. And the upfront investment was so huge, it was a critical decision for me. It was a point at which you have to move forward and there's no going back. That was that meeting that drew that line in the sand.'

The Live Nation deal is basically a joint venture, encompassing tickets, concert promoting rights, merchandise and website rights, a multi-rights deal that excludes publishing and recording where the band own those rights themselves and license them to Universal Music Publishing and Universal Records respectively. The last tour the band

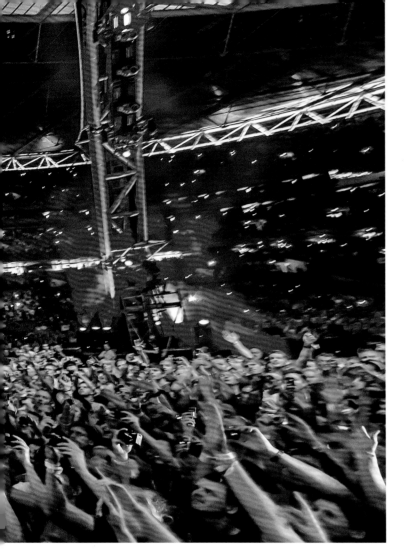

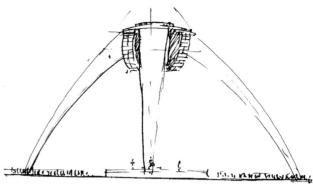

Mark Fisher's stage sketch, June 2006. Seen here, looking more like the control tower at LAX Hovering above a mass of bodies

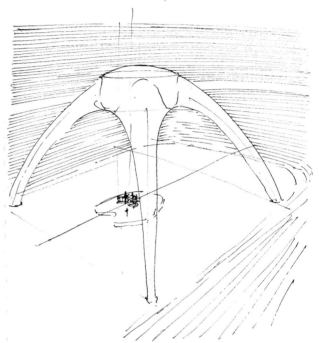

Mark Fisher stage sketch, June 2006

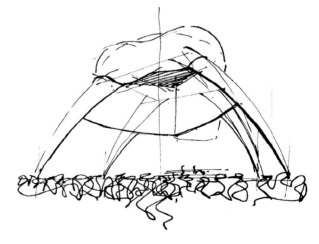

Mark Fisher stage sketch, June 2007

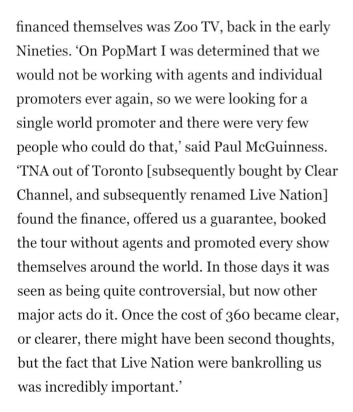

financed themselves was Zoo TV, back in the early Nineties. 'On PopMart I was determined that we would not be working with agents and individual promoters ever again, so we were looking for a single world promoter and there were very few people who could do that,' said Paul McGuinness. 'TNA out of Toronto [subsequently bought by Clear Channel, and subsequently renamed Live Nation] found the finance, offered us a guarantee, booked the tour without agents and promoted every show themselves around the world. In those days it was seen as being quite controversial, but now other major acts do it. Once the cost of 360 became clear, or clearer, there might have been second thoughts, but the fact that Live Nation were bankrolling us was incredibly important.'

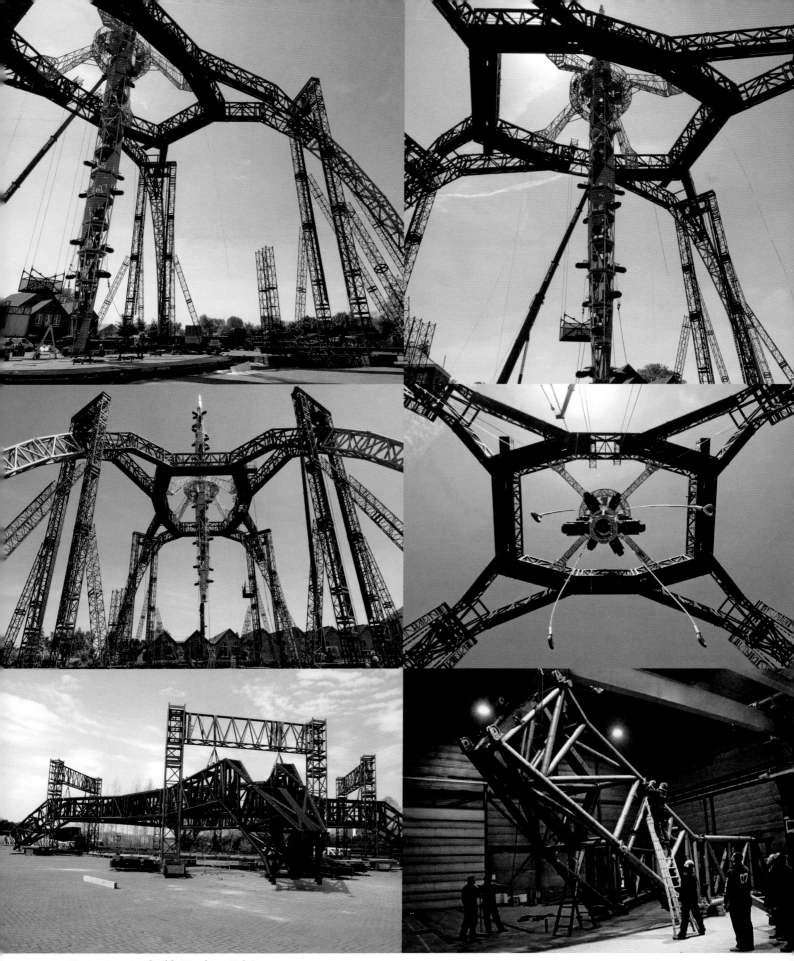

U2360 stage test build, Werchter, Belgium

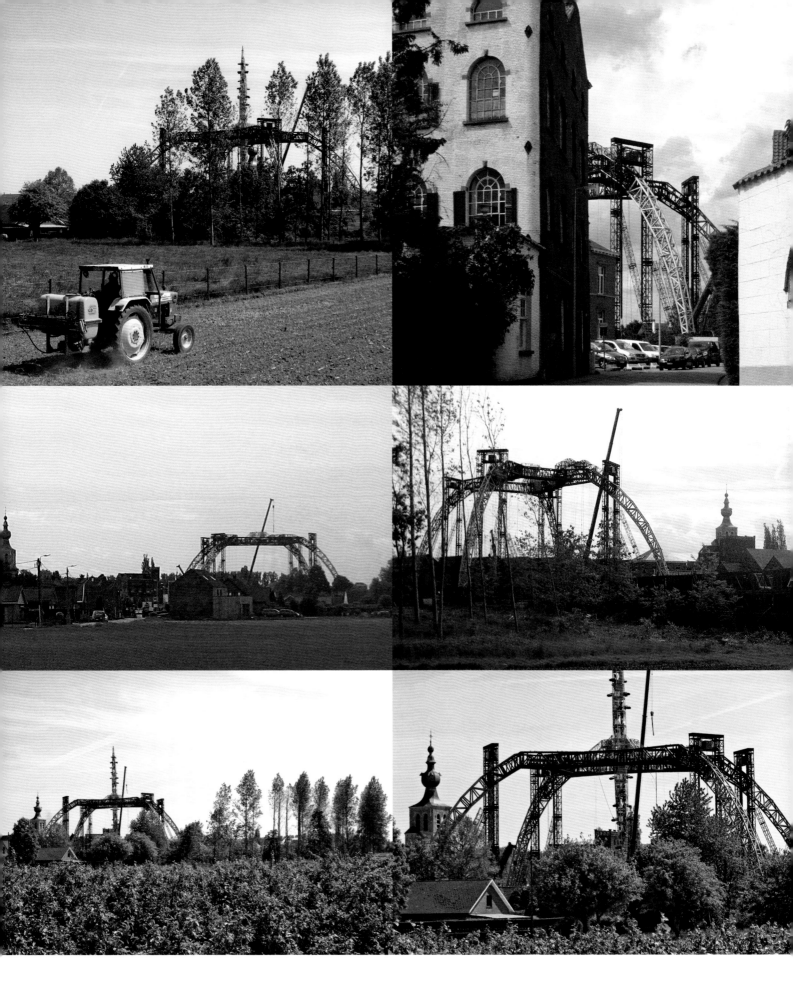

Mark Fisher stage sketches, June 2007

Between them, Willie and Mark came up with this structure that looked a little like an extremely large crab, something monstrous, yet something which was intended to shrink the stadiums it appeared in. The whole point of the Claw was to create something so huge that it dwarfed the stadia it would sit in, thus creating a more intimate environment. The rationale was simple: if you build something so big, it will actually become invisible, especially if it is skeletal. One of the joys of the set was the fact that there was no defined front or back, and was designed to be surrounded by the audience (even though it wasn't properly in the round).

The next challenge was wrapping it with video, allowing it to become a flat surface when it needed to be, a screen onto which the band could be projected.

'I thought the Vertigo show was the first thing that I had designed for them that hadn't really advanced the form,' said Willie, 'whereas Zoo TV and PopMart were these quantum leaps in the form of what a rock show is. And all of that stuff gets immediately plagiarised by everybody else.'

In the same way that the iconography of The Joshua Tree meant that in the eighteen months following its release, one in three videos shown on MTV was shot in the desert, so practically every large rock show after Zoo TV involved a large screen of some description.

'People come to U2 shows to see what the future will look like,' Willie continued. 'Every show you look at now looks like a cross between Zoo TV and PopMart. It's a person standing onstage, with a big LED screen behind them and that's your show. I wasn't sure of how to get out of that, because I'm also aware that video is the loudest voice in the room. If you take that away you better have

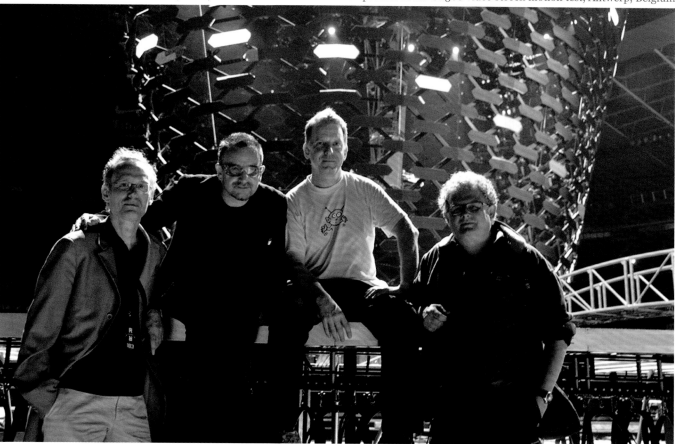

something pretty engaging to replace it with. So the notion that instead of having a big video backdrop, have a backdrop of audience, was really captivating. I had that in my mind for a long time.'

'On every tour we've done, we've been the first people to use a given technology,' Bono told me. 'So, on PopMart I asked could we do a screen that would be a pop art installation, and we used LEDs, not in clusters, but across the stage, so you got this huge screen. And now everyone uses an LED screen. Whenever we tour these days, the Belgians always think we're going to push them a little harder, and we do, because we know they can deliver. They say, "What is it now? Because we have to build this shit?!" And then we say, but if we're right, lots of people are going to start ordering it!'

Ah, the Belgians. Having come up with the

concept, it was time for Willie and Mark to contact Frederic Opsomer. Torhout-based Opsomer had worked with U2 since the European leg of the Zoo TV tour in 1993, and was instrumental in many of the video displays. He was working for a video rental company at the time and developed a projector cube system that was used on the tour. In between U2 jaunts he had worked on the opening ceremony for the Athens Olympics, sold his company to Barco (the Belgian American Radio Corporation) and had been at the forefront of videoscreen design for two decades. Willie approached him and asked if he could find a way to incorporate video into 'a claw-like structure'. He initially played around with the idea of having video on the sides of the legs, but then what would you do with the audience inside them? So they played around with the idea until

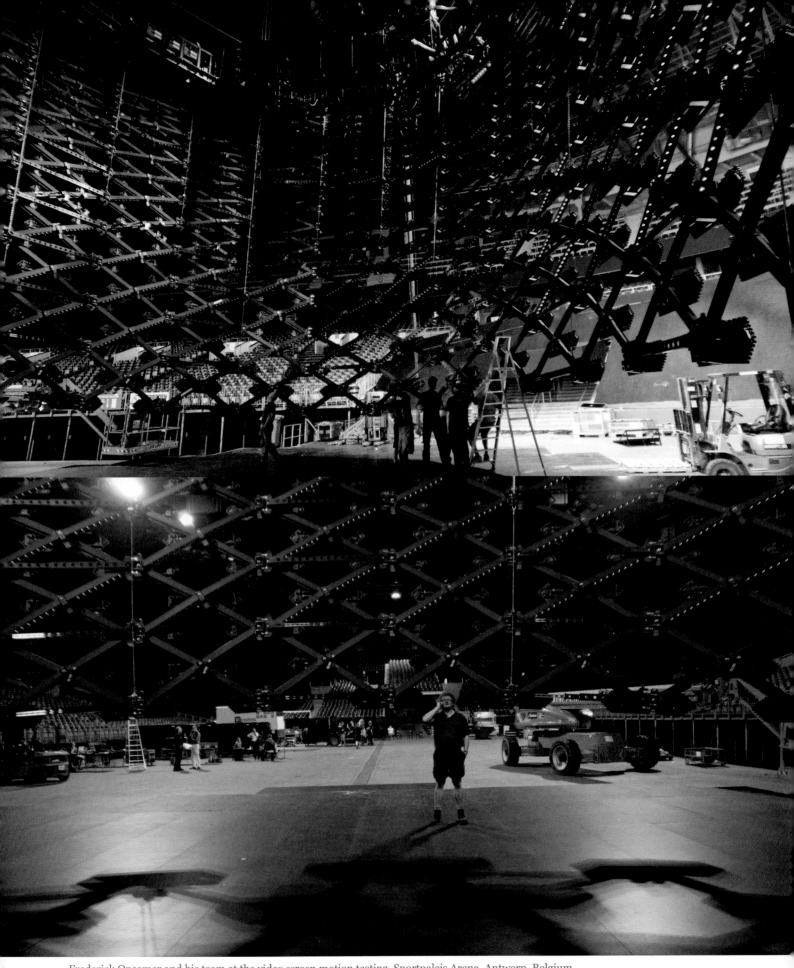

Frederick Opsomer and his team at the video screen motion testing, Sportpaleis Arena, Antwerp, Belgium

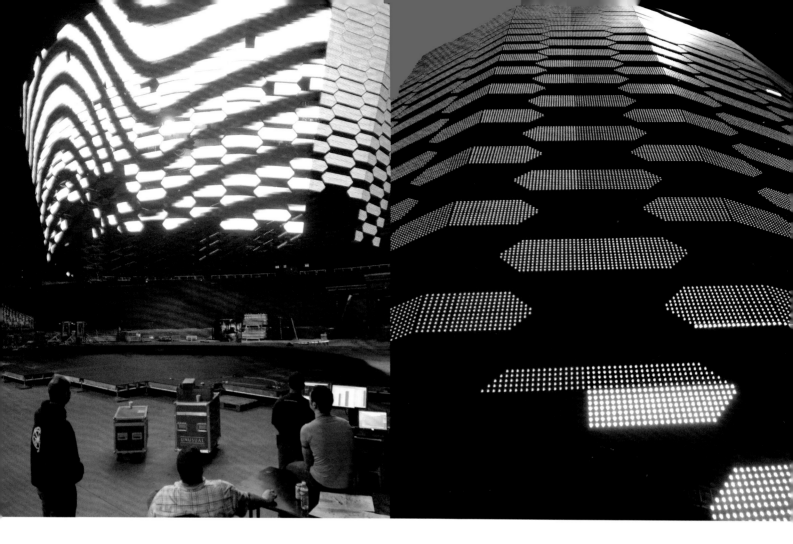

they came up with the circle.

'For me it all started when Willie Williams showed me some very conceptual drawings of what would become the 360 stage and said, "Think about how we can integrate video into this." Then Mark Fisher told me about this guy in New York he worked with for a project in Vegas, and who specialises in expandable structures. I was at that time already dreaming of expandable video screens but had not encountered anybody who could help me with the mathematics of such a thing. So Mark tells me about Chuck Hoberman, who makes mathematical models for expandable structures from his base in New York. A couple of weeks later I am in Chuck's office.'

They tried cylinders, flat surfaces, and various other options before coming up with the final design. They started developing the structure in October 2008 and had it finished by May the following year. 'U2 is a band prepared to really take it to the next level,' said Frederic, 'to take risks, and to go where no one has been before. The expandable structure had never been done before, nor had something like using "freeform pixels". Because of the shape of the structure we had to manufacture half a million separate hexagonal LED pixels. These pixels cost about €10 a piece, so you could see how much this thing was going to cost from the beginning.

'The key for me was to have a video screen that could be high resolution at some point and become a much bigger sculpture at another point, without obstructing the transparent look of the stage. Assisted by Chuck, I did some proposals for Willie

and Mark. One of the proposals was retained; the one that would become known as the "Freitzak" because of its very recognisable shape, for Belgians at least.' The expandable video screen looked like one big shaving mirror, collapsing and expanding seemingly at will. Frietzak is Flemish for chip basket. Ah, a conical chip basket! Who knew?

'Frederic saw one of Chuck's kinetic screens and was fascinated by seeing a mechanical device that moves and changes shape,' said Willie. 'Then he imagined it covered with video pixels and that's where the process began. We looked at various ways they might be deployed in the round, and then had a lightbulb moment when the cylinder emerged. Once Fisher got his hands on it, it took on a whole new dimension. The screen started off a cylinder, but Mark reworked it into an ellipse and also made it saddle-shaped, so the movement of it is mind-boggling – the expanded shape becomes a cone rather than a cylinder.

'This tour has been driven by technological advancement, as you couldn't have done this five years previously. We're always having to imagine what might be possible in a couple of years time, so we're always dealing with prototypes and always right on the edge of what is possible. On the Vertigo tour we originally wanted a three dimensional cloud filled with very tiny LED pixels, but the technology wasn't ready. It became obvious it wasn't going to be tiny pixels on filaments; it was basically going to be tennis balls on washing lines. But these things exist now – I saw one in Zurich train station.'

Having completed the initial designs, and built scale models, they then presented the structure to the band. 'There was myself, Mark Fisher, Willie Williams and a few others,' said Frederic, 'and Mark said, "Okay, we're now going to present this brief to

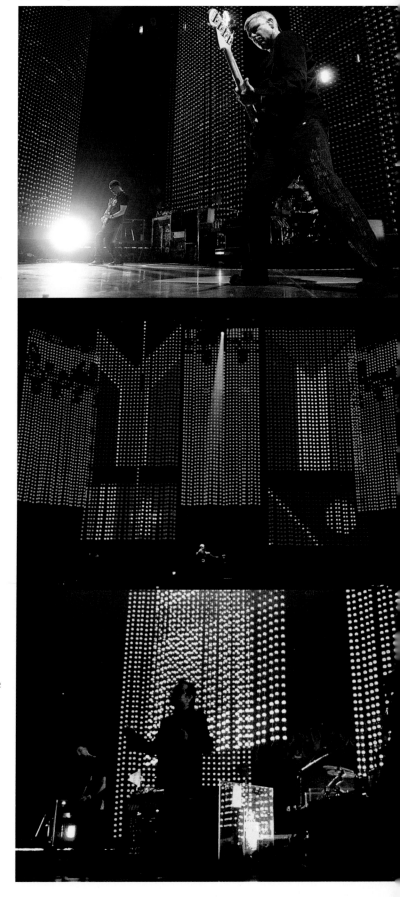

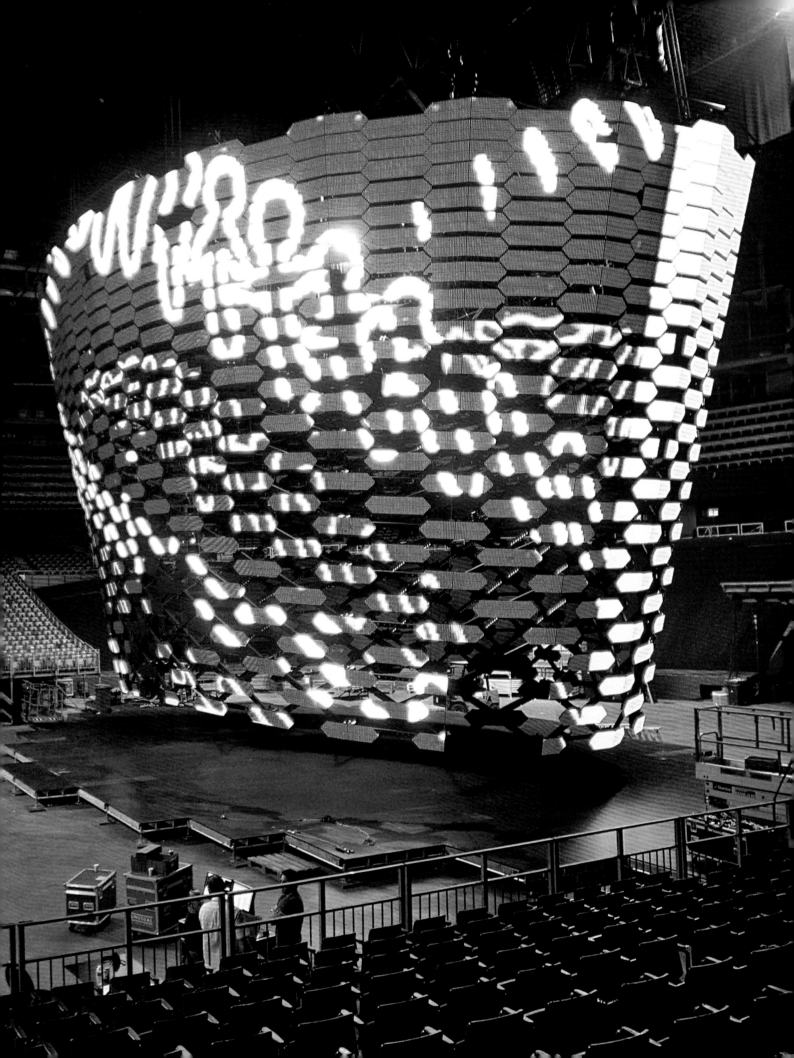

the band and try to push this forward, but we want everybody around the table here to be confident that we can do this." And that's one of those moments where then you have to think, if I now push the button, I say, "I can do it", then there's no going back. And everybody said yes. And Mark looked at me and said, "You're all smiling now, but you won't be in a year."'

Willie and Mark then convinced the band that this stage was the one for them, and finally in September 2008 they got the go ahead. 'I knew this was going to cost more than anyone had ever spent on a tour, but I could also see that we could open up maybe more than 30,000 extra seats a night,' said Willie. 'So I also went to Jake Berry, and Arthur Fogel and Paul and everyone else I needed to, and asked them what they thought. And to a man they all liked it. So armed with all of that I could go to the band. Actually, to be honest, I went to each band member separately, which I tend to do with ideas that I'm very precious about.'

'We've done so many tours with Willie and Mark, and we always start out with a fairly clear concept,' said Adam. 'We say, "Well, we want the stage to be able to do this," and then once we've figured out what the playing surface is we then figure out what the casing is going to be. So going back to PopMart, that was obviously a reference to shopping culture, and then the McDonald's arch came into it. Zoo TV, to some extent, that was pretty much Willie and Mark's concept from start to finish. But we give them enough, and then once we've got the bare bones, or the shape of the construct, then they start to push it to see what else they can get it to do.'

The video screen was eventually built by Opsomer's Innovative Designs using weather-

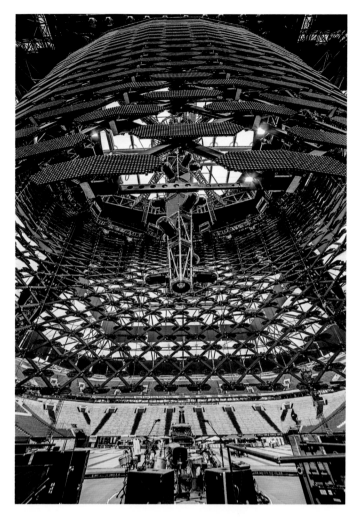

resistant LED pixels manufactured by Barco. It is made up of hundreds of hexagonal segments mounted onto a multiple pantograph system. The screen itself is made up of over one million pieces, including 500,000 pixels. The cabled pulley system enables the construction to be moved up and down like one huge Slinky, using technology that simply wasn't available the last time U2 went out on the road. The giant LED screen used on the PopMart tour would develop spontaneous Technicolor starfields when it got wet, yet this system was in a different league altogether.

'I was aware that everybody felt a frustration with repeating the same format,' said Willie. 'When you're on your tenth tour it's easy to feel like you're

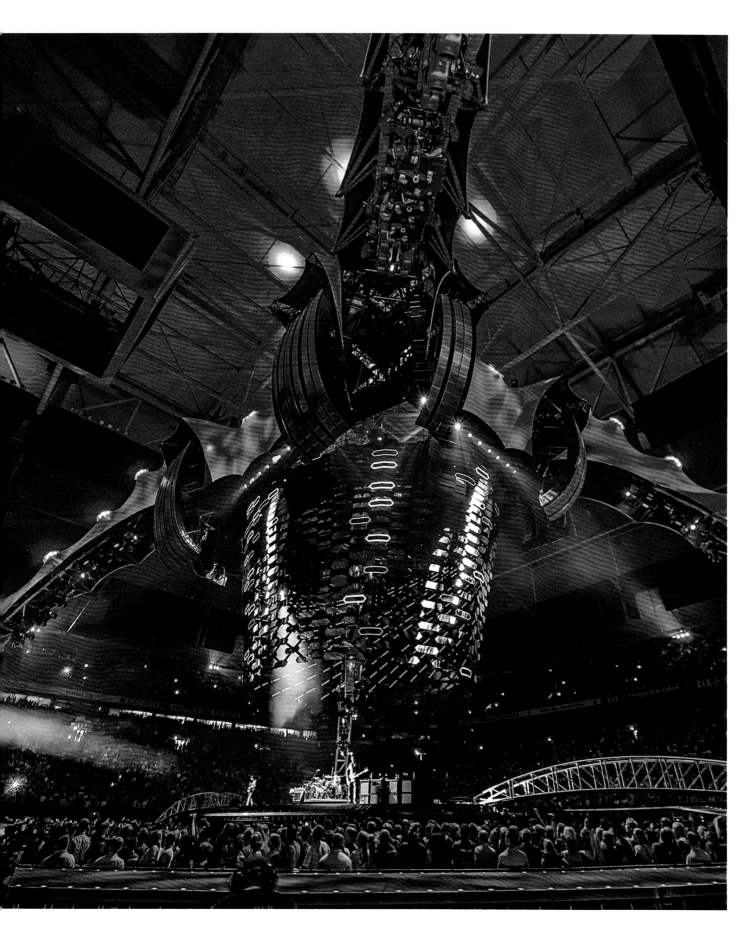

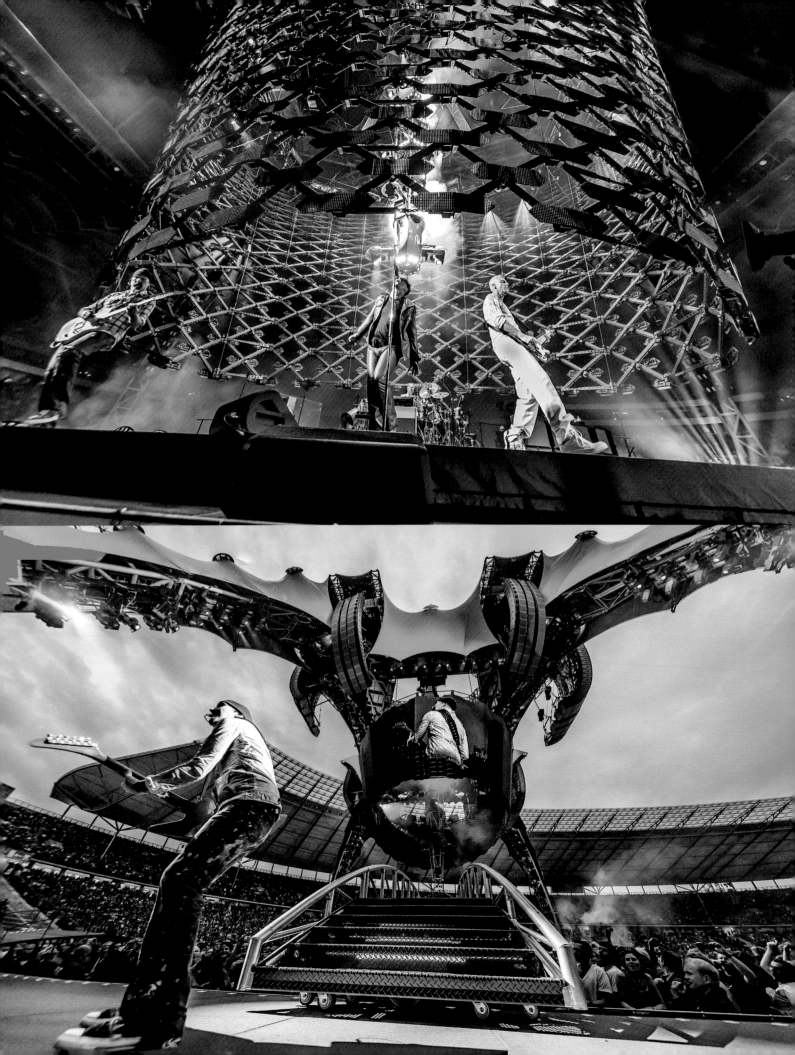

reaching the limit of available option. We'd built runways, we'd built B-stages, we'd kept pushing to find new things to do with the performance area. But of course, the successful ideas you want to keep, so they begin to reoccur in each successive design. That was what drove my looking towards 360 – wanting to move the goalposts in such a radical way that it was impossible to repeat outselves. It ended up being a double win for me because being in the round also meant that whatever happened, they weren't ever going to be standing in front of a video screen, which at the time felt incredibly liberating.'

When the design was complete, the band found they were the proud owners of Sci-fi cathedral, a gargantuan cyborg, with moving walkways, rotating lighting rigs, and a huge central conical video display that moves up and down like a Slinky. The central section looked like a submarine full of lights, and was assembled in situ, suspended from the Claw.

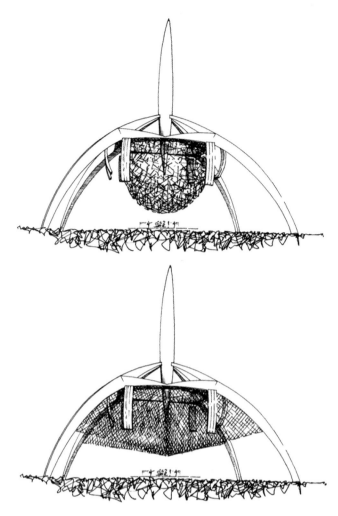

Mark Fisher stage sketches, February 2008

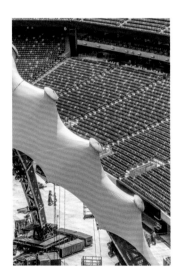

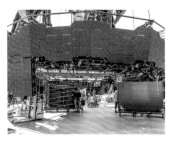

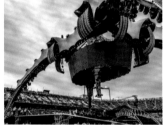

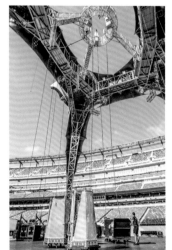

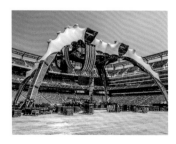

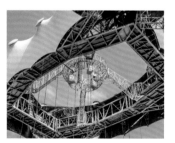

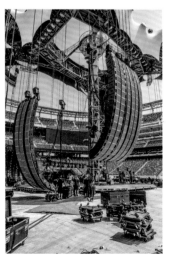

This was an Irish spaceship, sitting atop the biggest stage in rock 'n' roll history. 'We asked ourselves, how can we make it even bigger and bolder?' said Willie Williams. 'And so this is what we did.'

Built by Stageco, the Claw ended up being a plastic scalloped exostructure, an alien spaceship, a gigantic crustacean, 65 metres wide and 49 metres deep. Twenty-seven metres tall, with a central pylon reaching forty-six metres (or the 'spider-rocket' as it was immediately christened), it had a 54-ton cylindrical video screen made up of half a million led lights that opened to a size of 1,300 square metres.

The logistics on this tour would turn out to be more complicated than on any previous U2 venture.

And the man who felt it most acutely was Jake Berry. His first job was to visit some of the stadiums to see if something that weighed 450 tons could stand on an American-style football pitch without destroying it. The structure itself weighed 200 tons and was then going to be loaded with another 250 tons of mechanical and technological wizardry, including the PA, video screens and lights – these components would need 120 trucks to take them each time to the next location. Along with Craig Evans from Live Nation Global he did a six stadium tour of the US and Europe just to make sure they could cope with the weight, as they were attempting to put something on the field that was heavier than any previous stage. They went to Anaheim Stadium, Oakland Stadium in California, East Rutherford in New Jersey, Wembley Stadium, Croke Park and the Stade de France.

'It was the largest thing we've ever attempted to build, and we had no real idea how long it would take to assemble or dismantle it,' said Jake. 'I think

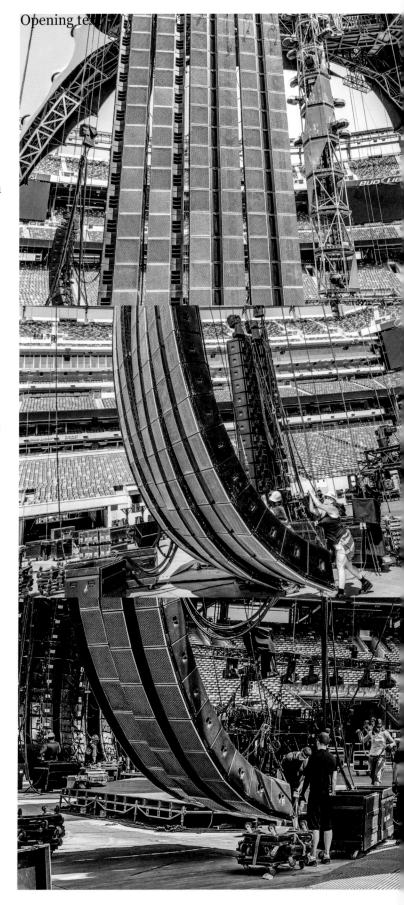

Opening te

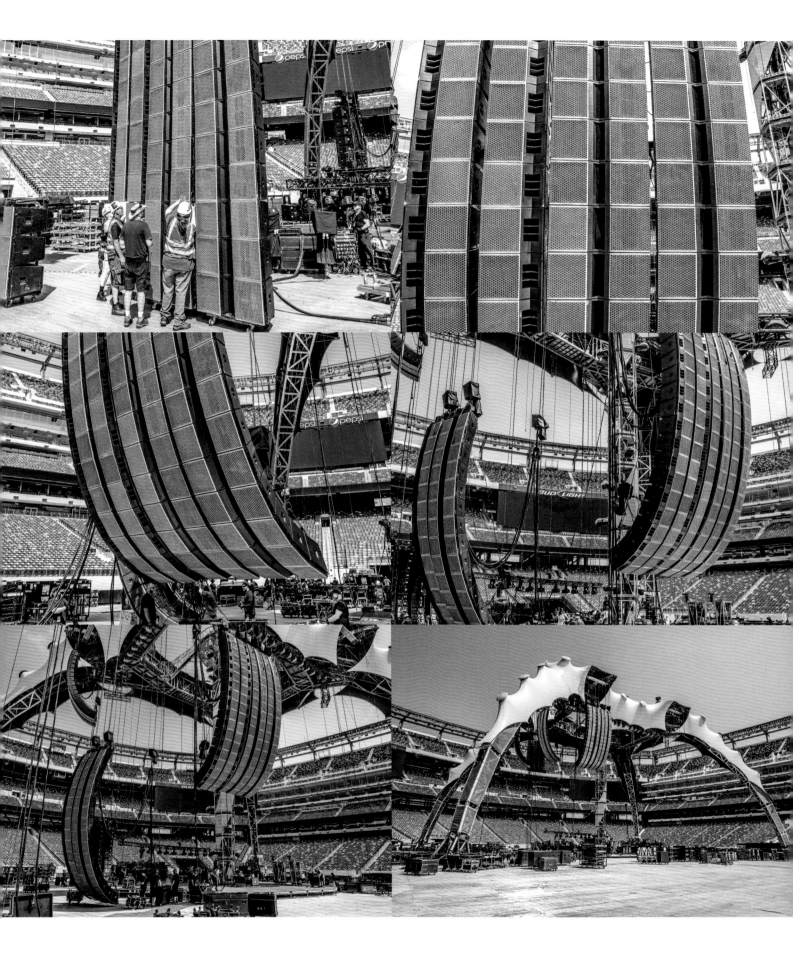

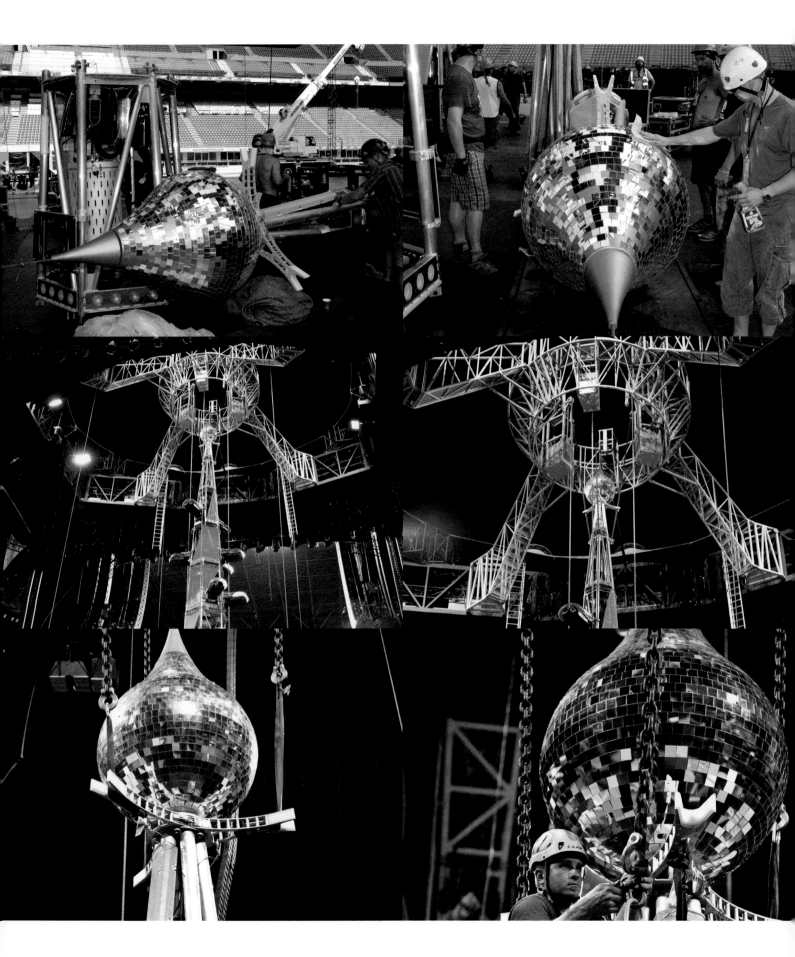

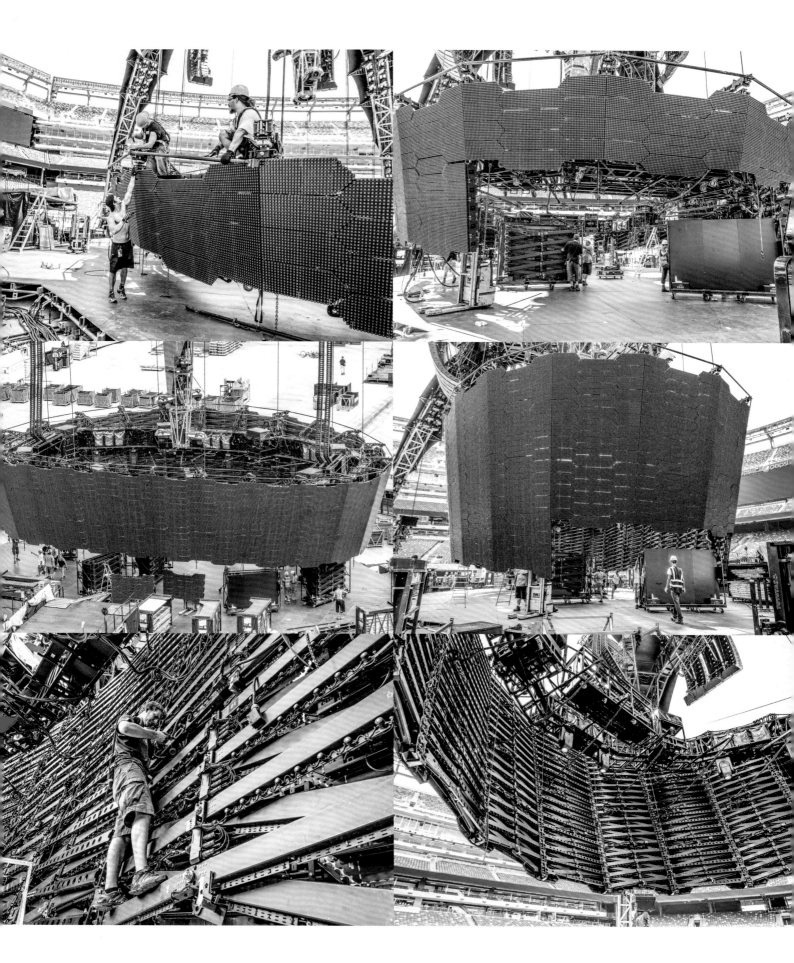

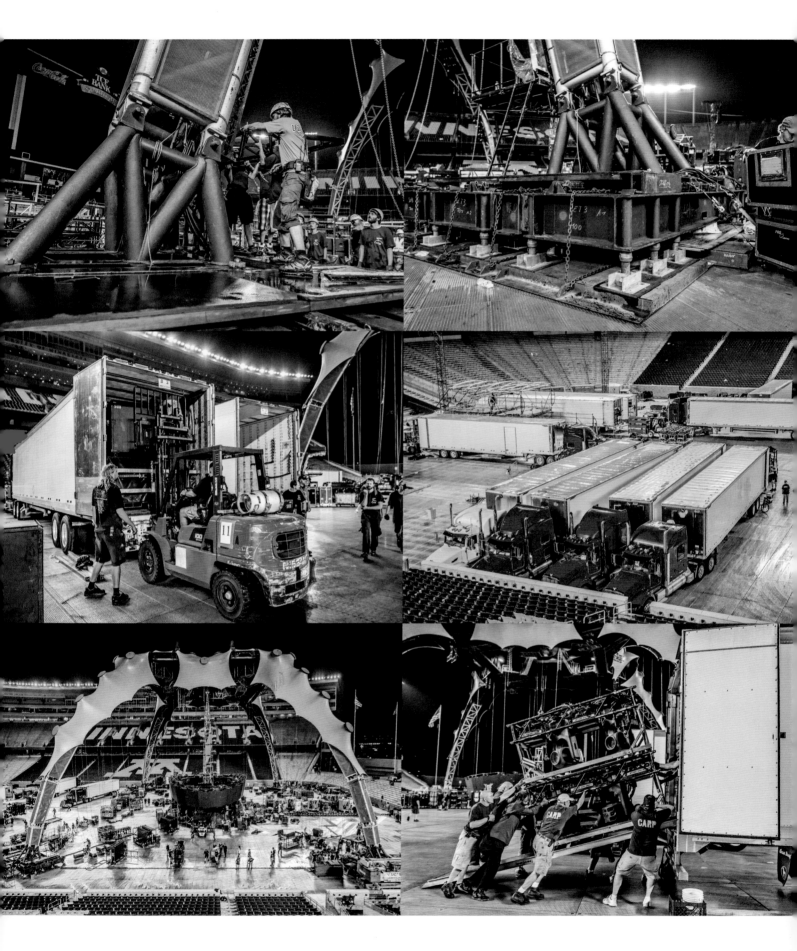

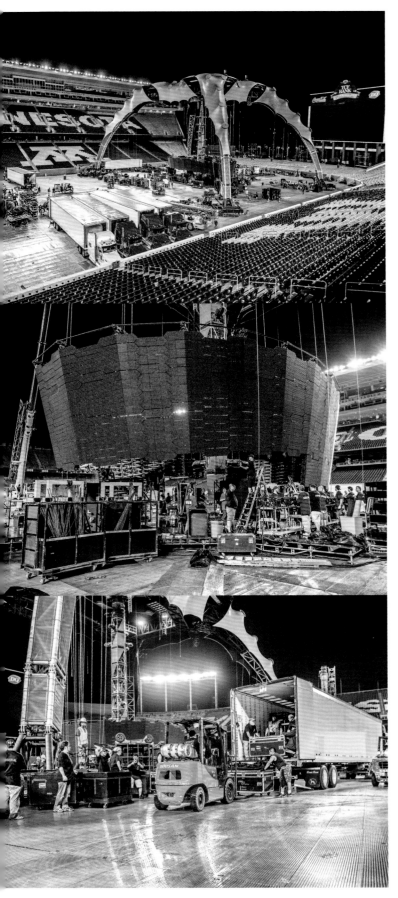

when we first put up the video screen for all four tiers it took something like twelve hours. Towards the end of the tour the guys could build it in under four – sometimes three! It got progressively quicker as we got progressively better. The first mechanism we had that somebody designed to actually put it up was something that looked like the robot out of *Lost in Space*. Most people probably think that the Claw is lifted up by cranes, and then kept up by legs underneath it, but it actually has computerised lifting tiles that actually pull it up. You build it and it lifts it up and you add pieces on the bottom.'

'The engineering was brain surgery, and there was a very depressing day when the specs of the sound system arrived which were double the weight we'd hoped for,' said Willie. 'You could beef up the steel but that would cost you more, and as you beefed the steel up, the structure itself became heavier so it almost became self-defeating. And we also found out that, above 26 metres, the wind loading changed dramatically. Because my initial thought was to just make it bigger, so we added about five metres to it, which solved lots of problems. But it pushed the bulk of the weight above this wind line and so that really was a nightmare. Everything was supposed to be underneath this body of the Claw, but the PA ended up on the side, which was actually a very elegant solution. But there were some dark days. It was not guaranteed that this would be possible.'

Even though the Claw was so big, because of being truly 'in the round' it opened up another thirty per cent of the stadiums for seating. 'When we started costing out I was told that we couldn't afford it,' said Bono. 'But, I said, pointing out the obvious, you've got room for thirty per cent more people! And then it was a maybe. But then I was told we'd

have to do 100 shows because if we only did fifty then we'd go bankrupt. OK, let's do it.'

He is obviously in awe of both Willie Williams and Mark Fisher, and is always eager to apportion credit where it's due. 'Mark Fisher is a great gift to mankind, let alone U2. And he can sit down and listen to Irish people. We have this creative committee – Willie Williams, Gavin Friday, etc. – and Mark's able to deal with all our eccentricities. He's as bored as the rest of us with the idea of a stage set, and he's designed the best of them. As for Willie, I don't know how he got my number, but he rang it in 1982. He said, "Look, I don't know who you have for lights, but I want to be your lighting guy." He said, "I'll travel anywhere. And do whatever it takes, but I really want to work with you." Underneath it all he's actually quite rock and roll, as he likes the basics. He loves art, and loves concepts, but he wants it to work as a rock 'n' roll show. Him and Joe [O'Herlihy] force us to look very closely at what we do. Because in the end, that's why we're here, because of having come from somewhere else. It's all about music.'

Ironically, although the structure very soon started to be called the Claw, nobody liked the name. Bono hated it from the off. 'I don't know where the name came from, but I hate, hate, hate it,' he told me, backstage after one of the Montreal concerts. 'We never called it that. And as soon as I heard someone use "the Claw" I tried to ban it. I always saw the set more as some sort of pop art space station – with the orange buttons and the sixties vibe it's very *Barbarella*.'

It got called the Claw because it looked like the metal hand in *Toy Story* that comes down and picks things up' said Willie. 'I thought this was official and it sort of got into *Rolling Stone*. I might have

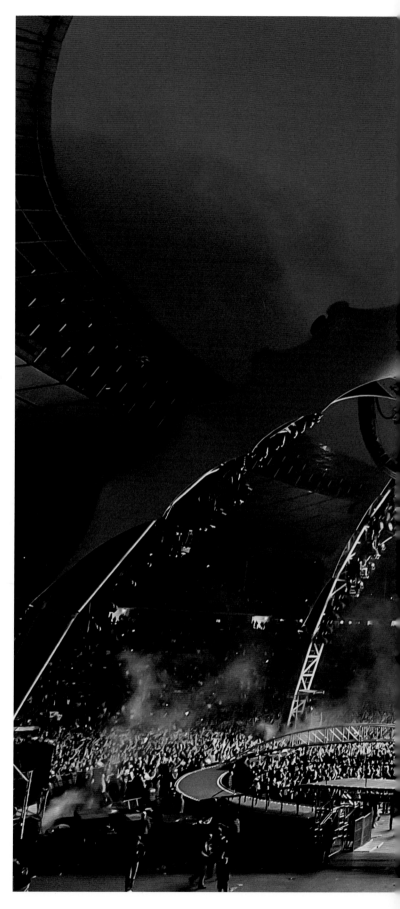

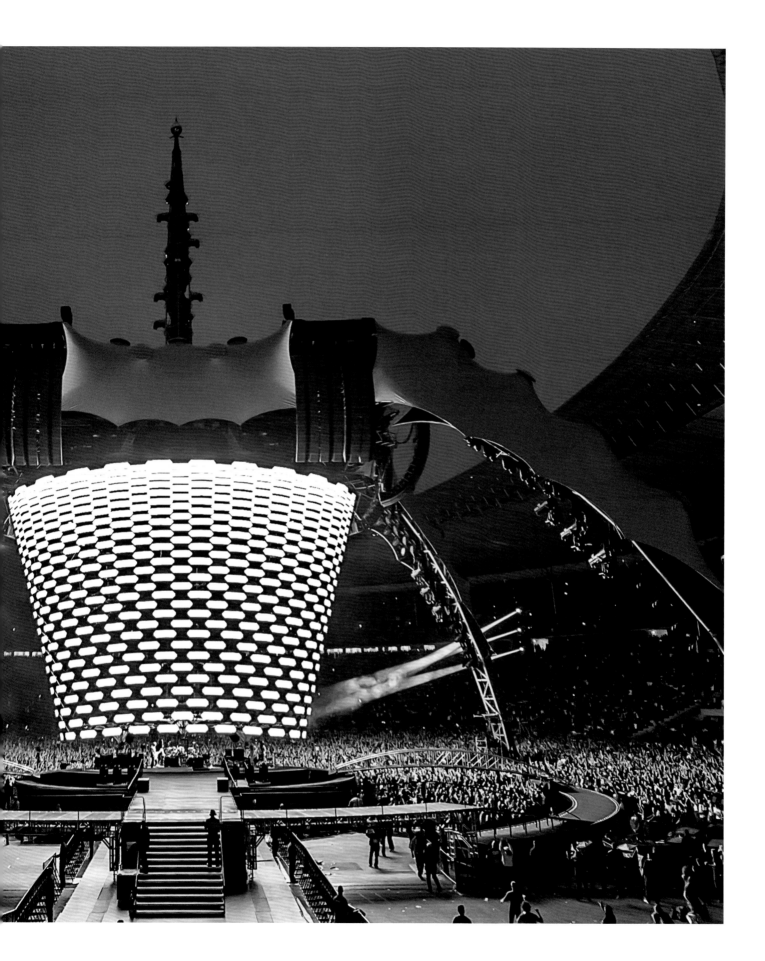

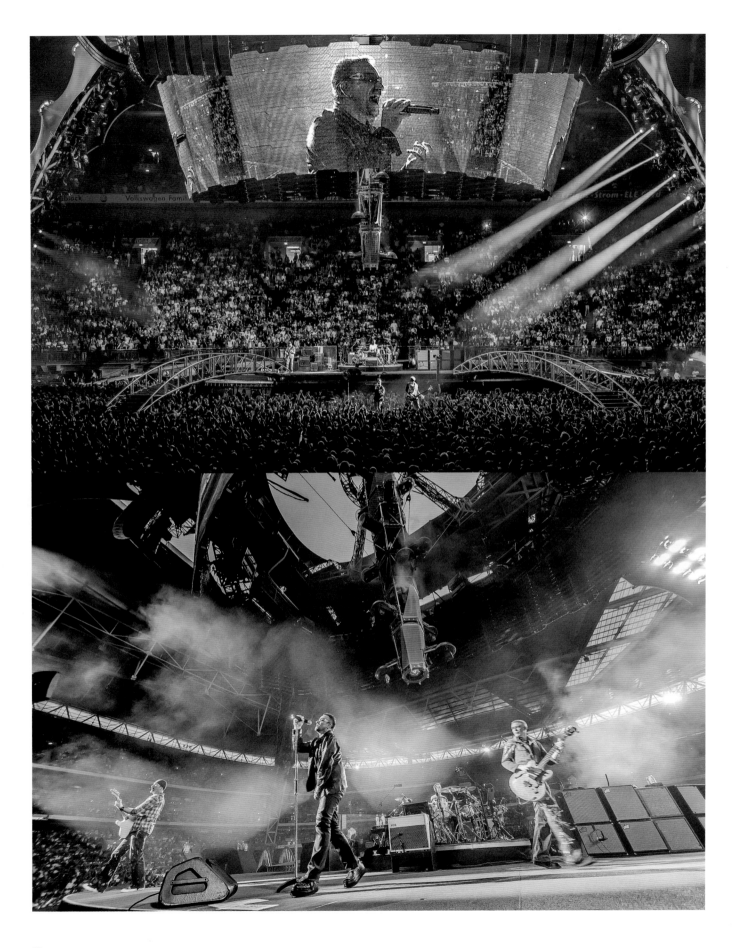

actually been the first person that said the word "Claw" that was then recorded in newsprint. Their piece was called "Meet the Claw".' I know Bono hated the name, but it was too late. I felt terrible that it was out there.'

'I tend to refer to it as the "dumb steel",' said Paul McGuinness, 'because I'm always distinguishing between the comparatively inexpensive steel part of it and the high-tech lighting, video and sound part; the video, sound and lighting there's only one set of, and there are three sets of the dumb steel.'

Whatever, it was big. And ambitious. A show that celebrated hybridity.

'In a way I think everyone else has given up,' said Willie. 'Apart from Pink Floyd and the Rolling Stones, nobody else can do anything on this scale. It's almost like a different art form. It's certainly not a rock show – it is this mad performance art spectacle. To be honest, I think part of it is just a habit, and partly because it's enormous fun and it suits who they are.

With the conical LED video display, and the lights, and the circular stage, U2 had produced something quite spectacular, and one that involved the entire audience. The sensation of seeing the Claw in full flight was similar to the feeling you got when you saw the spacecraft in Steven Spielberg's *Close Encounters* for the first time, as it hovers into view from the clouds. You can see the edifice in front of you, but you're not quite sure what it's going to do; it's impressive enough in itself, and as it begins to mutate, and transform itself into a CGI-like alien, expanding and contracting as though it were a James Cameron monster, you think it might actually get up and walk. Or indeed take off, spinning through the sky on its way back home.

Dumbfounded by its size, anticipating God-knows-what, the Claw was relentless in its pomp, and in a way the 360 set was its very own cathedral. Far from dwarfing the band, it lent even more weight to one of the band's underlying principles, the audacity to demand to be taken seriously. You stared at it for a while and then thought, 'Well, how did I get here? How did it get here?' In Britain, the live business had become increasingly problematic, largely because the industry had almost reached saturation point, with too many mediocre artists touring too often. However, it was still very much a growth business internationally. When U2 first started thirty years ago, shows and tours were the bottom of

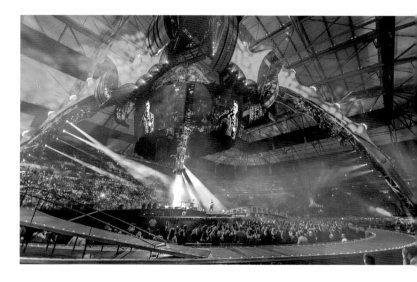

the food chain. It was all about creating excitement and motivation for people to go and buy records. Today it was completely reversed; artists sold less music, made less money from selling their music, record companies were in a state of disarray, and marketing dollars were very difficult to come by. And bizarrely, after all these years, the live business, the touring business, had become the centre of the universe, and it was where artists were really supporting themselves and building their name

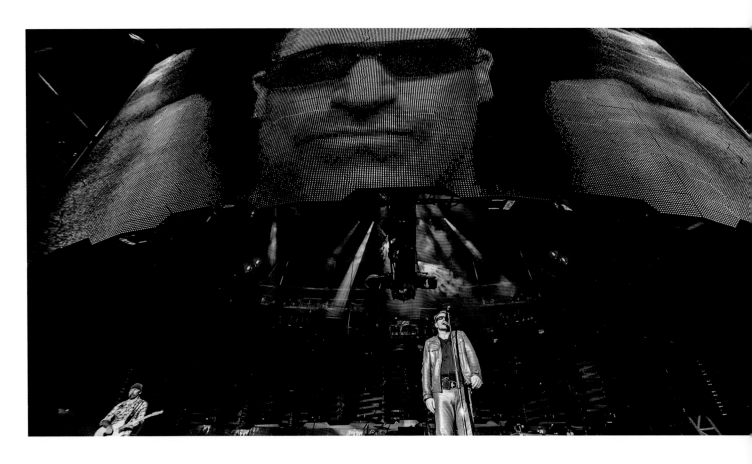

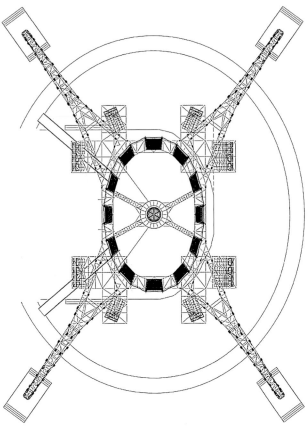

and their brand. U2 understood that people wanted spectacles, events, community.

One of the few times you realise you have a reputation is when you're not living up to it, and U2 have spent the last thirty years trying to make sure their reputation comes before them. Trying to be the biggest rock and roll band in the world wasn't as easy as it may have looked, and they've taken the job seriously. And when you see them live, it shows. Brendan Behan may have said that a job was like death without the dignity, but U2's shows are imbued with as much dignity as you could hope to find in a sports stadium. U2 are one of the few acts in the world who have got better the bigger they've become, and whose relationship with their audience has actually improved. U2 always wanted to be scalable, and they've done it with considerable style.

In the era of mass communication, when scale

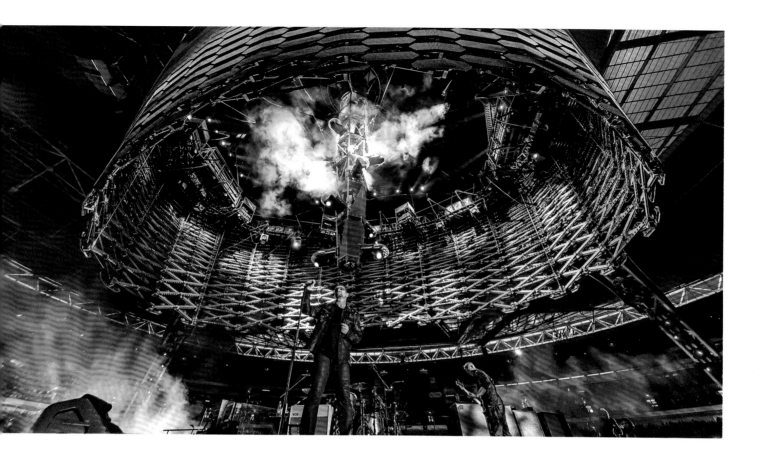

means so much, U2 are pretty much lords of all they survey – which, on most nights during the tour, was rather a lot. A lot of bunk is talked about 'owning the stage' (especially from actors who long ago gave up the hope of owning anything else), but U2 paid off their mortgages a long time ago. Simple Minds used to think that they made the kind of noise that was designed solely for stadiums, as did Oasis, and for a while they did, but usually bands only play big venues because they're too popular not to. And most of them simply can't hack it. No, just about the only people who can rival U2 on a big stage are Bruce Springsteen and Muse.

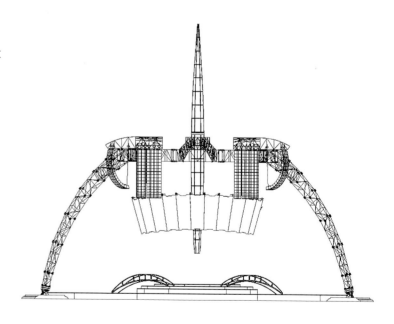

All you needed was love ... and a big Irish spaceship.

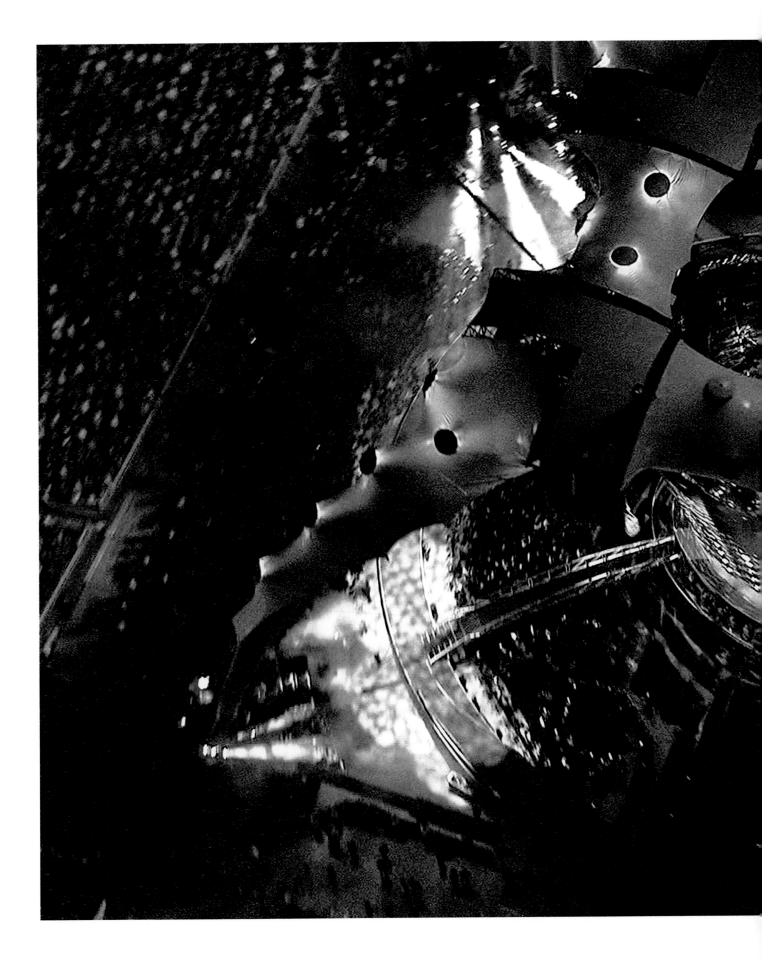

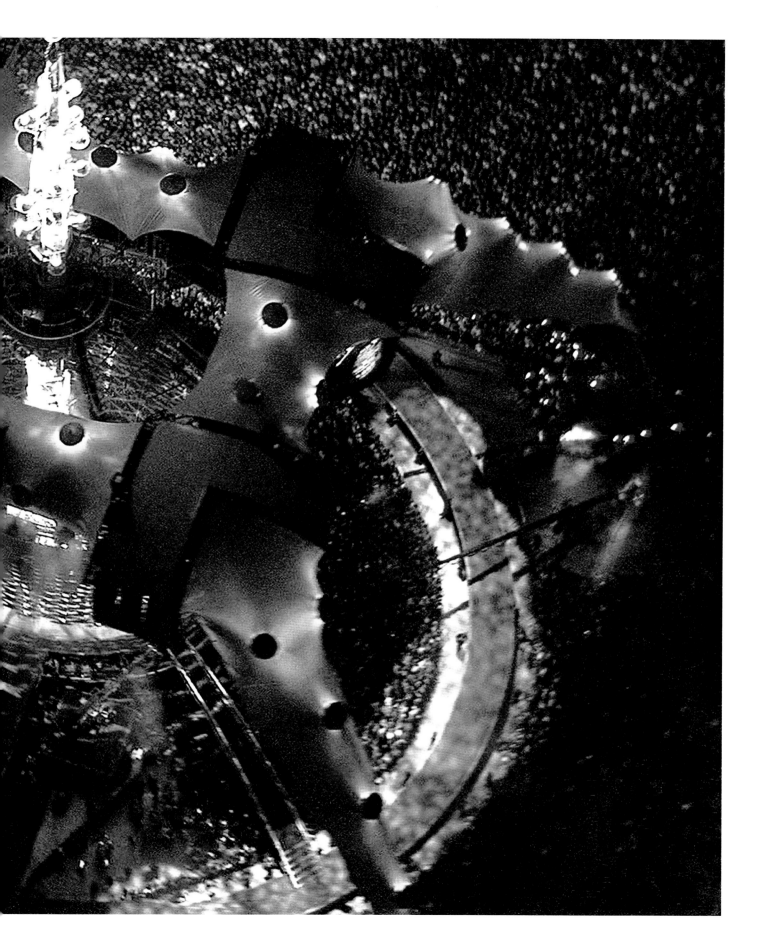

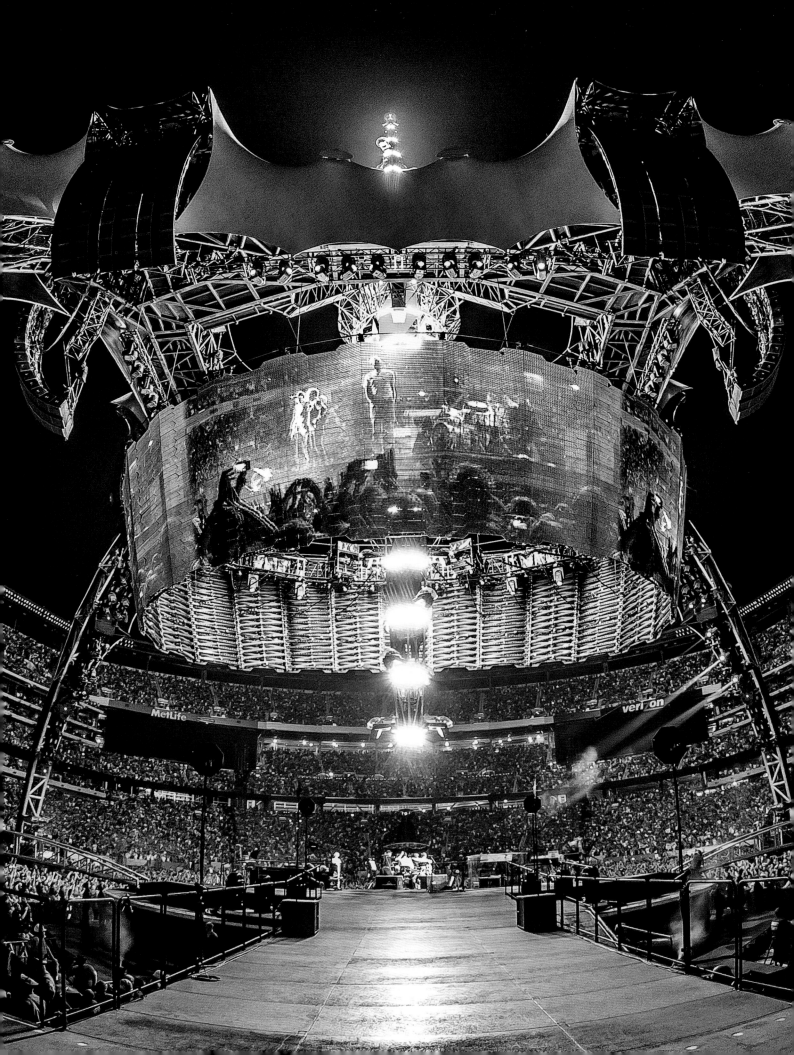

### THE SPACE-AGE SPIDER:
# BUILD IT AND THEY WILL COME AND TAKE PICTURES OF IT ON THEIR
# MOBILE PHONES

## Chapter Two

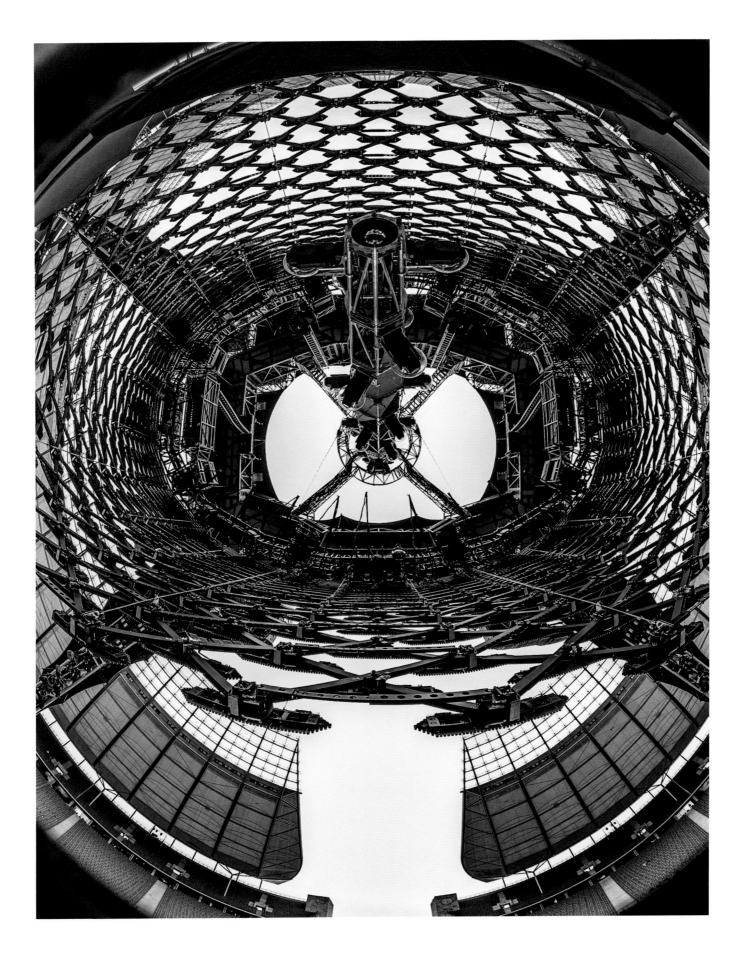

The U2 360 crew were a tightly-knit bunch, a hardy team of professionals who in the space of only a few months learned how to assemble a small city in the space of a few hours. They built the stage in North America, South America, Europe, Russia, Australia and most points in between. Not only was this the largest tour ever put on, with the largest structure, it had the most dedicated team.

# 'WE DISCOVERED THAT THE STAGE HAD ITS OWN PERSONALITY, ITS OWN AESTHETIC, ITS OWN REMIX CULTURE'

## *– The Edge*

**The logistics of building and touring the 360 stage were the most complex in the entertainment industry, like building and moving a movie set every night. This was a tour all about numbers – to wit: the 500,000 pixels on the expanding video screen, the 360 crew members (including drivers, vendors and ground crew), the eight hours it took to set up the video screen and the six hours to tear it down, the 164 feet of the central pylon, and the 52 different U2 songs played on the 110 dates.**

The 360 tour soon became a numbers game, a litany of digits, double digits, treble digits, and the sort of seven digit numbers never seen before. 360 very quickly became a tour all about numbers. The longest, the tallest, the smallest, the most expensive. There were the 120 trucks that were needed on a daily basis, the $750,000 a day overheads, the 360 tour employees, the 250 speakers, the 15 video cameras, and on it went. A 90-foot green and orange steel structure with a central spider-rocket pylon reaching 150 feet. A 54-ton cylindrical video screen made up of half a million LED lights that opens to a size of 14,000 square feet.

It would turn out to be the three-birthday tour. Three birthdays, five continents and seven legs. Oh, and eighteen births. There seemed to be an unusually high number of Cancerians on the tour, so consequently there were a high number

of birthday parties – 'I was in my thirties when I started this tour,' said one forty-two-year-old crew member towards the end of the tour.' In fact the tour's interruption increased its cost by £2.4 million because of the rise in the cost of fuel during the gap. The tour would go on to win the Billboard Touring Award for the highest-grossing tour of 2009, and again in 2010.

There also appeared to be more laminates than there usually were at rock shows: local staff, special guest, official tour staff, family, round room, media, hospitality, day pass, inner circle wristband, (RED)ZONE wristband – all of which were laid out every afternoon in the security office, which for no apparent reason was called 'Moose Lodge' on this tour.

Even the Motorola walkie-talkies had sixteen channels: 1. Production. 2. Carpenters (carps). 3. Sound. 4. Lights. 5. Video. 6. Rigging. 7. Site-co-ordinator/steel. 8. Power. 9. Wardrobe. 10. Backline. 11. LNGT (Live Nation Global Touring). 12. Tour management. 13. Merchandise. 14. Principle. 15. Security. 16. Show (after the opening act finished, everyone always went onto this frequency).

They chose to launch the tour in Europe's biggest football stadium, the Nou Camp in Barcelona, on 29 June 2009. They've opened so many shows in North America – Vertigo started in San Diego, Elevation in Florida, PopMart in Las Vegas, Zoo TV in Florida, etc. – that they wanted to kick off somewhere new, somewhere that didn't feel like the first day back at school.

When Bono saw the helix screen opening for the first time during rehearsals in Barcelona, he was singing a song on the B-stage, looking at the screen in motion. When the song was finished and the

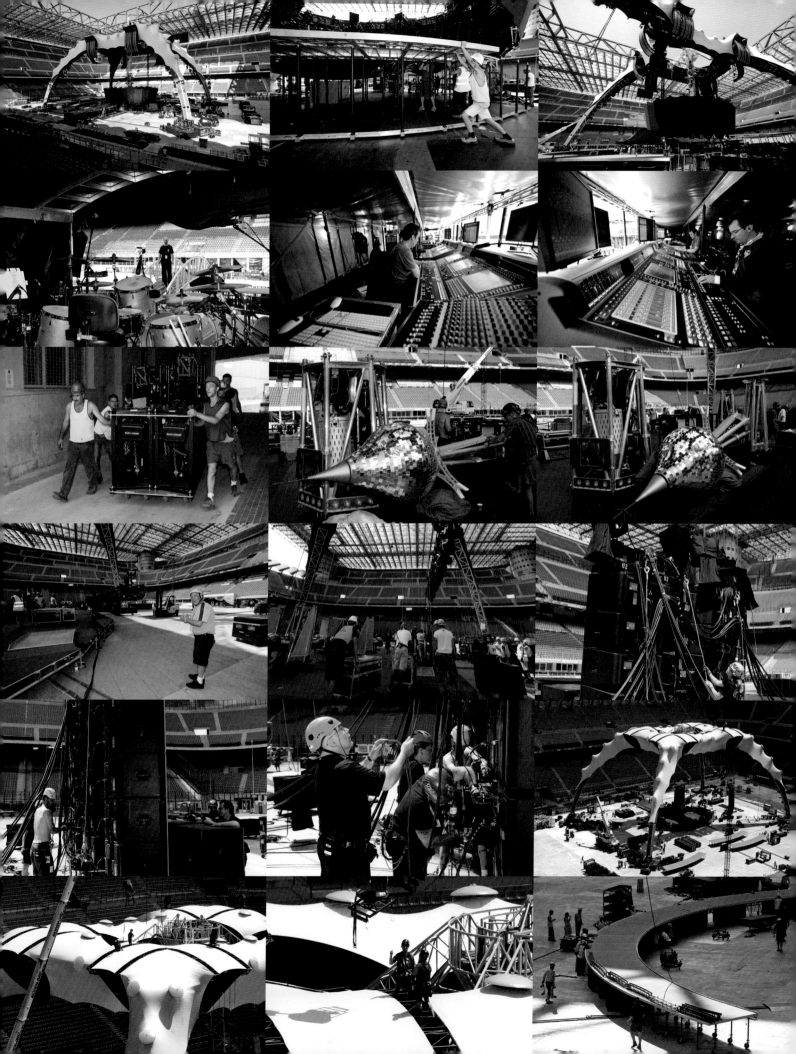

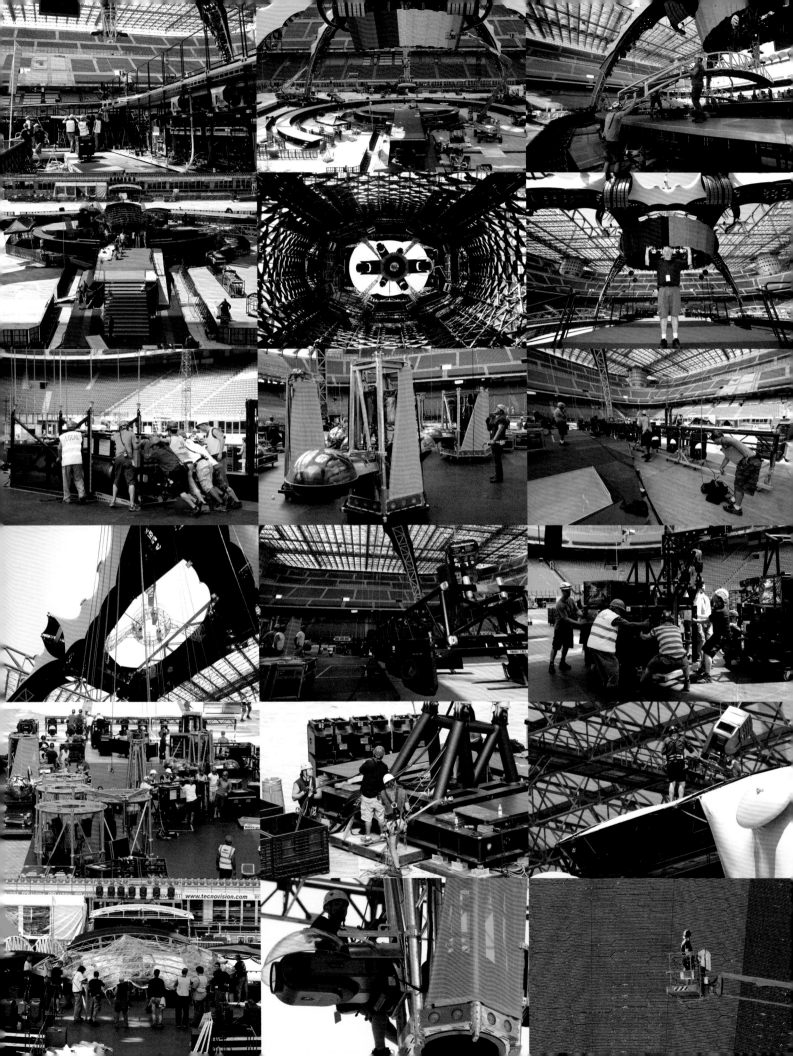

U2360°'s tour manager, Dennis Sheehan, was always in there in person whilst every one of the tour plane's decals were being applied. Just one of the many jobs that got done correctly first time when he was in attendance.

screen was deployed 100 per cent, it was quiet for fifteen seconds, and then Bono said, 'Holy shit.' The same night, Edge said, 'We're actually at the limit, the absolute limit, when you consider the economics and the practicality of the transportation. We're really as big as we could ever get.'

When Bono introduced 'Angel of Harlem', he said, 'We wrote this song for Billie Holiday, but we're gonna play it tonight for Michael Jackson.' The singer had died three days previously.

That night, as with every other date on the tour, the set started when the PA started blasting out David Bowie's 'Space Oddity', and the screens showed the band walking onto the Claw from backstage. The video screens showed the band walking up from behind the stage, as though they were astronauts, walking onto their rocket. On the odd occasion during later dates on the tour they were forced to walk through the crowd, making the audience go even more demented.

The cannon of smoke that was released during the song was officially called 'starting the show'.

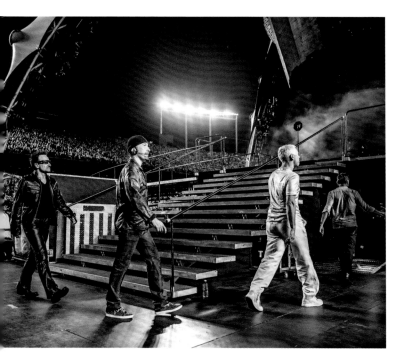

The stage manager would tell Dennis Sheehan, the tour manager, that the band had started walking up the gangway to the stage. Then Dennis would tell Joe O'Herlihy on the mixing desk, who would then ask whatever celebrity had been asked to start the show to press the button on the console in front of them, causing the smoke to shoot up into the sky. The 'button' was actually on the lighting console upstairs, on the lighting and video control level of the front of house mix tower. It was manned by the tour's lighting director, Ethan Weber.

'As I always saw the stage as a space station I liked the idea of immediately setting the scene with "Space Oddity",' said Bono. 'It reminded me a bit of "Space travels in my mind ..." from the Only Ones song ["Another Girl Another Planet"]. So. We're all here, where are we going to go? The most powerful throwdown in our set is in "Where The Streets Have No Name", and I sing, "Wanna go there, wanna go there." It's all about travel, and that's what "Space Oddity" is about too ...'

'We couldn't have picked a better place than Barcelona for the band, because the audience was so enthusiastic,' said Jake Berry, 'but we couldn't have picked a worse place for production. There's one cobblestoned tunnel through which we could only run one forklift truck. I paid €18,000 to get it asphalted, just to make it that much easier to get out.'

In Barcelona, as Bono had discovered, the sight of the stage in the middle of 100,000 people was as extraordinary for the band and the crew as it was for the audience. It was as though a benign spaceship had landed right in the middle of the park. Sure, standing in front of the Claw, you weren't positive that you weren't going to be subjected to a hail of laser fire, but you figured you might get a song or two first. (Gaudi had actually been an influence on the 360 stage.)

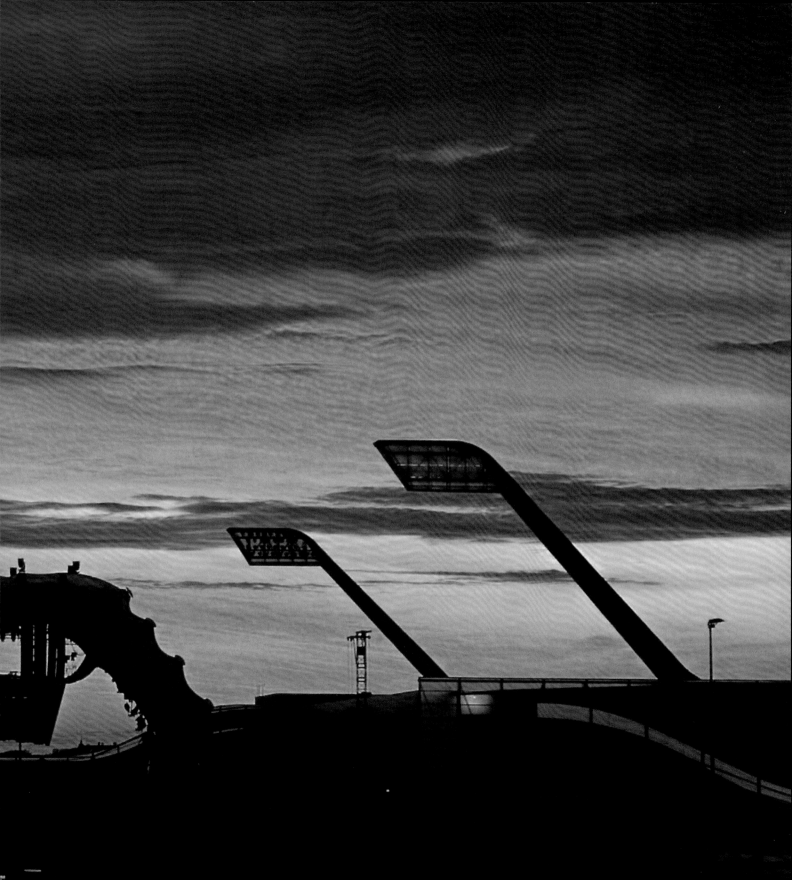

There were three distinct areas in the stadium. 1. In the (Red)ZONE, which was under the Claw, in the middle of the production, giving the crowd a visceral experience. 2. On the floor of the stadium, giving the audience a transparent stadium experience, allowing them to see right through the band. 3. In the stands, giving you the full spectacle of the show. The (Red)ZONEs were to the left and right of the stage, immediately outside the outer runway. These tickets were sold by auction, with the band giving the proceeds to the Global Fund to fight AIDS, TB and malaria – $11.4 million by the end of the tour. The inner circle, closest to the stage was general admission, open to all, first come, first served. And there wasn't a bad seat in the house.

you see it in a very large building – you see this really big structure, and it has a comic quality to it because your mind actually can't figure out how this big object got in there. Logic takes over. And then you realise as you focus that it starts to make the rest of the building look smaller. Certainly by the time that darkness comes. It was very strange to play on it at first as you could never find the corner. You kind of kept going around that edge and you were not quite sure where you were going.'

Initially, Edge found the new stage impossible to come to terms with. He equated it to suddenly not knowing where his left arm was. Traditionally, even though U2's shows are far from traditional, you tended to know where everyone else was on the stage.

'I saw the Claw for the first time when we arrived in Barcelona,' Adam told me, over eighteen months later. 'I saw some photographs and some videos of the steel structure when it was assembled in a field in Belgium, but you didn't really get the sense of proportion and the effect that it has when

Suddenly with this production, that was gone, and Edge had no idea. He'd be like, 'Where's Adam? Where is he? Where's he gone? Oh my God, he's over there!' Physically, the bond was broken, or at least fractured, and they had to reconnect, in their intuitive terms. They had to relearn how to sense where everyone else was.

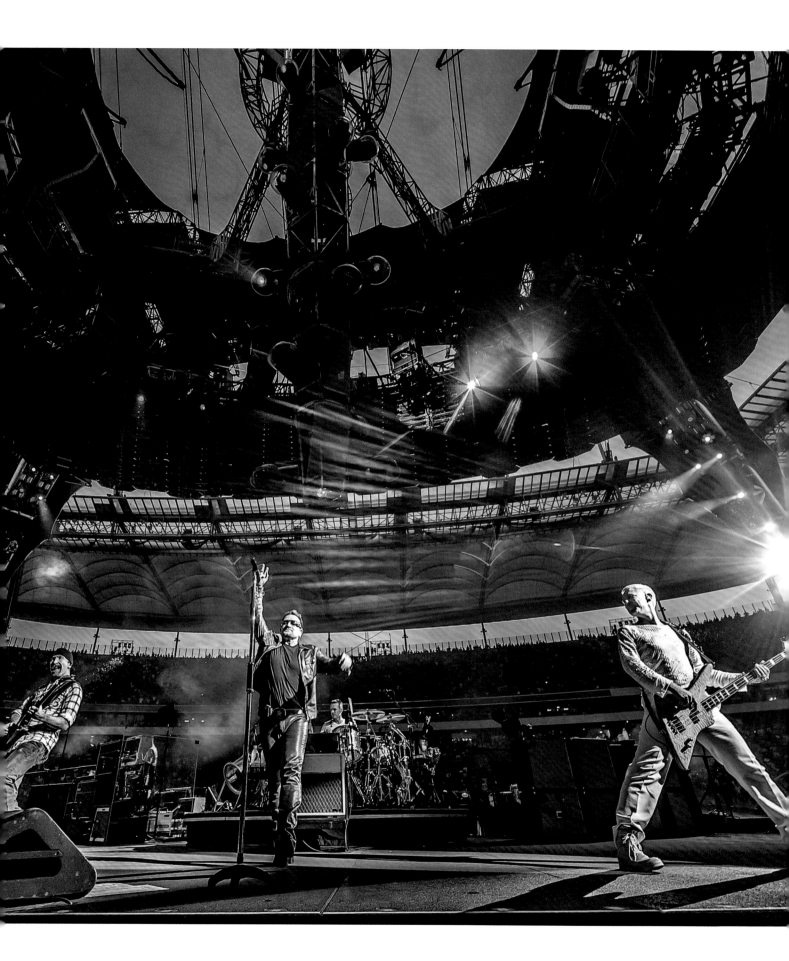

'One great discovery was finding that by simply coming together in the centre of the stage, it create a certain kind of intimacy,' he said. 'Intimacy became a word that we started using early on in the tour because two things were clear about this setting.

One was that there was nowhere to hide, and you're exposed in a 360 sense. And the other was that this created the ability to focus on members of the band like never before. So even though the distance might be still quite considerable between top tiers of the stands, there's a kind of simplicity of presentation. That became an important thing to achieve in order to take advantage of the contrast between the monolithic object and the players, as it were.'

They had filmed the first few rehearsals, and then filmed the first few shows, so they could all get a sense of how things looked, how things worked. Willie Williams was doing the same thing, and thinking to himself, 'We have this incredible thing, now what are we gonna do with it?'

At the start of the tour they were obviously playing a lot of No Line On The Horizon, starting off with four or five songs, and some nights playing up to eight. But it was too much. The album had failed to create a song, a video, or a moment that had punctured public consciousness, and so hadn't sold in the way that U2 albums are meant to sell.

But the band soon discovered that the stage had its own personality – it had its own aesthetic – which they were willing and able to take advantage of. The remixed version of 'I'll Go Crazy If I Don't Go Crazy Tonight' was inspired very much by the production itself because as they saw this object in the centre of the stadium they realised the aesthetic lent itself to remix culture. 'It's not something that we'd really thought about before,' said Edge. 'So we started to experiment with remix ideas. We looked

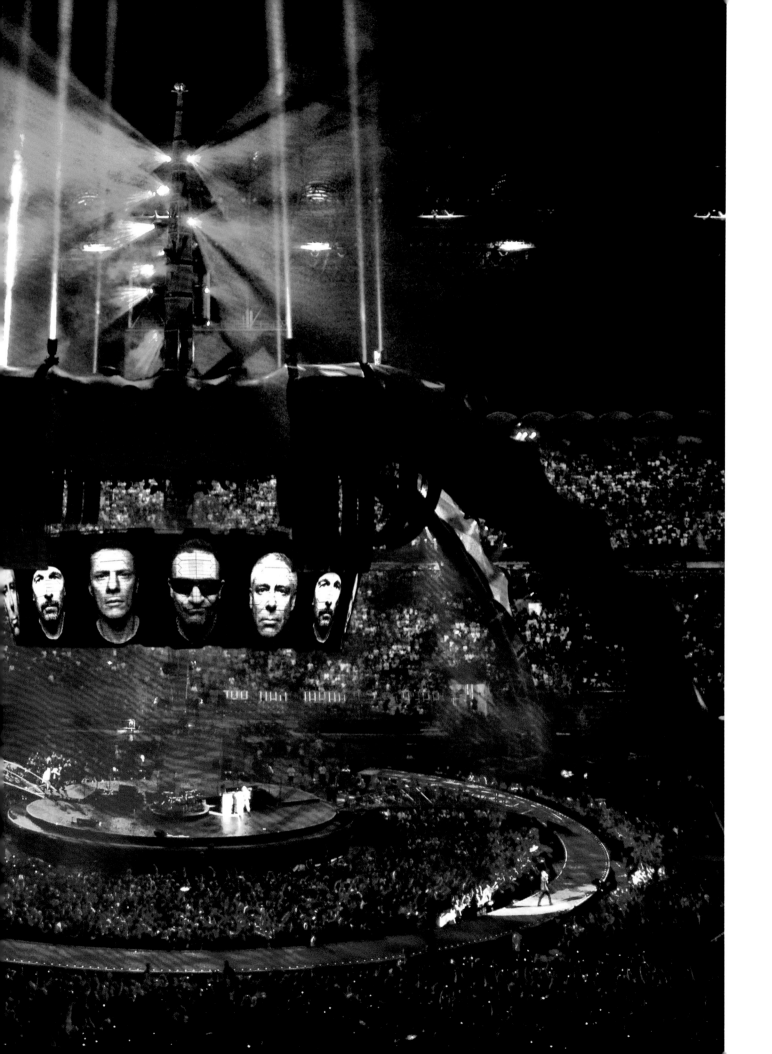

at the remix of "Real Thing" to see if that would work and we looked at various others and the remix of "Crazy Tonight" was the one that seemed to fit the context. So we developed an arrangement that utilised a lot of the remix elements, so Larry comes out and he's playing a djembe over effectively a remix rhythm section. So that came to us as an idea because of seeing the production and realising that we had to play with it a bit more, and move closer to where it was as an aesthetic statement.' True to form, this was a U2 project in a state of flux, fluid, a continuum of stress. The imagery itself was tantalising in the extreme, echoing Robert Longo's polyvalent eighties promo videos, creating the kind of aesthetic vocabulary rarely seen in stadium shows. Here, interdisciplinarity was everywhere.

Surprise at this level is difficult, yet the impression the 360 show gave was galactic, and you couldn't help but by cowed by the experience; it was just so damn extraordinary. This was the precision tour, where nothing was left to chance, where even Edge's guitar patterns were counted-in by the sound techs speaking through his earphones. However, the show's wiring was no less impressive, no less immersive. Underneath the stage was a subterranean technological powerhouse. Down here you'd find a quick-change wardrobe spot, a loo, the band's individual mixing monitors – standing next to each other in a line, they were oddly reminiscent of Kraftwerk – plus Bono World, Edge World, Adam World and Larry World – four particular areas where they kept their accoutrements, toys, good-luck charms, and – rather sweetly – their Beatles posters, lots of them. Once the band was on stage, there was no visual contact down here: everything was done either by CCTV or through in-ear monitors.

This was where Edge's vast array of guitars were kept, too, not far from his on-stage panel board. There are 36 buttons on this board, and Dallas Schoo, Edge's guitar tech, says it's not unusual for the guitarist to experiment with new effect combinations during the set. 'Sometimes you don't know where he's gonna go,' he said, 'so it's all got to be there.' (On 360 Edge played half a dozen songs with a lead and the other eighteen or so with a wireless connection.) Down here you'd also find Terry Lawless, sitting like a king in Terry World, playing the piano sequences that accompany many of the songs. For the encore, Bono wore a laser-embedded suit and sang into an illuminated microphone in the shape of a steering wheel, and all were kept down here, each in their own little designated space. Crucially, this was also the home of the UPS, the uninterruptible power supply, the back-up electricity feed in case disaster reared its disconnected head.

This area was under the control of Joe O'Herlihy, their veteran soundman, although he spent most of his time on the mixing desk, fifty yards in front of the stage. Joe had a team of sixteen – 'Team Audio' – two of whom were spotters, whose job it was to roam the stadium during U2's set, looking for weak spots, soft spots. Joe did the same during the support act's set, phoning in suggestions as to how and where they could improve their sound. And he did it all from the mixing desk platform. On one of his desks there he had a Lexicon 480L vocal reverb box, a thirty-five-year-old white plastic tablet that looked like a Claes Oldenburg calculator. 'It looks old because it is,' said Joe. 'It's never been bettered.' There were other toys, too: a DCL 200 Dual Compressor Limiter made by Summit Audio (it 'squashed' Edge's guitar lines), and many echo effects, all of which were manually

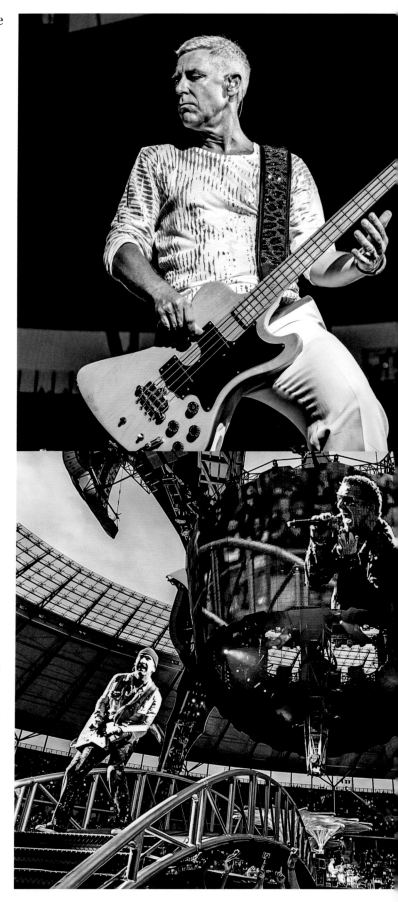

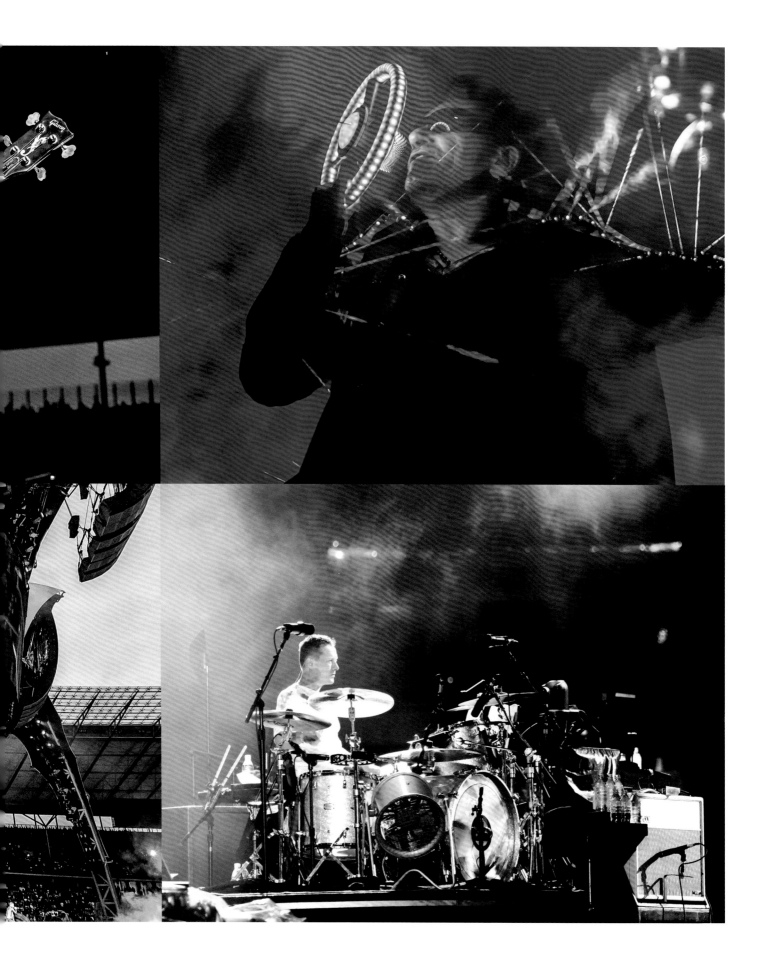

introduced. There were a whole bunch of pre-sets, too; if you pressed 'Mysterious Ways' (say) on the screen in front of him, all the faders moved into their start positions, like a marshalled army of toy soldiers.

Strangely, for such a big show, up until the summer of 2009, the band only had one master mixing desk (a Digico SD7). For years Joe was happy with one, but at the start of the tour at Hampden Park in Glasgow, the desk shut down due to excess humidity. And so for eighteen seconds, in the middle of 'Walk On', Joe experienced 'the most extraordinary karaoke session' of his life. 'It's only happened once in thirty years, and it will never happen again.'

Joe O'Herlihy has made U2 his life's work, and spent most of his career making them sound like the band they've always wanted to be. He is often referred to as the most diplomatic member of the crew, a man who is a past master at the art of saying nothing at all in the longest time possible ... He has spent much of his career staring at the band on stage, and understandably has a well-nurtured waistline. It would be difficult to find anyone on the road more charming.

Joe has been with the band since 1978, when Paul McGuinness asked him to supply a PA system, having become renowned for trying to turn a washing machine into a bass bin. He consults for Vanguardia, and has helped design the acoustics for the O2 in London, Wembley Stadium, Twickenham, and the Millenium Stadium in Cardiff.

'In the early days, the band were raw,' he told me one afternoon on the mixing desk. 'A piece of music started and a piece of music finished and whatever happened in the middle happened in the middle, you know? I mean they played their own

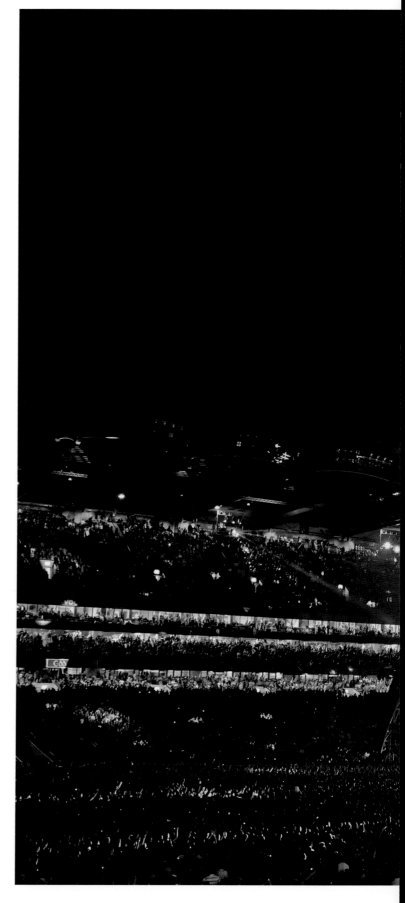

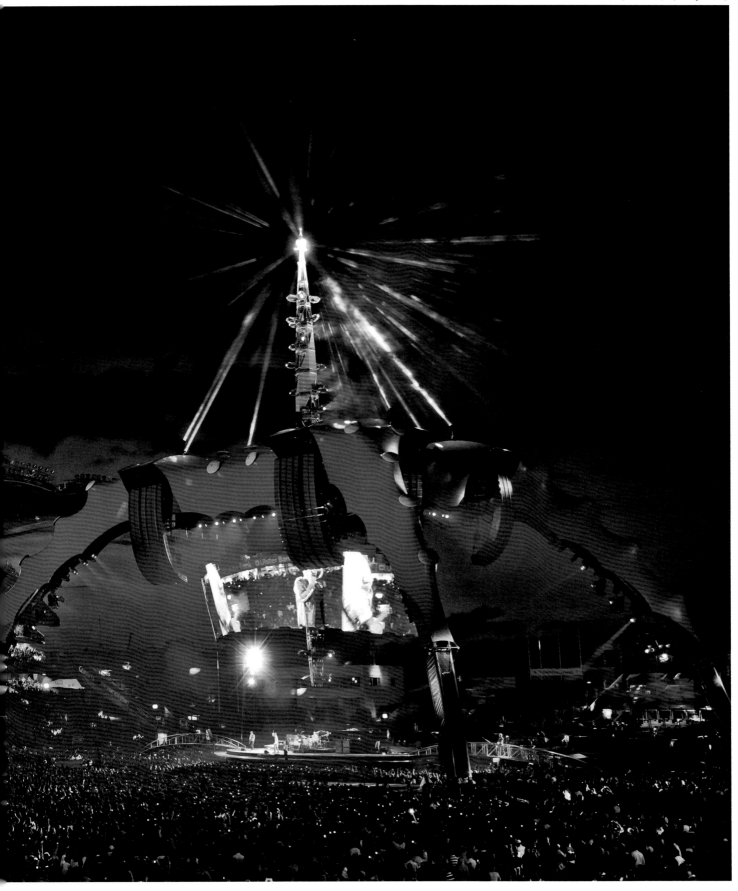

material because they couldn't play anybody else's.'

He used to do the sound for Rory Gallagher, the legendary Irish guitarist, and Joe saw the same experimental force in Edge, a man who has gone from being, in Joe's words, 'Edge the guitar player, to Edge the Edge Orchestra.'

Nowadays the greatest thing for Joe is being in the situation where he can manipulate the technology to do what he wants it to do. 'What I mean by that – and I'm speaking totally on behalf of the audio department here – all of the technology and all of the stuff that's available now to us is extraordinary. In the past you were always hampered by the fact that the performance technology hadn't really caught up with the studio aspect of the technology.'

The U2 360 sound design was made up of six different PA systems (offstage left, offstage right, two in front, and two in the back), all of which were calibrated in such a way as to make the performance sound as though it were taking place in a controlled environment. The bass bins circled the stage, each one with an identical speaker 73' behind it, in order to get the best functionality, and to stop the sound bouncing back onto the stage. Sort of like an audio shield. I spent an hour with Joe under the Claw, walking round it while he explained to me the various distances the speakers have to be from each other, in order to cancel out any effects the speakers may have on each other, and to cope with the wind, the height of the stacks, or indeed the density of the crowd (bass is difficult to control in a stadium, I learned). It was a physics lesson writ large, one that sounded good while I was listening but looks baffling on paper.

One of Joe's most precise measures was the Line Array system, designed to counteract any inclement weather or particular environmental

issues concerning wind. By putting two systems into the mix, you got much better penetration and dispersion, as Joe called it, that carried the sound back to the last seat in the house without experiencing 'slapback'. Joe's sound system was so sophisticated, so intricate, so sensitive, and so responsive - that it was now possible for him to sit with an iPad – using Time Alignment and Time Referencing, Sound Pressure Levels, and AutoCAD, and by isolating particular spines of the PA system, and by turning

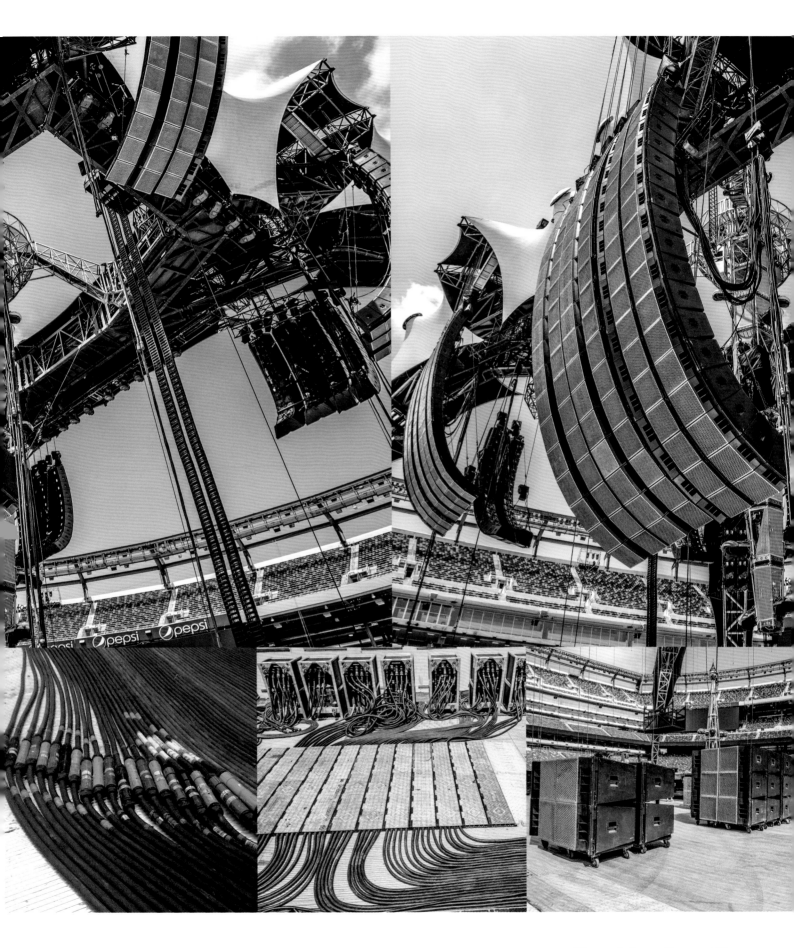

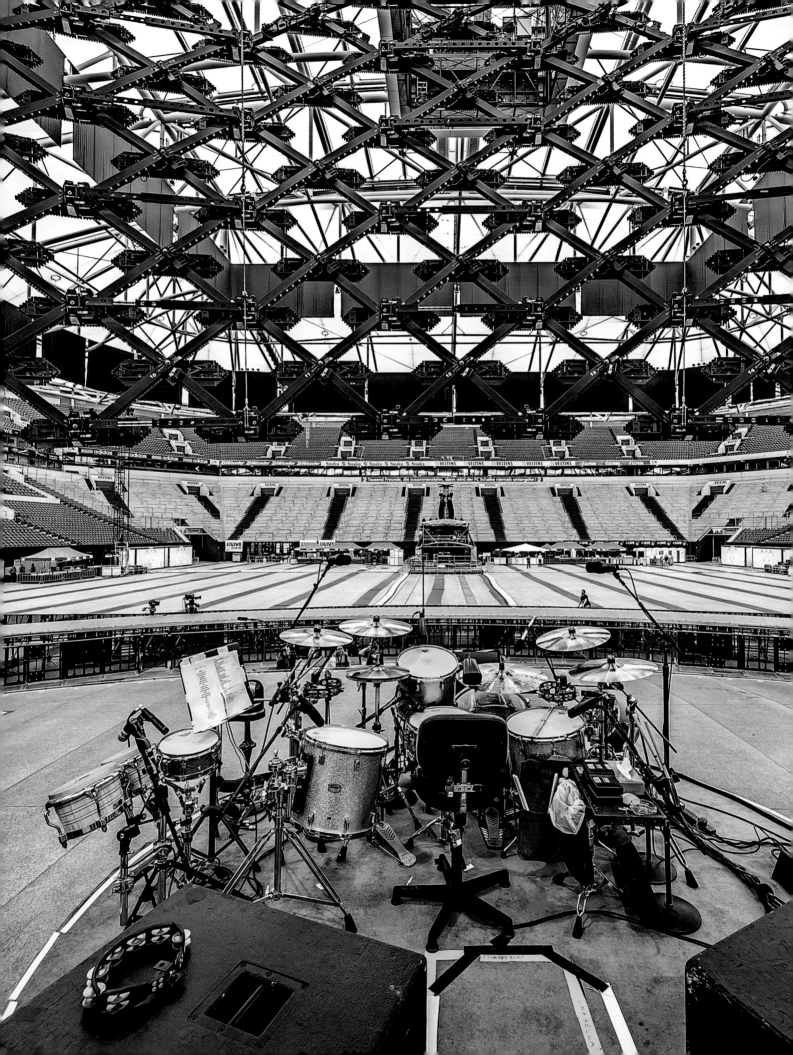

the bass up, turning the bass down, the mid-range up, the high-frequencies up and down – and by immersing himself in all the wizardry (kelping, anyone?) now available at the touch of a flat-screen, he could bend and shape the sound of the band to fit any stadium in any weather condition at any time to any deadline. This was not so much sound design as grand sorcery. I had imagined I might be

able to soak up some of the tech knowledge needed to produce such a noise on such a mammoth scale, but after eighty minutes with Joe I realised that it was probably as difficult to create the 360 sound as it was to build an actual rocket ship. This was the poetry of the equation, and to listen to this man talk about acoustics was to listen to a man grappling with the intricacies of existence itself. Who knew, for instance, that every stadium had its own sonic value, or that every stage needed to be bass transmission free?

Whatever, what drives Joe is not just sonic perfection, but also the group of men he's striving for. 'I think the magic is based upon a genuine sense of belonging. I think the music, for me, was always the attraction in the context of the sincerity attached to it. Everything is from the heart to the heart, and people connect with that, you know? I come from a background of the blues, which is very much the same, I suppose. I spent seven months on the road with them in 1980, and you get to know an awful lot about people when you're living in a transit van for that length of time.'

Around half the crew had been with the band since the early days, the lifers, the loyal roadies who know they wouldn't get treated better by any other organisation (one senior crew member was the former bass player in Survivor, who had a huge hit in the Eighties with 'Eye Of The Tiger'). The crew has a binary existence, as they're either on the road or at home. They get excited at the beginning of a tour, and wistful towards the end, knowing they might not see each other again until term-time starts again. There's about 130 crew in the universal team and when they're traveling between cities, the mass movement is seamless. 'Like a load-in, everybody knows where to be, what to do and when to do it,' said Willie. 'Lobby, check out, bags in the bays, on to buses, at the airport, check in, boarding passes, through security and straight to the closest bar to the gate.'

A 150-plus supplementary local crew is always hired at each new location, some of whom are freelance, and others who work for vendors, supply

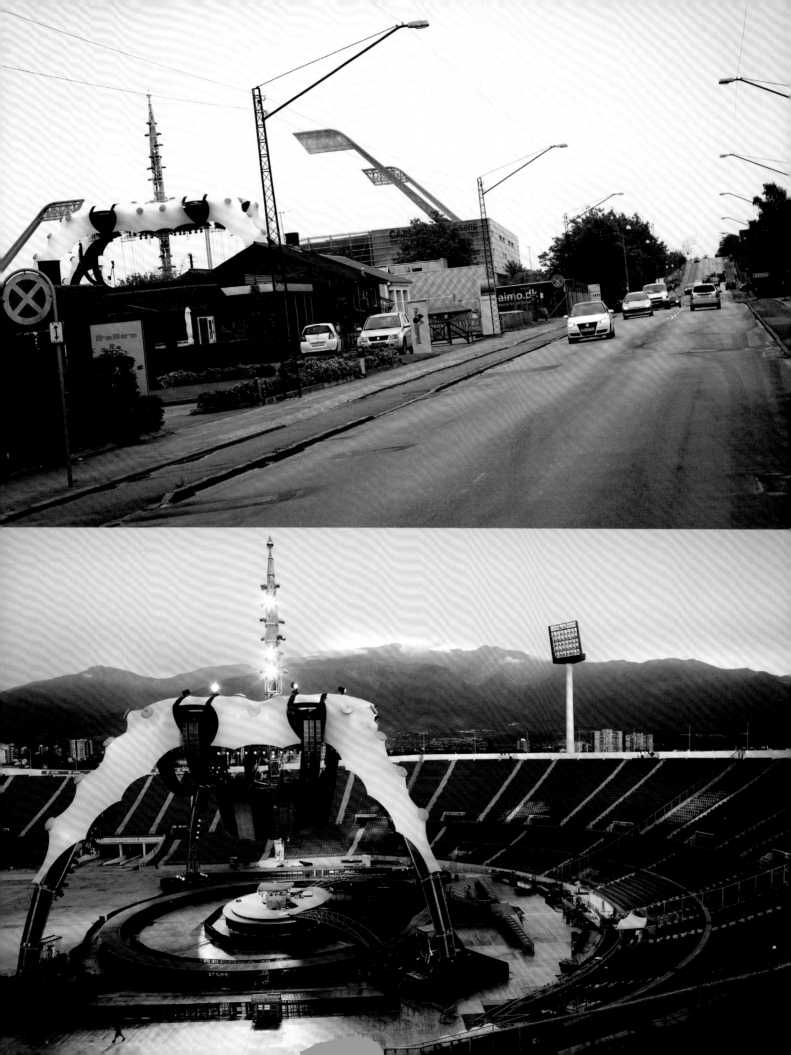

companies who also feed other tours and theatre productions. They were the illustrated crew, as so many of them had tattoos. There were Hungarian riggers, Australian drivers, and lots of Brits and Americans.

And you only had to be on the tour for half an hour to sense that you were surrounded by Belgians. They were everywhere. As Willie wrote on his tour blog, 'It is a well-documented fact that the Flemish have the U2360° pretty much sewn up. As with Jews on Broadway or gays in the Anglican clergy, if all the Belgians left the U2 360 tour there'd be practically nobody left to run the operation. In particular, steel and video are the two areas most heavily colonised, with the giant steel structure having been built by StageCo in Werchter and the video screen having been built by Frederic Opsomer and Barco. We've even got a Belgian astronaut in the show.'

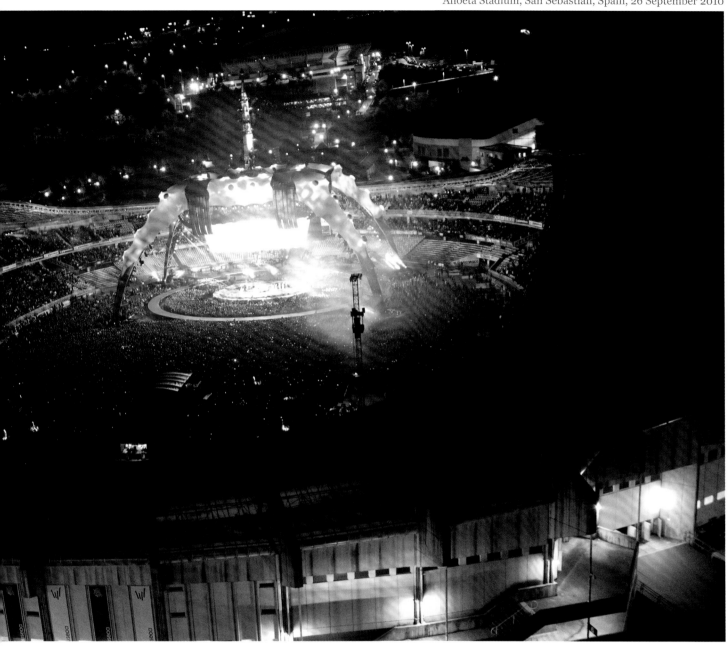

And where the Flemish go, anecdotes follow. When the crew flew from Mexico City to Denver in May 2011, one of the video team left his passport in one of the trucks, yet still managed to gain access to the States. For weeks afterwards his colleagues couldn't stop talking about how he had got into the USA whilst in possession of nothing more official than a photocopy of a Flemish driving license.

In Helsinki in August, Willie had a side project,

namely helping organise the fortieth birthday of video director Stefaan 'Smasher' Desmedt. In Flemish culture there is a tradition that when you have a birthday ending with a zero, your friends get together and give you a new front door. 'Consequently, there's been a covert operation underway for the past couple of weeks to figure out what we might do along these lines,' Willie wrote in his blog. 'Bono suggested that we make a small replica door

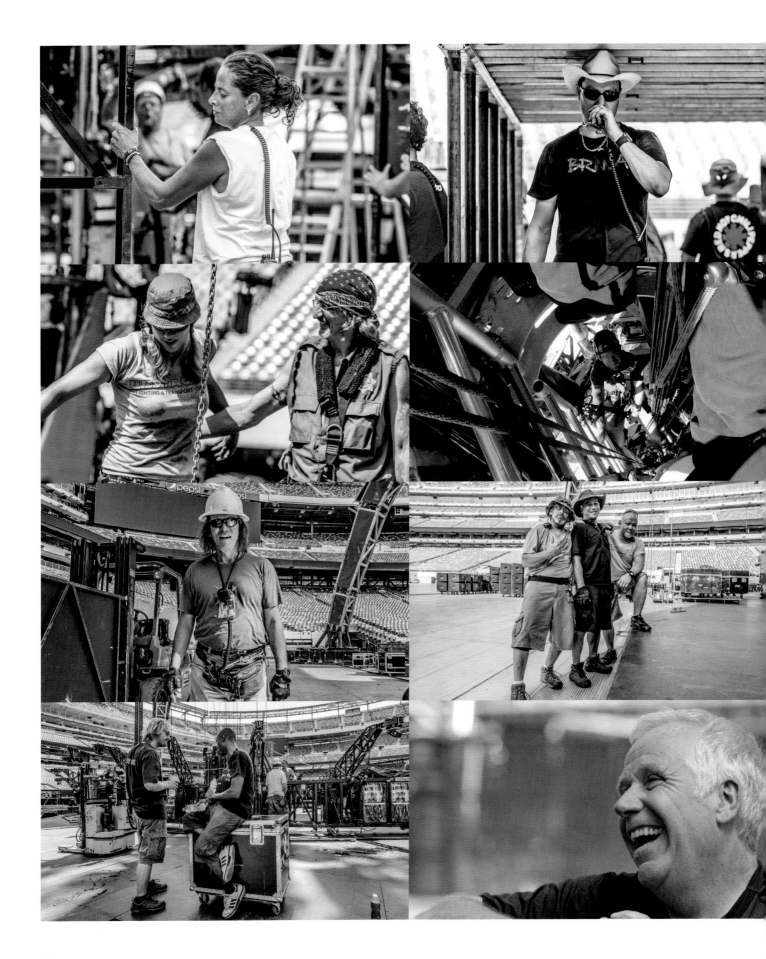

that everyone could sign but this was deemed insufficiently traditional by the Belgian jury. Eventually we decided that if we were going to do it, we might as well do it properly and set about sourcing a door from Belgium. We talked about shipping his actual front door from home out to the tour, but Smasher's wife felt obliged to point out that this would leave their house open to the public for at least a week.

NO I DON'T KNOW✓
· ANYONE IN THE BAND
· HOW TO PICK UP RED ZONE Tics
· WHAT TIME THE SHOW STARTS
· WHERE AND WHEN THE BAND IS ARRIVING
· TO BUY FOOD OR DRINKS
AND IF YOU WERE WONDERING, I'M
WORKING ON MY NEW TOOL BOX. THANKS

In the end a compromise was reached in having his office door removed from its hinges and freighted to Helsinki to become Finland's largest birthday card.'

Every Groundhog Tour has its Groundhog Days, and these obviously included the load-ins and load-outs. These are the terms used for the building and dismantling of the stage, and which are a kind of theatre in their own right. Looking down on the load-in from the bleachers you'd see an army of worker bees, all dressed in Van Halen or Def Leppard T-shirts and black cargo shorts or three-quarter-length trousers, each and every one of them knowing exactly what they had to do and by what time. In terms of the robustness of industrial equipment, there are five recognised levels. Level one is consumer, level two is professional, then military, NASA, and finally rock 'n'roll. This stuff needed to be sturdy, and it needed to be handled carefully. It was like watching soldiers work in Camp Bastion in Helmand, only with slightly less swearing.

At the start of the tour the load-in took as long as it took (in Barcelona it had taken fifteen hours), but once the team had got into their stride they had cut it down to around four hours. The build itself would take five days: on the first day they would build the floor (fourteen hours, starting at 9 a.m.), and the other four build the stand, the Claw. And then it would take two days to pull down, although the PA and the lighting rig would be dismantled immediately and put into trucks, and sent on their way to the next gig. Tour production director Jake Berry started his career as the drum and percussion tech for Rick Wakeman in 1975, and so became witness to the vast extravagances of the mid-seventies rock show. With U2 he has become the king of spending money to save money. One of the most expensive elements of a tour is union labour, so to cut the time of the load-in and load-out, Jake simply ordered more trucks.

The trucks backstage on the tour were the cleanest, most lustrous in the world; after all, they were only used for a few hours a day, so there was a lot of time for polishing. They sat parked in enormous long rows, looking like ground beetles, surrounded by security guards and primed for a moonlit dash to their next destination. There were 38 trucks for the

Freedom of Expression & Democracy In Iran

steel, 32 for the Claw and 15 for the flooring; each section of the Claw was the largest it could be and still fit in a truck. As soon as the screen, the PA and everything else that was going to be used for the next show was ready, the trucks would start to leave, along with the twelve-person mini-vans. Having just built a movie set, they were moving on to do it somewhere else.

What a movie set it was. And what a movie. One of the highlights of the show soon became the Aung San Suu Kyi moment. In 1989 the Burmese leader had been placed under house arrest by the country's military, and each night during 'Walk On' the band would make a dramatic call for her release, as a procession of volunteers from Bono's ONE advocacy organisation and members of Amnesty International, along with local volunteers, paraded around the stage wearing masks with her image on. In November 2010, she finally won her freedom, and was filmed for an incredibly moving video which was later included in the show, where she addressed the crowd and thanked them for helping with her cause: 'If you demand it, change will come. It starts with one person. One.'

'When she got out of jail, we wondered if it might be possible to get her to do a piece to camera in the slot where Desmond Tutu used to be,' said Willie,

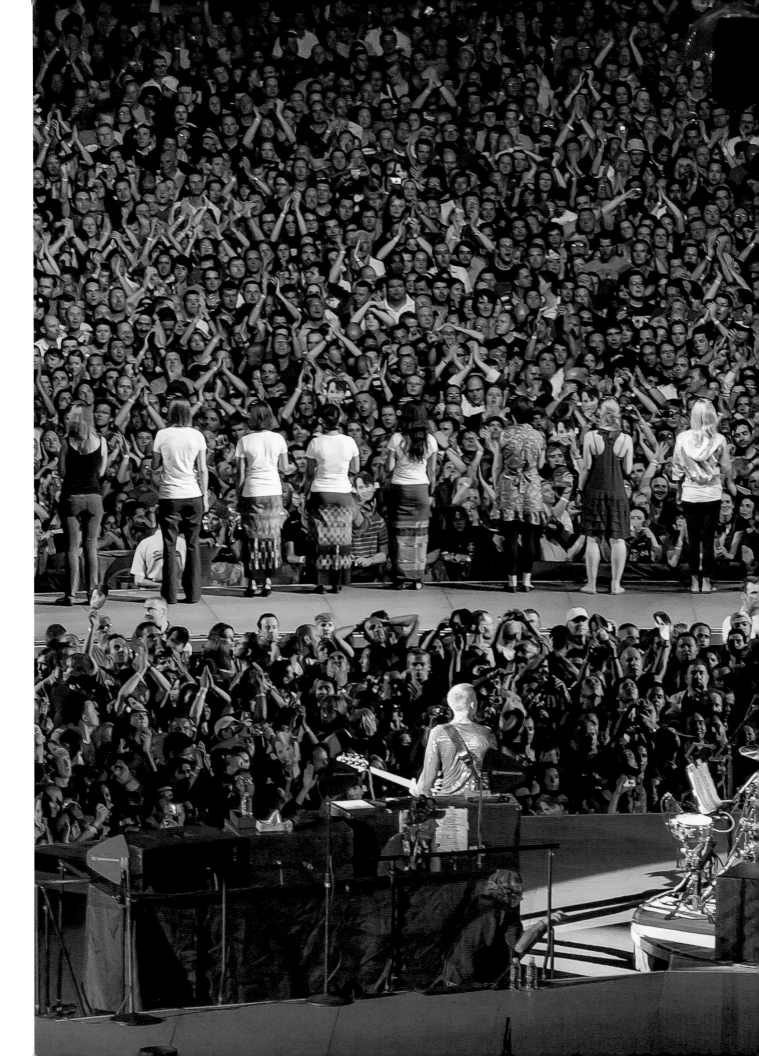

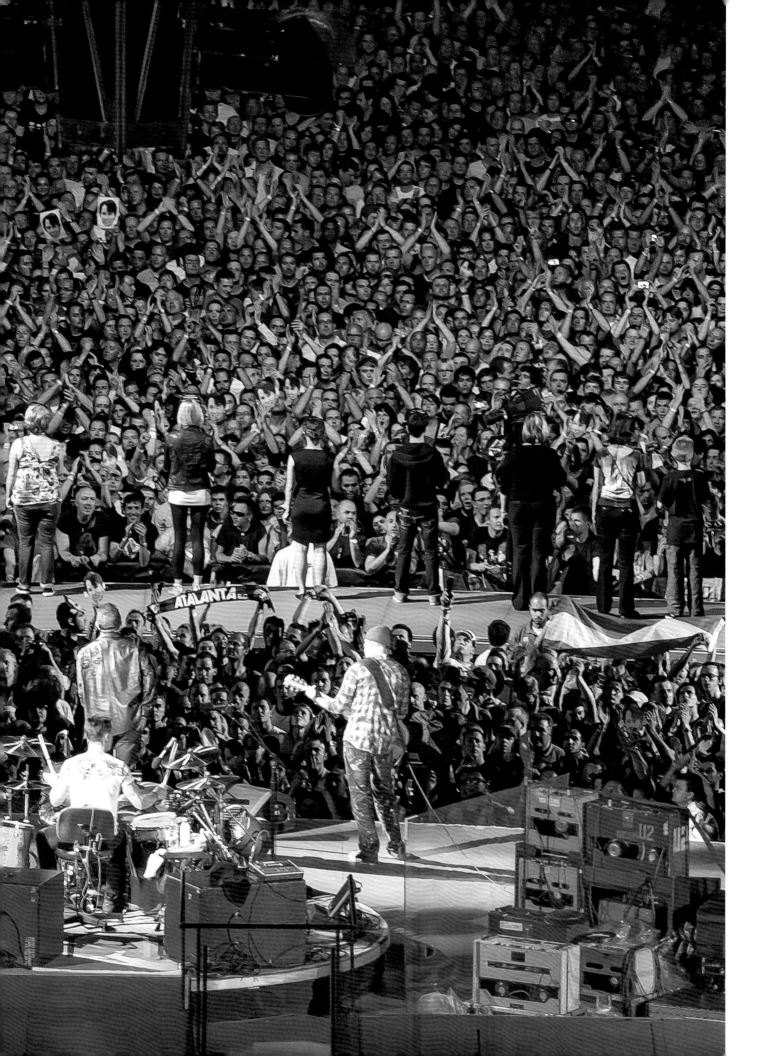

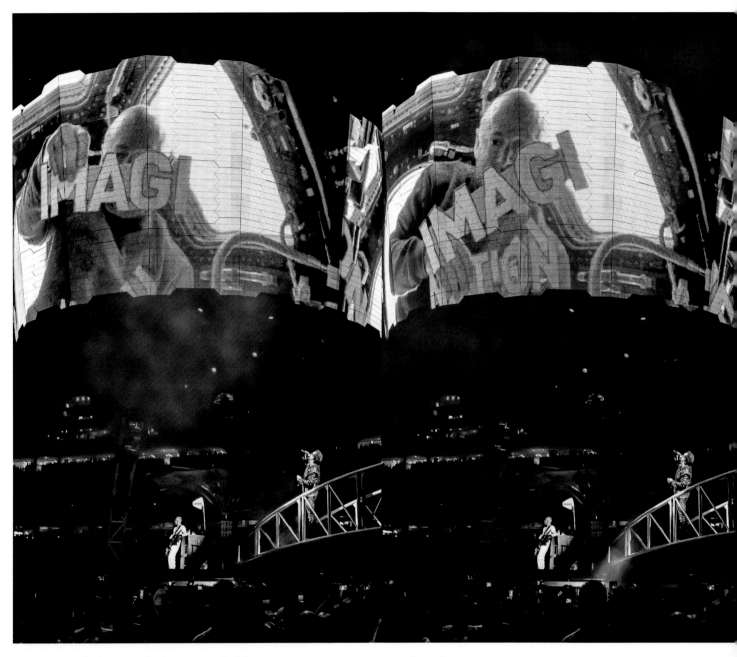

'and we ended up with this remarkable moment where she speaks to the audience, thanking them for what they were doing two years ago.'

Another highlight of the show became a video link-up with the International Space Station, with crew member Mark Kelly reciting the lyrics to 'Beautiful Day', before the band launched into it on stage. With lyrics lifted from 'Space Oddity', he dedicated the song to his wife, US Congresswoman Gabrielle Giffords, who was injured in the 2011 Tucson shootings.

'It began because Bono was friendly with Cirque du Soleil's Guy Laliberté, who had bought a ticket to the space station,' said Willie. 'And we got in touch with the NASA people; they were up for it because they love having press stories about NASA that aren't to do with things blowing up, so we developed this relationship [especially with the enormously helpful Commander Frank DeWinne]. At the time the commander of the space station happened

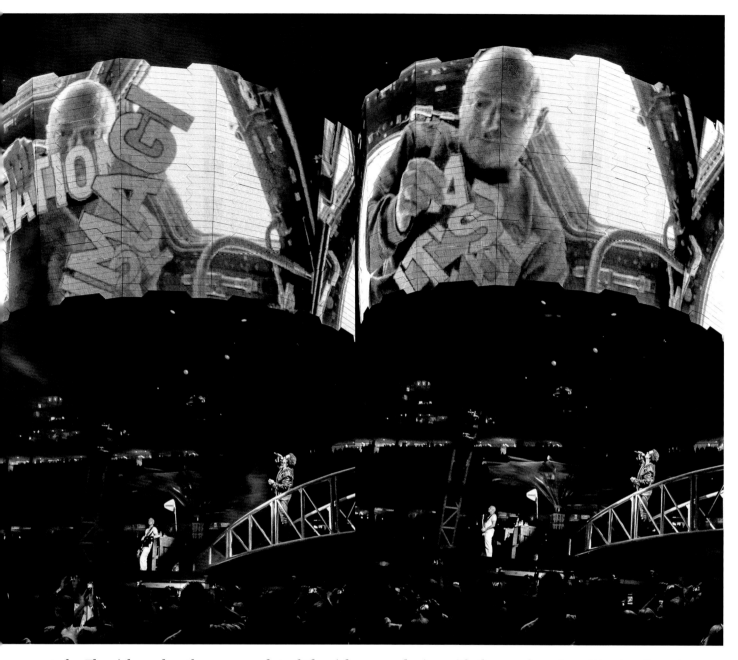

to be Flemish, and as there were a lot of Flemish people on the tour they developed a completely independent relationship, which did us loads of favours. And we got him to send things through, a few clips and things, so this piece began to develop and it took a couple of goes to get it right, but we did it in the end. And then Bono suggested he say, "Tell my wife I love her very much …"

'We gave him a series of three-dimensional cut-out words, and he spent a while filming himself playing with the words and positioning them in space, so they bobbed around the cupola of the ISS. The words read, "7-BILLION", "ONE", "ONE NATION", "IMAGI-NATION" and finally he builds the phrase "IT'S … A … BEAU …TIFUL … DAY". He then looks into the camera and says, "Tell my wife I love her very much … she knows".' As someone smart put it not so long ago, in the beginning, we squinted. Then we used binoculars. Finally, we just stared at the video screens. This has been

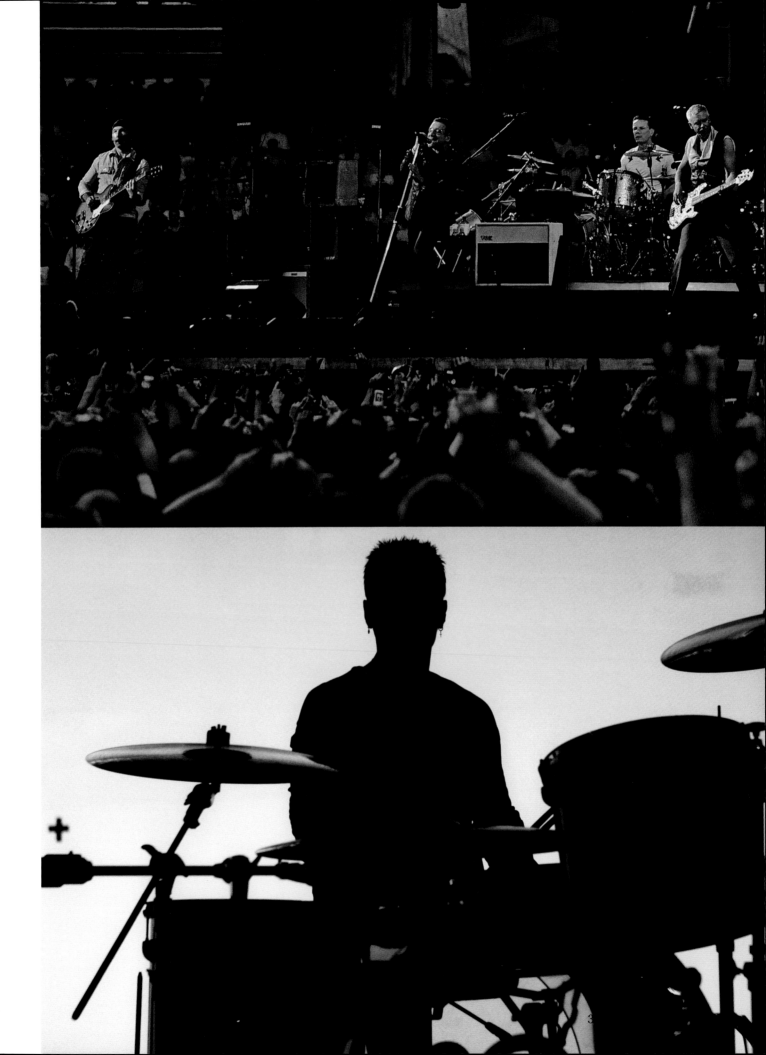

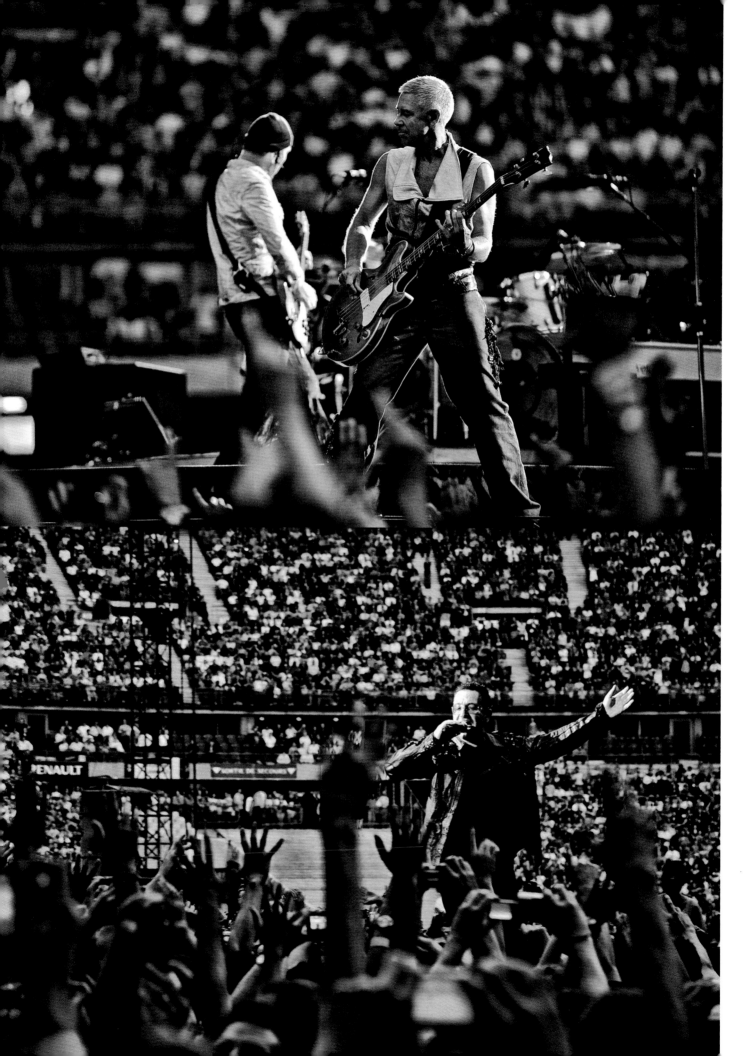

the evolution of the concert experience. Since the early Nineties the band and their production team have continually upped the ante where the use of video onstage is concerned – initially through the use of conceptual video-art. 360 was always going to be different, essentially because it wrapped around the stage before tapering downwards into an ice-cream cone, expanding from 4,000 square feet to 14,000. Weighing 54 tons, and suspended from the ceiling, the screen was made up of 888 miniature LED screens containing 500,000 pixels. As Chuck Hoberman, whose New York-based Hoberman Associates designed the cone, said, 'It's basically a large transforming shape, like a growing organism, that can get 70-feet tall, wrapped in content.' What was it trying to incarnate? Well, at certain times the kinetic sensation of watching the show reminded me a tad of the dolly zoom tracking shot of Roy Scheider that Spielberg used in *Jaws*,

Chuck Hoberman - kinetic architect and U2360 video screen designer

irrationally hurtling towards something at the same time as moving away from it ... both little and large at the same time, as the perspective distortion became a little overwhelming, as if you'd suddenly been transported to a gothic athletic stadium in which Escher had once imagined a twenty-first-century Po-Mo carnival ride. It was consistently rewarding, a relentless cavalcade of illumination, the kind of thing perhaps that Christo may have approximated if he had been party to the development of digital technology.

Edge was fond of quoting Bob Dylan throughout the tour: 'Dylan wrote, "He not busy being born is busy dying." Well, this show was still being born, even two years in.' Because of digital technology, every version of every video clip used in the show was kept intact on a hard drive, there to be plucked by one of Willie's team should it be needed, at any time of the day or night, and quickly cut into a new song sequence.

Every day, Willie would don his smock and beret, get out his laptop and get creative. For instance, while in Sydney he decided to make some video inserts for 'Miss Sarajevo', to remind the audience what the song was about and give it greater resonance. Willie thought the section didn't get beyond being a showcase for Bono's operatic moment. It was written about the response of a group of Bosnian women to the siege of their city, which was being largely ignored by the outside world. Their response, amid the chaos and destruction, was to stage a beauty pageant. 'This was such a defiant statement that for them life would carry on,' said Willie, 'an excuse to glam up and feel beautiful. For me the footage of the event comes across as an act of dissenting surrealism. It is defiant, ironic, subversive and not a little crazy.' The song

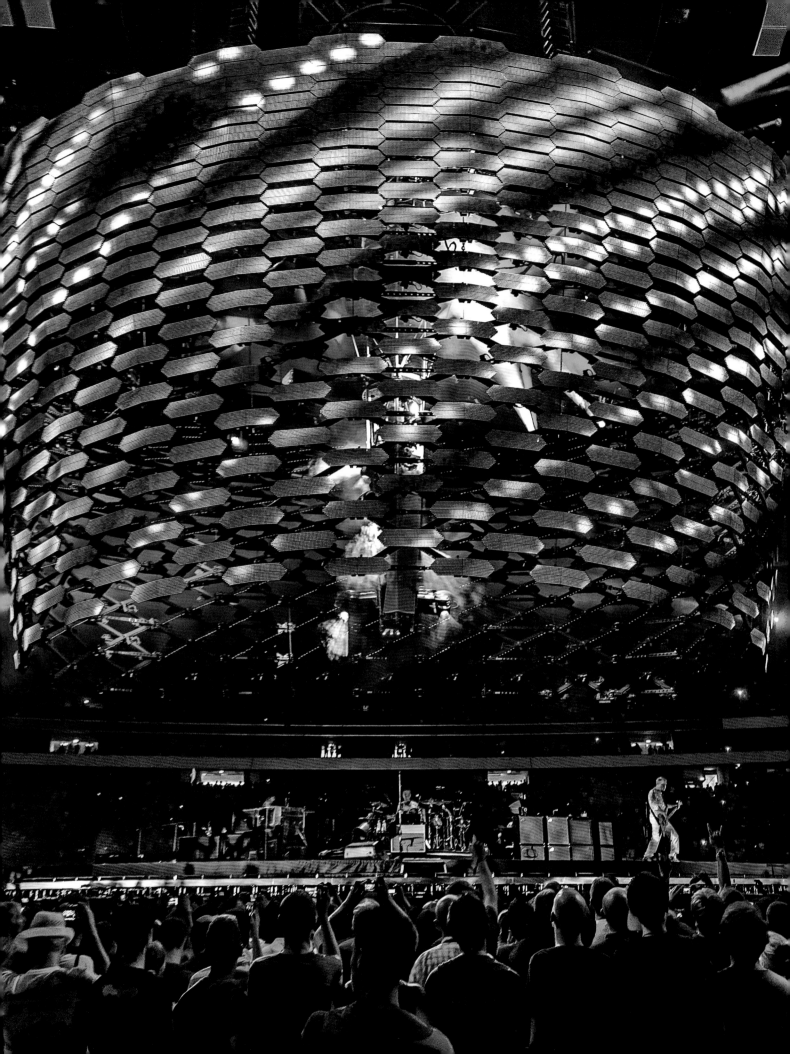

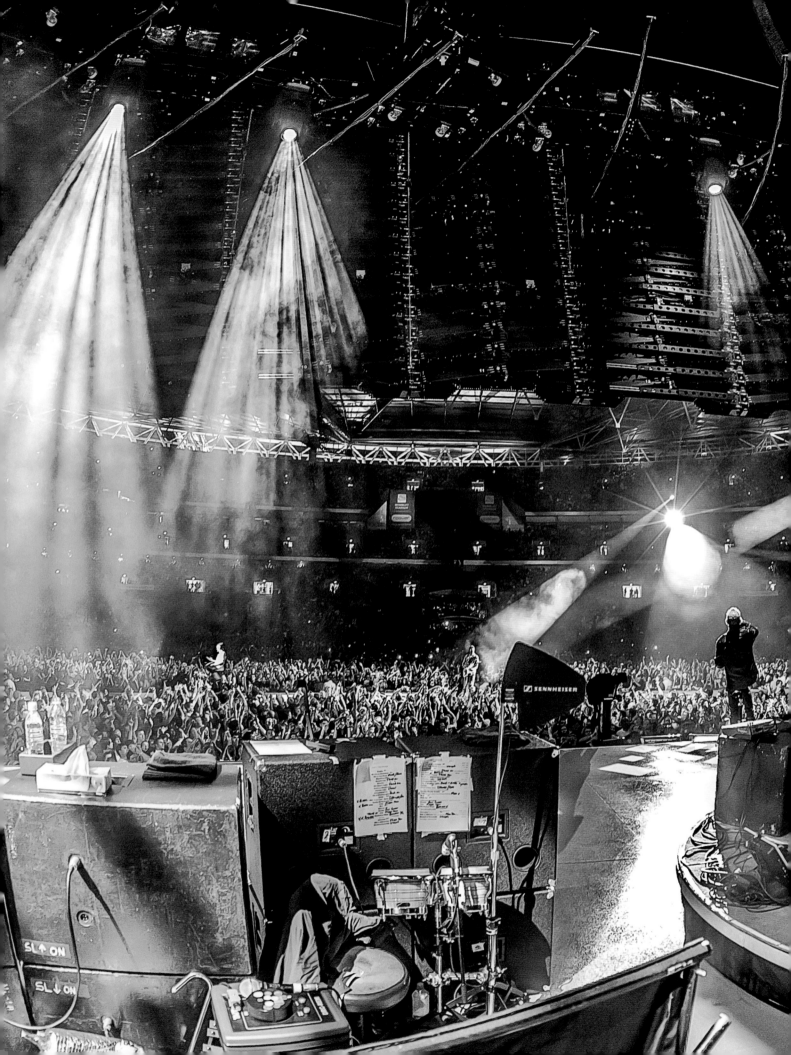

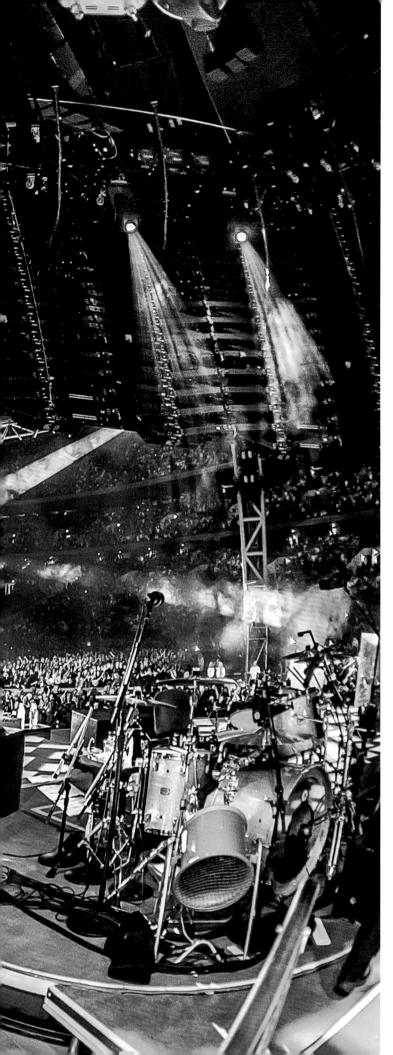

had been around since 1995 and had been performed many times, but the band usually used the same film to accompany it, and so Willie spent an afternoon figuring out how to subvert it.

Most afternoons he would trawl and trawl until he'd found what he was looking for, or maybe discover something he didn't even know he had. Often he'd find something even the band didn't know they had: one of his favourite clips was the sound of a cassette tape recorder being fast-forwarded, which was buried somewhere in the Zooropa master. On 360, he even managed to bury the sound of a carriage clock in the mix.

'I didn't want the videos to be the core of the show, because that's how every show is now,' said Willie. 'I thought there was a real opportunity to create a different kind of mood in the show. The audience is facing the stage, but they're also facing each other, so you have that football match thing where you're all watching the action but you can see the people on the other side. And as Bono said, "The advantage with sport is that you don't know who's going to win, although the upside to a U2 show is that nobody loses." Some of the most amazing moments, like with the cell phones, work simply because we're in the round [the phone section at Glastonbury would be great for the band but wouldn't really mean anything to the audience]. In a stadium, where everyone can see what 80,000 cell phones look like, it's an incredible moment. So I was much more interested in that kind of thing than video content.'

Towards the end of 2010 Willie began mulling over an idea for a new video sequence to accompany 'Moment of Surrender'. Occasionally ideas would come to him in a moment of blinding creative inspiration, but far more usually they tended to seep into his consciousness gradually, in a sort of artistic

osmosis. Often ideas came about as a result of something he'd seen and liked or been temporarily fascinated with. An image or a concept might sit in his head for years until eventually it met another notion lurking in there somewhere and between them they formed a complete idea.

In the past, this idea had surfaced in a few different places, in particular in Julian Opie's 'Walking Man' sequence, which appeared during 'Sometimes You Can't Make It On Your Own' on the Vertigo tour. Given the lyric, 'I did not notice the passers-by, and they did not notice me', it became obvious that this might be a clue for a visual piece to accompany '... Surrender', but according to Willie it needed to cross-pollinate with something else to turn it into a viable idea. At the start of the song, Bono would ask the audience to take out their cell phones and then call to Willie to turn out the lights. This was the moment when Bono got the crowd to create an electronic milky way, a night sky on Earth. When U2 used to tour, the audience held lighters and matches aloft to pledge their allegiance, but since the world went digital they have used mobiles. Consequently the 360 tour was the most photographed tour in the history of entertainment, a tour photographed by the people who paid to see it.

'The darkness reveals a universe of cell phone lights that, in the 360 configuration, is so vast and so concentrated that it's hard to comprehend until you see it with your own eyes,' said Willie. 'Most of these tiny points of light are a cold white, but there are some green, some blue and then short-lived orange ones as the phone cameras do their auto-focus, with white flashes going off periodically.'

This cell-phone 'star-field' section of the set got brighter the longer the tour went on, as each

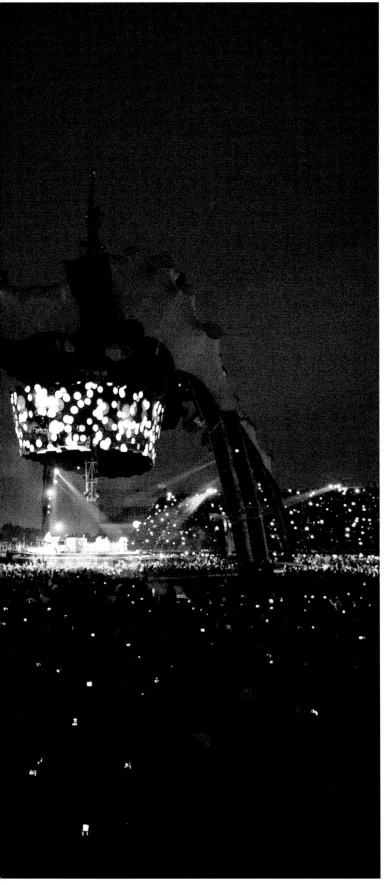

Hippodrome, Montreal, 9 July 2011

new generation of cell phones was released, and it became increasingly effective as a piece of stage craft. The image had been picked up by one of the cameras and then turned into an abstract, out-of-focus image on the giant 360 screen, and it reminded Willie of some work by Jennifer Keeler-Milne, an artist friend of his in Australia, who produced beautiful large-scale oil paintings of out-of-focus points of light. Gradually Willie began to realise that this could be the second string to the idea, and so set up a video shoot back in London, a cavalcade of silhouettes. Before discussing the segue between 'City Of Blinding Lights' and 'Zooropa' and Willie's suggestion to use the theme tune to the *Tellytubbies,* both he and Bono attempted to out-mad each other. Bono thought he had the upper hand with his story about being picked up hitch-hiking by a famous Canadian ice hockey player. When that didn't work, he drew on a story which ran in the previous day's newspapers ... 'Did you see the UFO hovering above the sound desk?' 'No,' replied Willie, looking puzzled. 'I saw it', said Bono, deadpan.

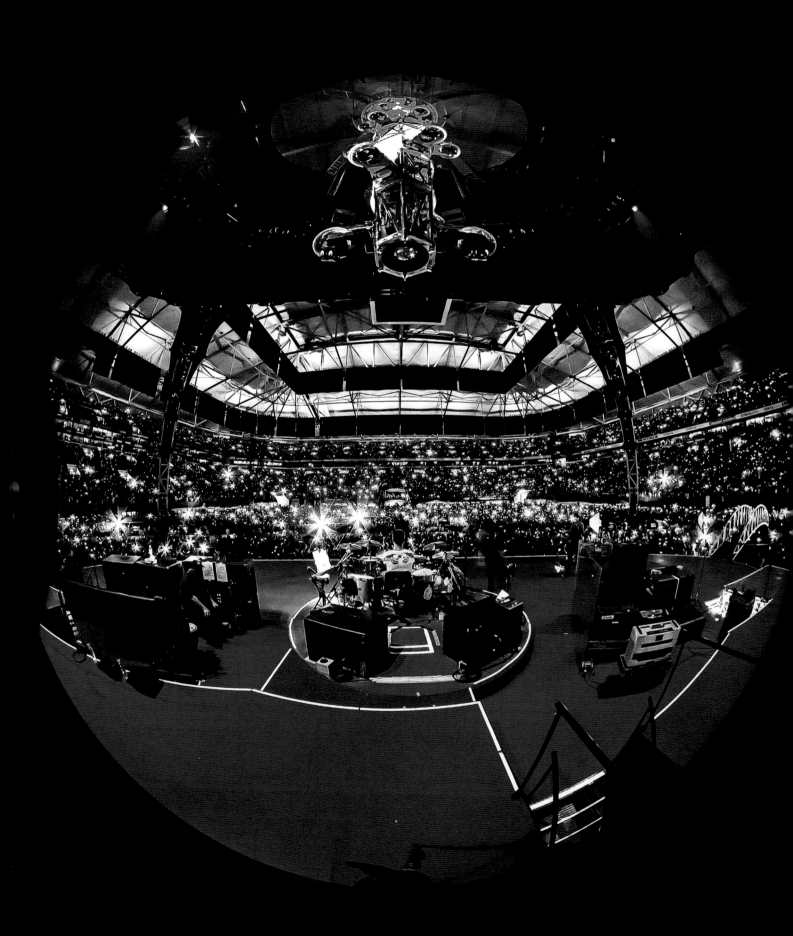

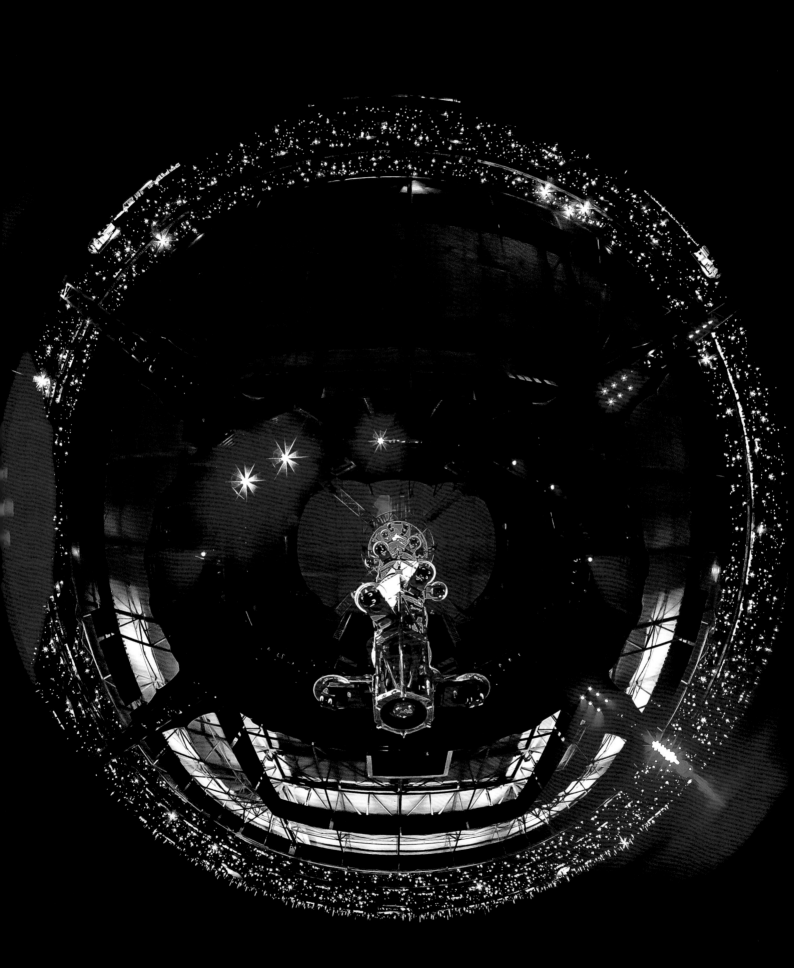

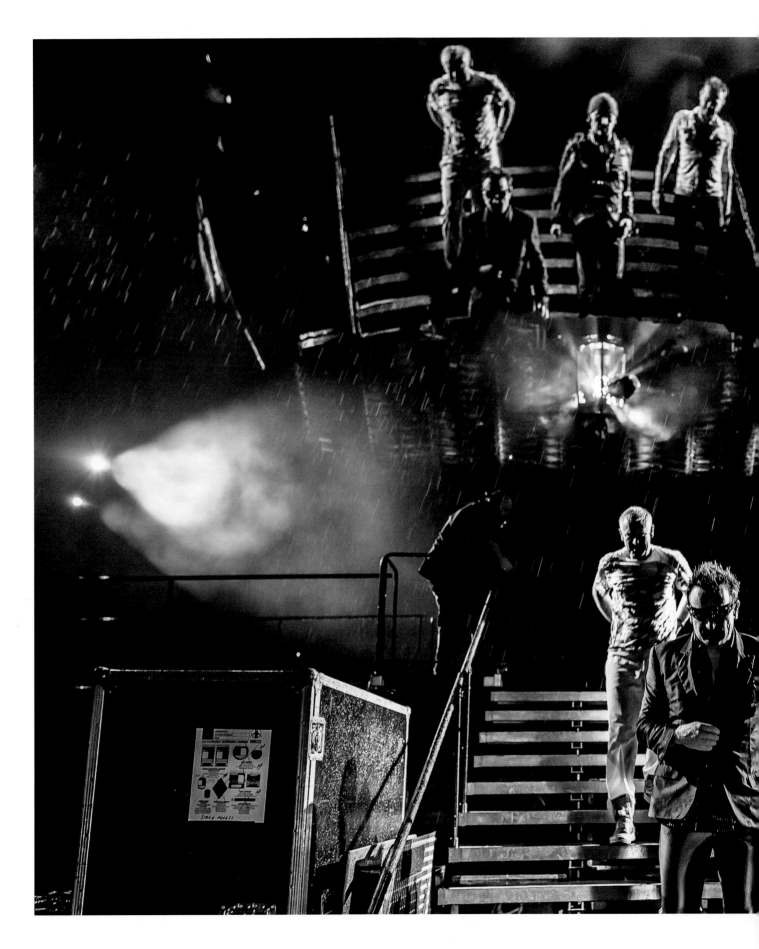

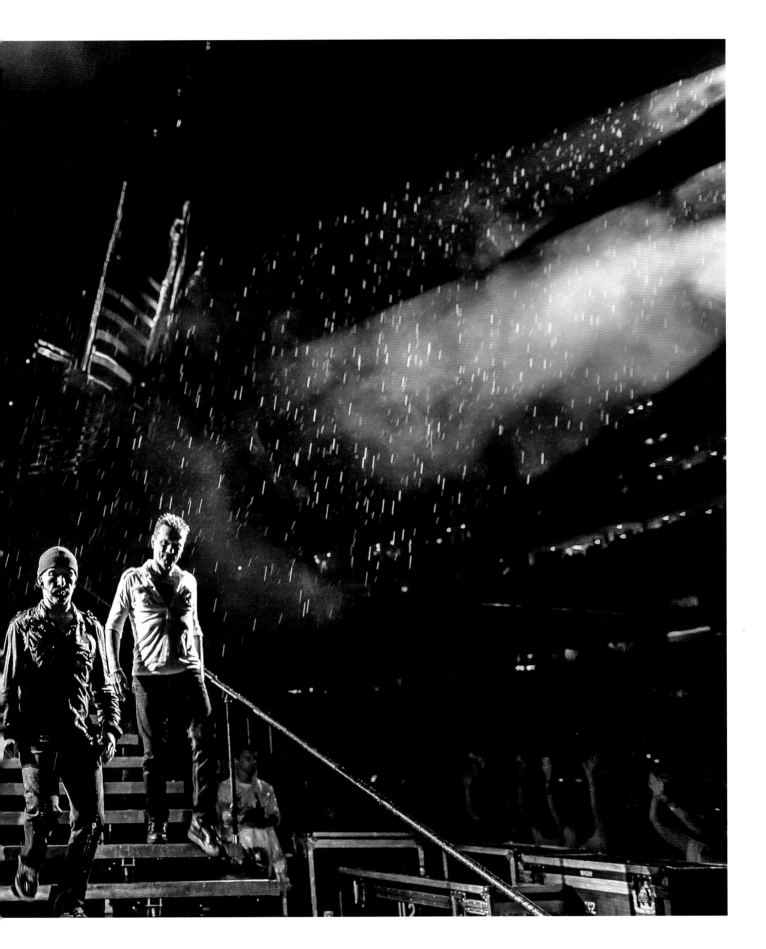

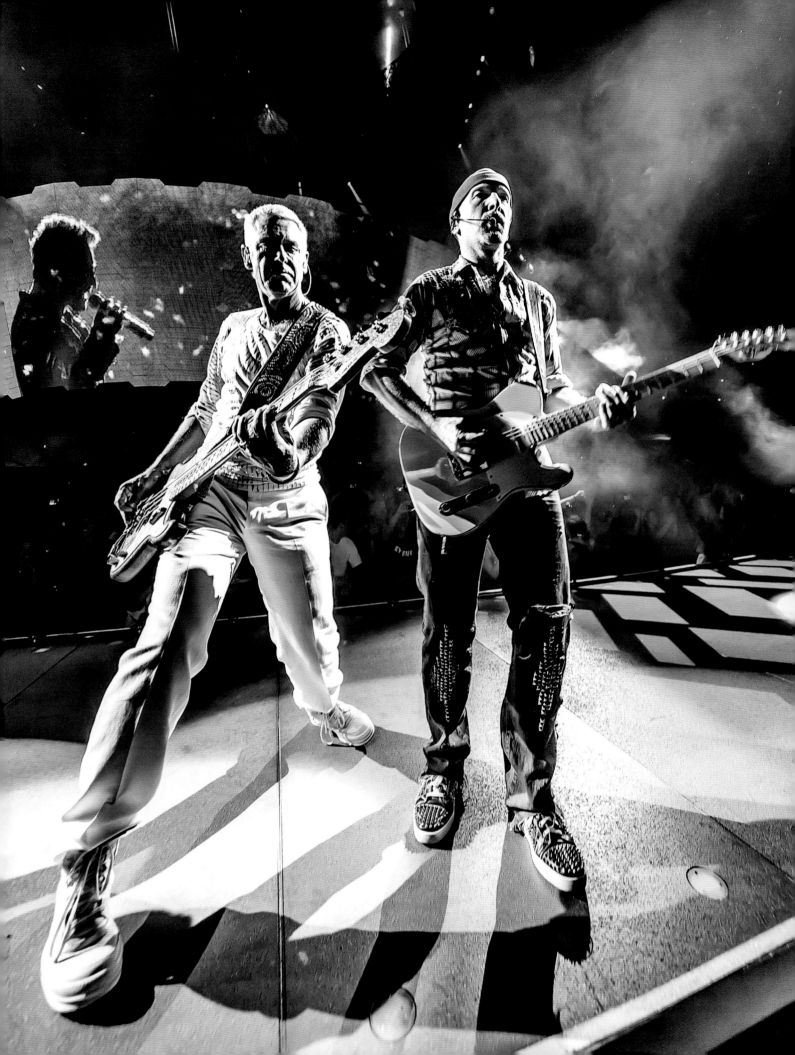

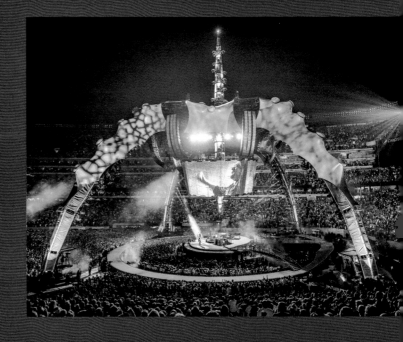

**FROM BARCELONA TO MONCTON:
AROUND THE WORLD IN 760 DAYS**

Chapter Three

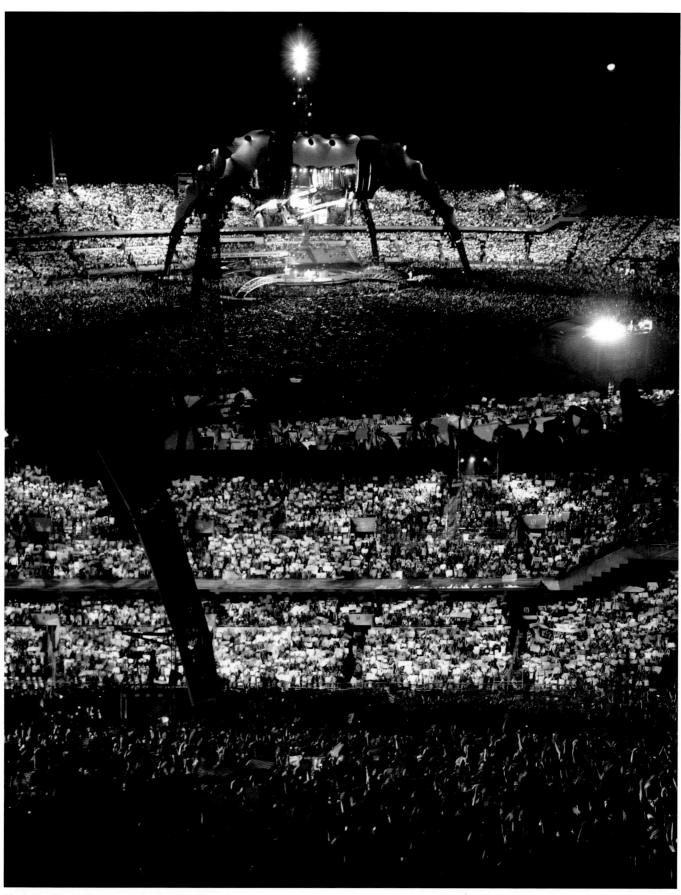

Slaski Stadium, Chorzow, Poland, 6 August 2009

# 'BEING ON STAGE IS SOMETIMES LIKE BEING IN AN IPOD'

*— Adam Clayton*

Taking a small army on the road had become U2's way, although even their nerves were stretched when Bono seriously injured his back, and the tour ended up lasting twice as long as it should have done. From Europe to Australia, via North and South America, and their first ever concert in Moscow, 360 was a tour that never seemed to end, that never looked like it could end.

When Nicole Kidman said that the U2 gig at Giants Stadium was the best she had ever seen, no one was surprised. Most guests after a show tended to say the same thing; even if they were just being polite it was highly unlikely that they had seen a better show. Before the show she had been hanging out in Paul McGuinness's office, along with Mick Jagger, L'Wren Scott, Salman Rushdie, Jeff Koons and *Rolling Stone* publisher Jann Wenner. 'I hate to say it, but it's extraordinary. It's such a great show,' said Jagger.

The guest lists on the tour were 'commendably out of control', to quote Willie Williams, and some nights were so star-studded you were overrun with 'Madame Tussauds Syndrome'. One night there was Tom Cruise, Katie Holmes and Cameron Diaz, another night Wim Wenders, another still the poet Paul Muldoon. At the Angel Stadium in Anaheim

there was Cindy Crawford, Gordon Ramsay, Hilary Swank, Jake Gyllenhaal, Sharon Stone and Maria Shriver. And on the night I flew from Nice to Hannover on Air 360, Sam Taylor-Wood, Aaron Johnson and Michael Stipe.

This is Willie Williams describing in his blog the aftershow at the Sydney Intercontinental on 14 December at the end of 2010, where the roll call included Nicole Kidman, Keith Urban, Cate Blanchett, Baz Luhrmann and Oprah Winfrey (a close friend of Bono): 'Despite my general disgust with the citywide genuflexion that's been rampant all week, I confess I went because I knew that Oprah would be coming. It was quite busy when I got there and, wandering out onto the crowded terrace (sweeping views of night-time Sydney, bridge, opera house, etc.), I heard my name mentioned. I looked around and heard Edge say, "In fact, there he is," at which point I was pulled into a circle of conversation including Edge, Bono, Oprah and another woman I took to be her producer, p'raps. "You're Willie Williams ..." says Oprah, shaking my hand and I meet the producer too. They ask about my role in the show, designing it and so forth, Oprah looking right into my eyes. I felt like I was being scanned, What do you have? What can you tell me?, then the producer cheerfully says, "We're going to rip you off!" and, rather randomly adds, "How many cameras do you have?" "Fourteen," I reply. "You hear that? Fourteen cameras," she says to Oprah, then the circle of conversation moved on and I knew it was time to let it pull away.'

On the 360 tour, every date was a party, every pre-gig meet-and-greet a summit, every after-show a VIP love-in. This was the first time U2 had ever played in Russia, and in August 2010, a day after Bono traveled to Sochi on the Black Sea for an official meeting with Medvedev, the band finally played the Luzhniki stadium in Moscow. And there were nearly as many security guards at the show as there were genuine fans. According to the crew, being in Moscow meant that anything you needed to get done would probably take at least twice as long as usual and would be fraught with entirely pointless obstacles.

'Why hadn't we played Moscow before?' said Paul McGuinness. 'For the same reason as Hitler and Napoleon actually: it's too far. Until recently there weren't many places in between you could route to. If it takes three days to get the trucks to Moscow and three days to get them to the next place you can play, let's say it's Berlin, it's not worth it. So as Eastern Europe has become more prosperous and

there are places to play, it gets easier. It certainly wasn't a decision in principle, we just never got round to it.'

'In many ways it's a country that's come very far and in other ways it's not moved very quickly at all,' said Arthur Fogel. 'So doing business can be very

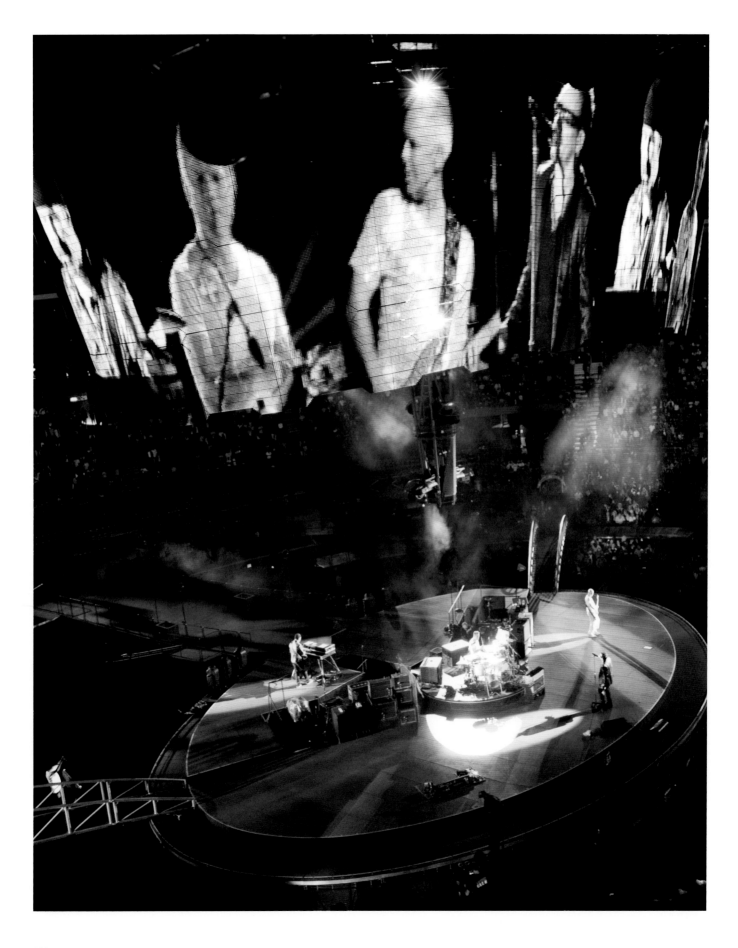

challenging, but it's definitely opened up as a real market for shows, and there's a lot of tourists that go through there.'

'They knew the tunes, and they were enthusiastic and rowdy, although there was a lot of security,' said Adam. 'The authorities had a problem with Amnesty International and Greenpeace, who were both petitioning, and wanted to arrest them all. So a phone call was made and everything calmed down. But we had police with guns and stuff like that, and we're just not used to that. In the past we were always slightly wary that there wasn't a real market in Russia, that you couldn't actually get tickets out to the general public, and it's still questionable because there's such a differential between the middle classes and the poor. But it's better than it was.'

At the Moscow show, Bono treated the crowd to an ad hoc a cappella version of 'Singing in the Rain,' though most fans seemed more familiar with the words to 'Where the Streets Have No Name', 'One' and 'With or Without You'. And as it rained – and in Moscow the rain falls like it does nowhere else in the world – Larry's own computerised umbrella shot up to cover the drum riser, making the crowd instinctively applaud yet another of the show's sci-fi elements.

The band's show-day afternoon regime was much the same as it ever was. Adam's regime certainly was. In the afternoon he'd see a physio, to loosen him out after training in the morning. Then he'd have a light meal in the dressing room, and go into wardrobe. Then the band would discuss the set, which would see them through to about quarter to eight, at which point they'd go to their various hospitality rooms, to meet any guests they may have invited for the evening.

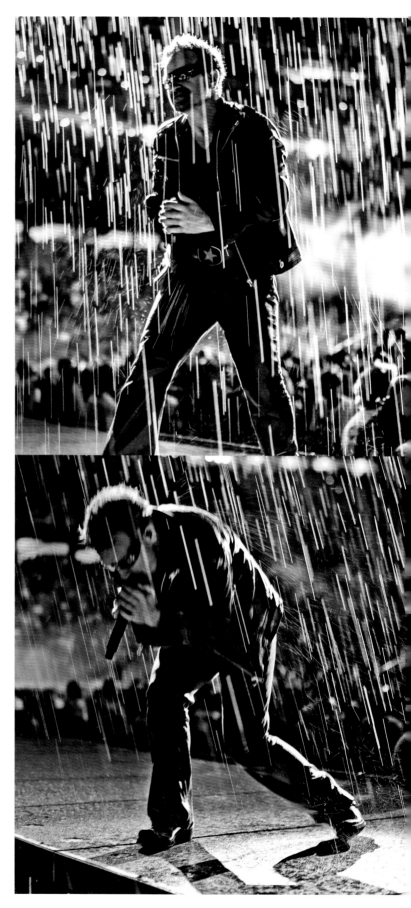

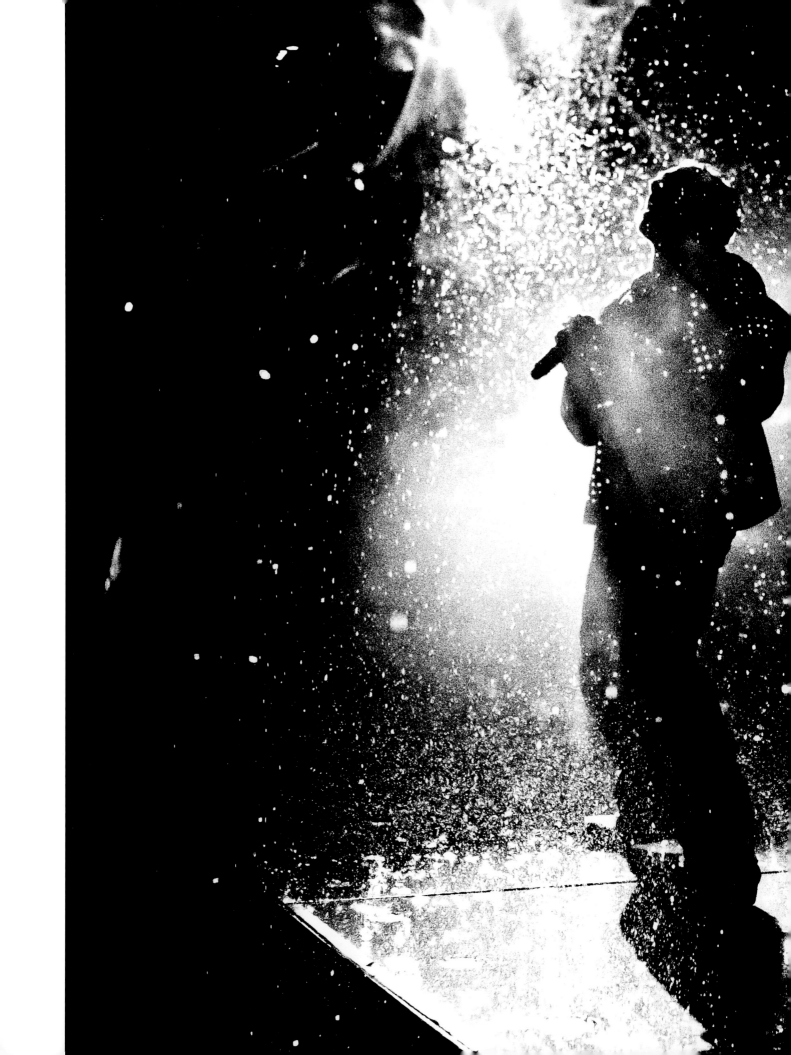

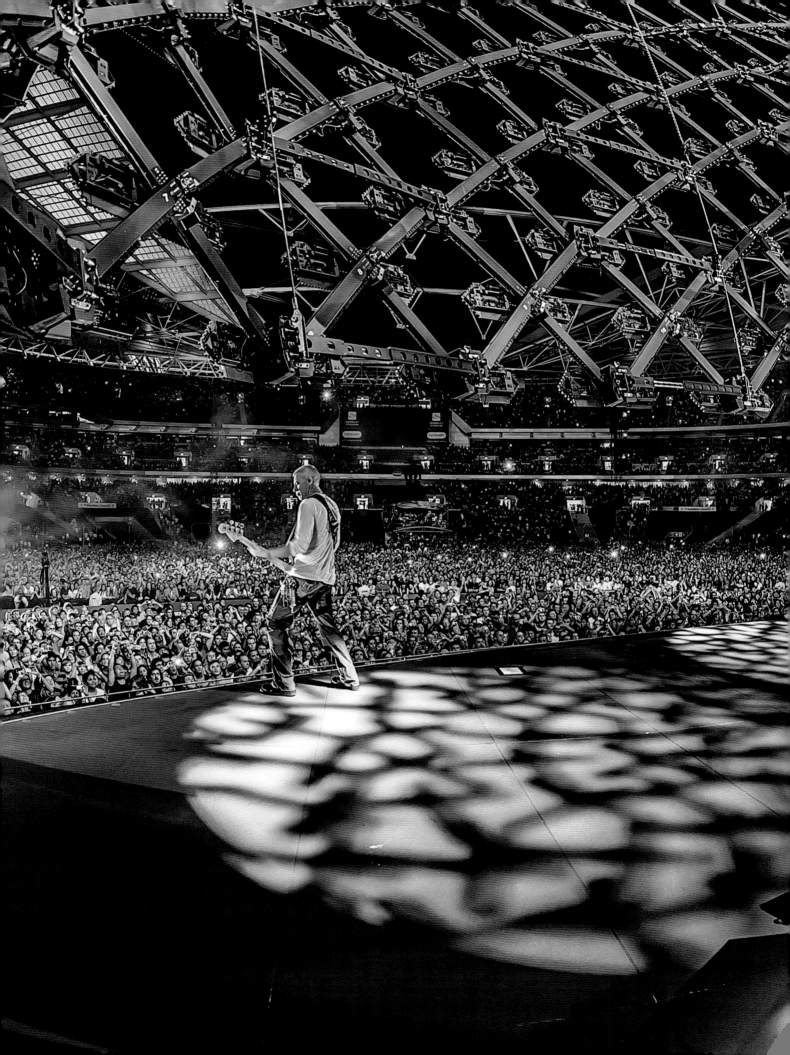

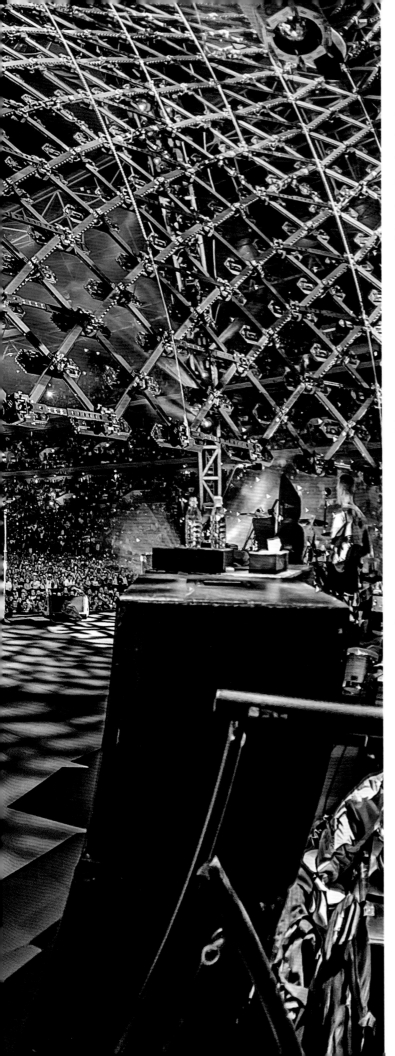

'I have to say nowadays I can really cope with a lot more distraction before the show than I used to be able to,' said Adam. 'I'm much more focused than I used to be. I empty the mind of anything that might be distracting, trying to get present in the now as opposed to thinking about phone calls you have to make or emails you have to reply to or anything that's too in the organisational mode that could be a distraction. The dressing room has quite a monastic quality; people are quiet, concentrating on the running order.'

Bizarrely, Adam actually gets apprehensive. 'There are times when, even though you've performed a song thousands of times, every time you come back to it it's trouble. So there are times when I have a brain freeze, where if I haven't wrestled a tune into submission – and it's usually when we recorded it, when I couldn't quite resolve a chord change, or didn't think it was fluid enough – it always niggles me and it kind of just wrong foots me. So it's a bit of a battle of wills and then eventually I'm fine with it. "Walk On" is a tune that I just dread, and I can see it coming with real horror. I've kind of got there now, but I just keep forgetting a block of notes. And you know "Streets" is always a problem as there's always a lot of chord changes that takes a lot of concentration. But, you know, it changes ...'

360 was the second U2 tour on which Adam had worn his 'ears', as they are known in the trade. These are the in-ear monitors used by musicians today in order to hear what they're playing on stage. They look like iPod ear buds, and are made-to-measure from moulded impressions taken from the wearer's ears. Essentially you have a syringe put in your ear, which squirts out a substance akin to modelling clay and toothpaste, creating a thrillingly

violating sensation in your ear canal. This is left to set, then extracted with a satisfying squelch before being sent off to the audiologists.

'The rest of the band have been using them since Zoo TV, but I only started on the last tour,' said Adam. 'They give you a very accurate sound mix no matter where you are on the stage, so it's a bit like listening to a proper live gig, whereas traditionally if you're performing you tend to get your little sweet spot; so for a bass player you're hearing the drums, you're obviously hearing the bass. You're hearing enough of the rest of the band to know where you are. But if you need to hear more of anything you just move, because you can stand nearer the guitar amp if you want to hear the solo, or you can be nearer the singer if you want more of the vocal. So once you've got these things in it's like having headphones in, it's like listening to your iPod. Actually, being on stage is sometimes like being in an iPod.'

Just before show time, Edge would quietly strum a guitar, Larry kept himself to himself, and Bono would start his vocal warm-up. If you sat in one of the adjacent rooms you could hear him doing his exercises, which, through stone and plasterboard, often sounded like badly recorded Bjork bootlegs.

And then before they met their guests, the band would change, being dressed by Sharon Blankson and her wardrobe team. Adam tended to wear All Saints, Rick Owens, Hermes and Balmain; Bono liked bespoke leather jackets, Edun jeans, American Apparel T-shirts and his by-now famous Frye engineer boots; Edge wore Atelier Dom Rebel T-shirts, Dior jeans, All Saints leather jackets and extremely rock 'n' roll Louboutin studded sneakers; while Larry preferred Levis and simple T-shirts.

The show schedule almost never changed:
5 p.m. Doors,
7.15 p.m. Snow Patrol (say),
8 p.m. Set Change,
8.45 p.m. U2 On Stage,
11 p.m. Curfew.

And while the band did soundcheck in the early days of the tour, as they were playing stadiums, it was fundamentally problematic as the doors opened so early. They started letting people in at five o'clock, which meant that any sound check would need to start at 3 p.m., which seriously compressed the day.

The pre-show ritual never changed either. Each night, before they go on stage, U2 do exactly the same thing. They walk from their individual dressing rooms, or from their hospitality suites, and they convene with each other.

Often the band won't have spoken to each other all day, as they've been doing their own thing, or looking after their family, and it's a way of reconnecting. It's not exactly a self-administered pep talk, as they're not really that jockish (not at all, really), but a kind of communion, and a moment of gratitude.

'We always have half an hour before we go on stage,' said Bono. 'It's a hard thing to describe, but we sort of pray. We tell each other how lucky we are. In that way that one shouldn't be public about private matters of faith, what we say is secret, but it's important. We are grateful for what our music has given us, and above all, what God has given us. We reflect on the fact that the audience we try to serve as musicians has given us so much and how we might serve them better? As I say, it's a private moment. This is the only time that it's just us together, heads together, praying, and we do it at every gig.'

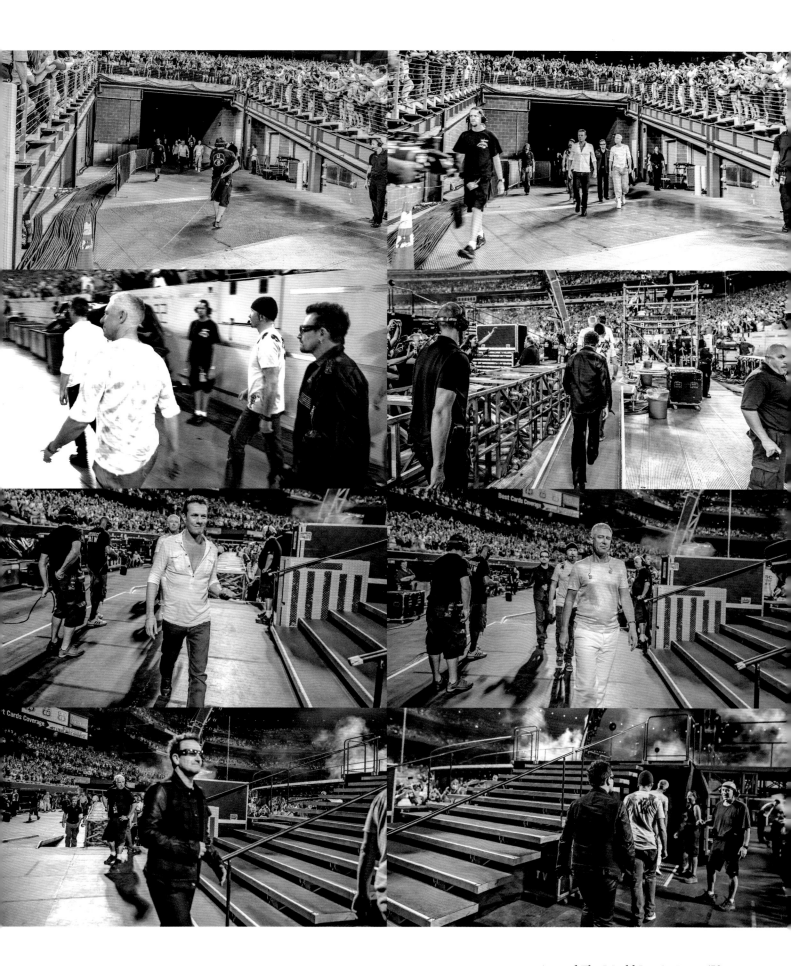

The crew knows never to interrupt them during these moments, although sometimes their reverie is broken by outsiders. Famous outsiders. One such incident happened at Live 8, in London's Hyde Park in 2005, just before they were due to open the show.

'We were standing there praying, just the four of us, and there's a rat-a-tat-tat at the door,' Bono told me, with an embarrassed laugh. 'There's this rat-a-tat-tat. And it's Paul McCartney. And the band had no idea it was Paul McCartney. But Dennis Sheehan, our tour manager, or Paul McGuinness, wouldn't open the door at such a private moment. So he was left outside our holy huddle, waiting. When we eventually came out and realised it was the Macca, we ran over to him and apologised. And Paul's like "I was just coming over to say hello and wish us all well for the show." I explained that we have this moment before we go on that we ask for a blessing. And he said, "Oh I'd be so into that, I'd love a blessing too." And we said, "Oh, we had no idea or we would have invited you in"... and so for the first time ever in public, we have a prayer meeting. Four members of U2 and a Beatle. And I tell you what, Paul McCartney does the most poetic prayer. Something along the lines of, "we are so blessed to be here, on this day especially, to serve the poor, the vulnerable." Sorry, that's not as poetic as it was, it was awesome ... a fucking Beatle! Love is all you need, I guess at the very heart of the Beatles music, was a meditation on the word love. Not just romantic love, the big love, unconditional love. We try to do the same. The word love turns up a lot in our songs and it's a really easy corny word and you've got to be careful how you use it. It better have some meaning.'

'We always knew that we had two careers and each was important and interlinked,' said Paul

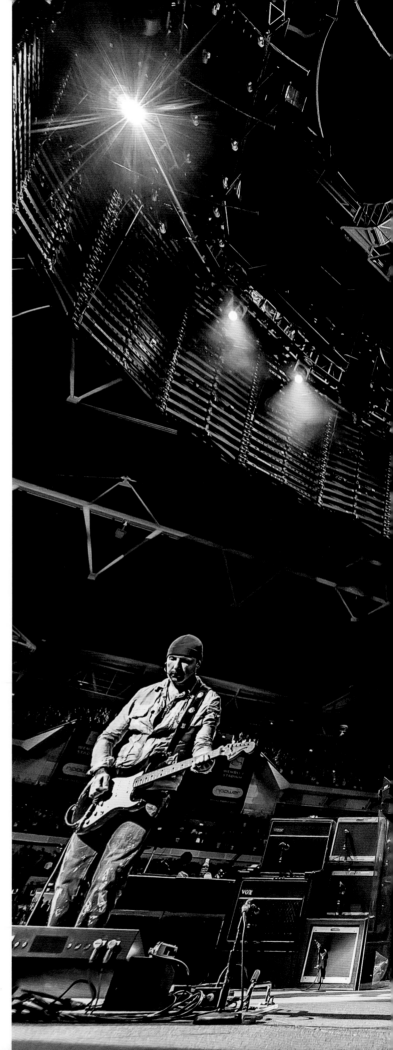

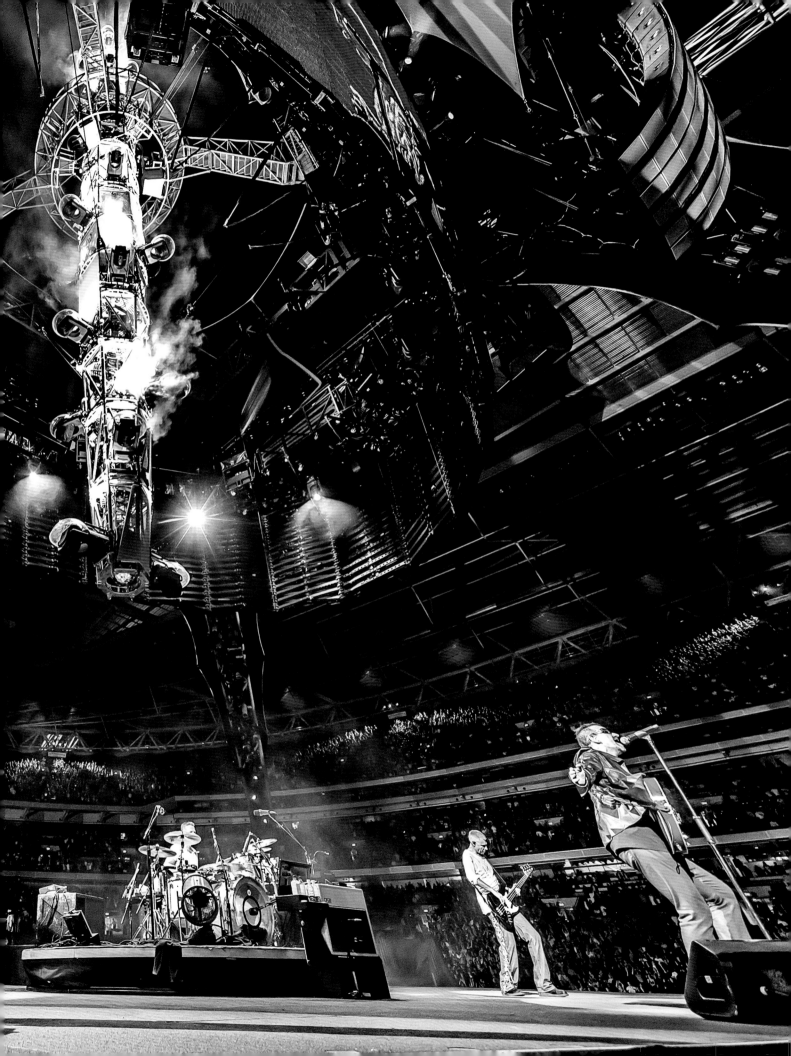

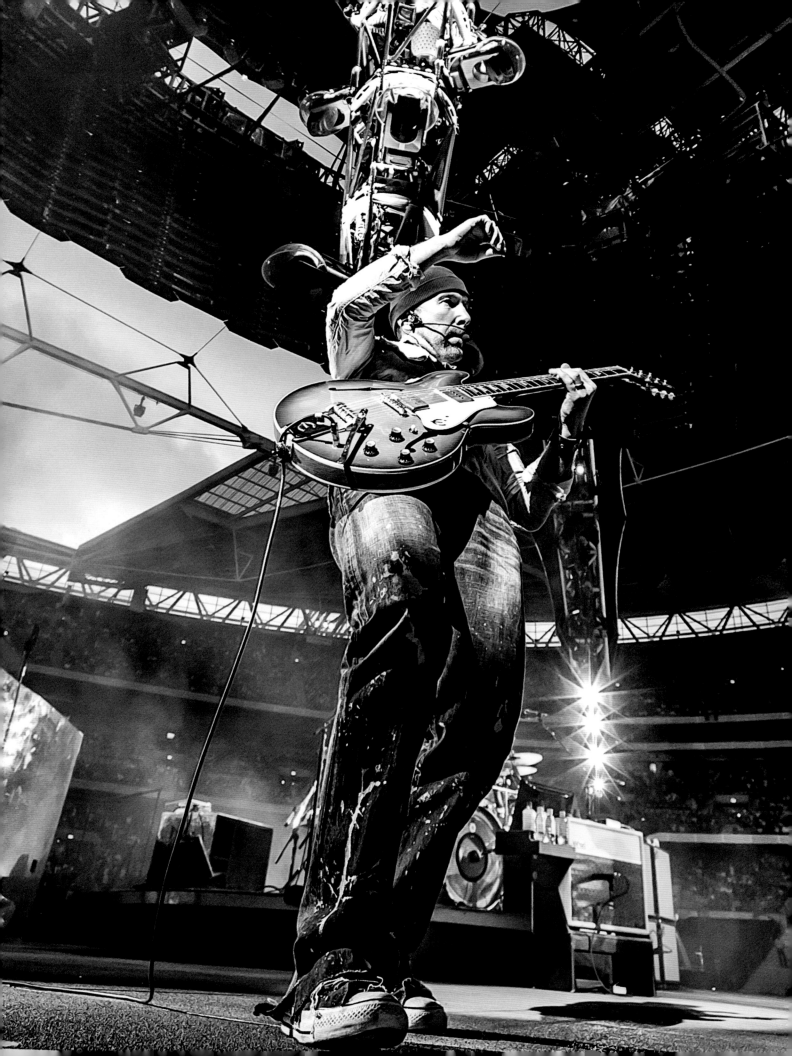

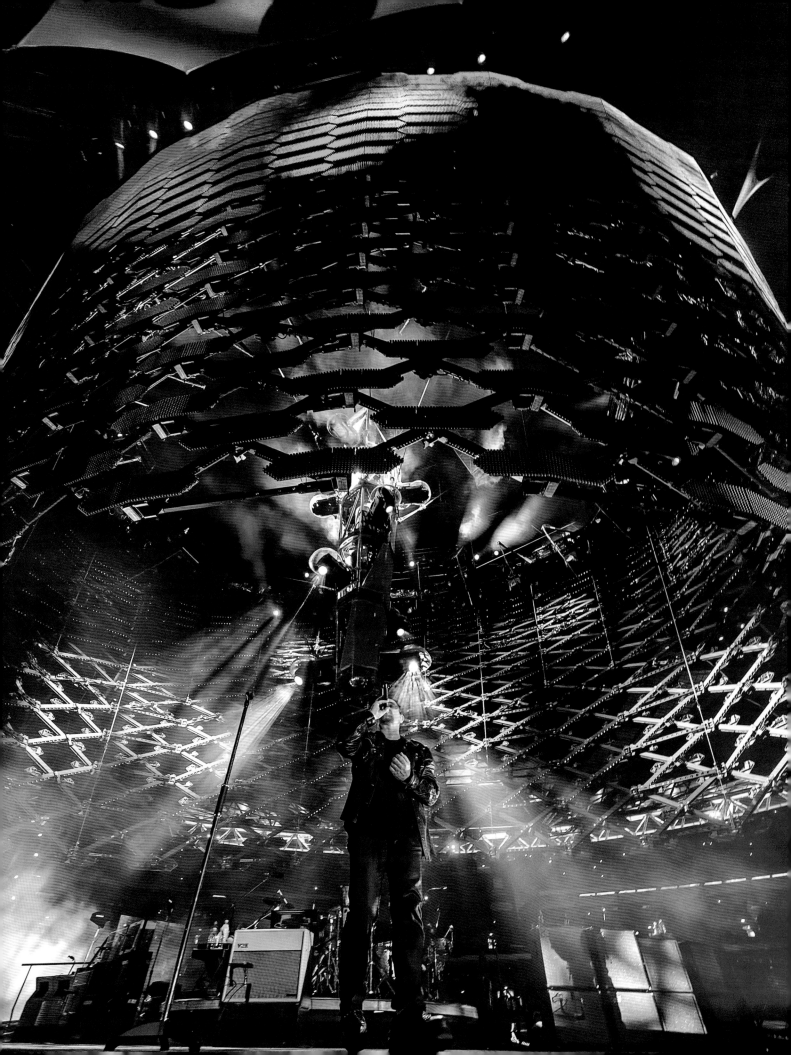

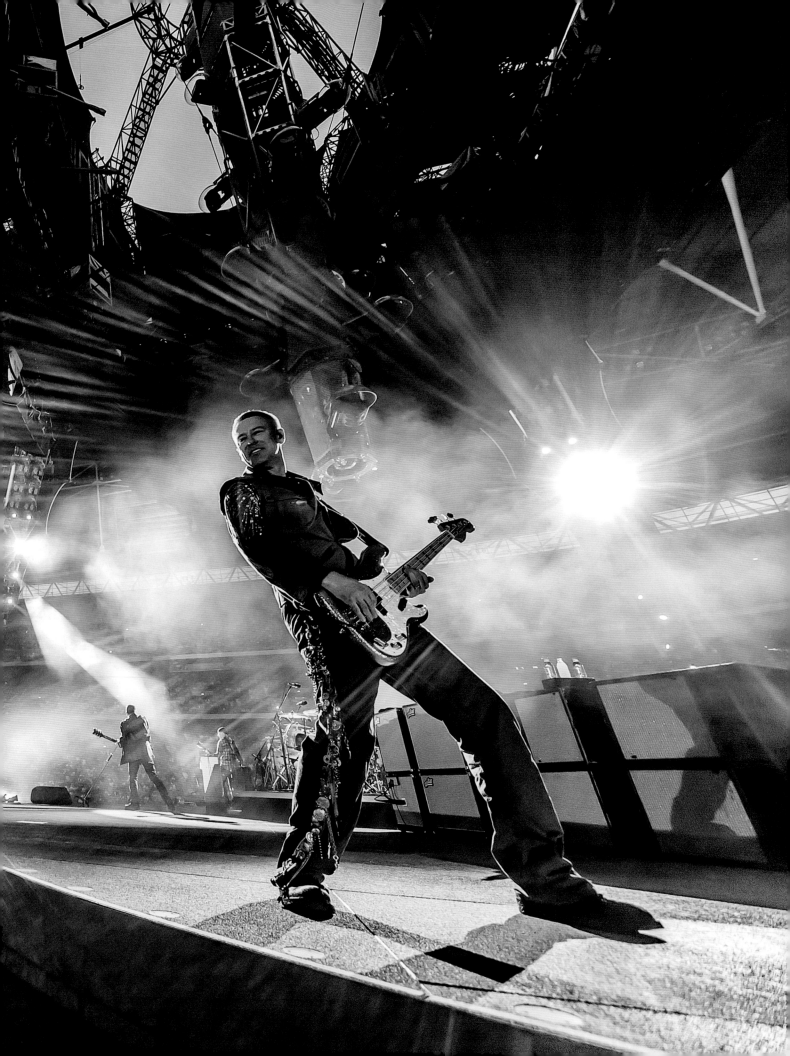

McGuinness. 'But U2 was a more successful live act in the beginning than it was a record-selling act. Our peak record selling years from the late eighties through the nineties coincided with what you would call the golden age of the record business anyway. So that suited us. I think the problems of the record business are solvable, but only with the participation and active willingness of the other industries which have been parasitic on content for so many years. I would love to see some ingenuity from Google, Apple and the other huge winners of the digital age. I would like to see them applying themselves to something that really shouldn't be that difficult, or seems to me as a non-technology person that it shouldn't be that difficult. If I make a phone call to my cousin in Australia, I'm not bewildered that Vodafone know about it and charge me for it, and I trust that what's on my bill reflects the number of minutes I've spent speaking to my cousin. No big deal to do the same sort of thing, it seems to me, for music consumed all over the world online via the billions of people who like music.'

By October 2009, the tour was running on rails, having been to both Europe and North America. The band had been to Zagreb, London, Glasgow, Chicago, Toronto, Los Angeles and most places in between. The attendance figures had been staggering, and the press adulatory. In the words of Willie Williams, it was turning out to be the most successful tour since Noah set sail. The show was so good, and going down so well, that everyone aboard the U2 spaceship was having the time of their life. Every 360 night was a feast. 'The reason I'm here is these three men,' said Bono onstage at the Gillette Stadium in Foxborough, Massachusetts, introducing the band as bizarre scientific experiments: Larry was Robocop 3, Edge a cross between Jimmy Page and Stephen Hawking, while Clayton was 'our very own Big Bang'. As for himself, he was 'a work in progress …' Later that night the video screens broadcast Desmond Tutu thanking U2 fans for their part in the fight against extreme poverty. Later still the stadium was filled with an audio recording of Maya Angelou reading her poem, 'A Brave And Startling Truth'. Every night there was a drama, every night was a gas. When they played Chicago on 12 September, Bono even had an Elvis moment, stopping the motorcade so he could get a Big Mac.

There was going to be an hiatus until the summer, when they were due to start the third leg of the tour, starting in Salt Lake City on 3 June. But then disaster struck. While he was in New York on vacation, Bono tore a ligament in his back, and suddenly the tour looked as though it would have to be postponed. Bono and his family were in New York for his fiftieth and his daughter's twenty-first birthdays. He was walking across the Brooklyn Bridge, on his way to see the family, and he suddenly got a pain in his back, a pain that wouldn't go away. The next morning they took some bicycles down the West Side Highway, on their way to meet Jordan and some of her friends at the Greenwich Hotel downtown, and still the pain wasn't going away. He was propping himself up with painkillers, but they didn't appear to be having any effect. 'I'd had a couple of issues when I was boxing, and I'd had a prolapsed disc before, and it's very, very painful, but it's not the end of the world,' said Bono. 'This, however, was a very different pain, and it just refused to go away.'

The next day, they all flew down to the South of France, to stay with the Belfast entrepreneur Paddy McKillen, in his extraordinary art park in Le Puy-Sainte-Réparade, an agricultural village ten

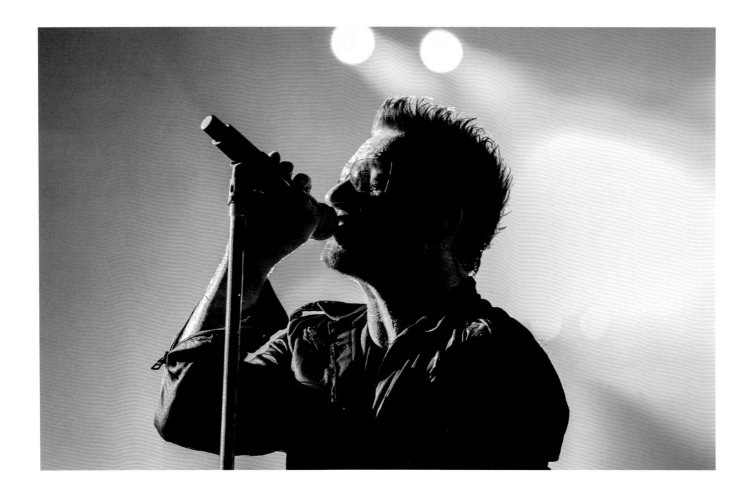

miles north of Aix-en-Provence. Chateau La Coste is essentially a biodynamic vineyard, although in 2003 he set about turning the site into an architectural theme park, commissioning works from Jean Nouvel, Frank Gehry, Richard Rogers, Norman Foster, Renzo Piano and Tadao Ando. There were also extraordinary sculptures by Richard Serra, Andy Goldsworthy and Louise Bourgeois.

'Anyway, we're there, and it's lovely, and we can't quite believe the place is so beautiful,' said Bono. 'But I have got such a pain in my back that I have started walking with a stick, and it's getting harder and harder to get around ... as it's Jordan's birthday too, and her friends are around – we go out dancing the next night to Jimmyz in Monte Carlo. Now, some think that Jimmyz is the very axis of Euro trash evil, but these are people without a sense of humor. It's a classic seventies Franco discotheque. I have, however, lost my sense of humor at this point, due to the heavy heavy-duty painkillers. My daughters Eve and Jordan both suggest that I look a little under the weather. When I object to their characterisation, they point out that I have just mistaken the girl sitting next to me for Ali, and am now in earnest conversation with the not so earnest, fun loving, very blonde, Paris Hilton. A visit from the regent, Prince Albert, to offer his belated birthday greetings, makes the whole thing a very Monte Carlo moment. My daughter whispers, "You need a fan if you're pretending to be Karl Lagerfeld." I was out-Jimmy-ing the Jimmy-z's for sur-reality. By the end of the night, I knew I was in trouble, just not how much. Had I been dancing with my daughters, I wouldn't be walking now.'

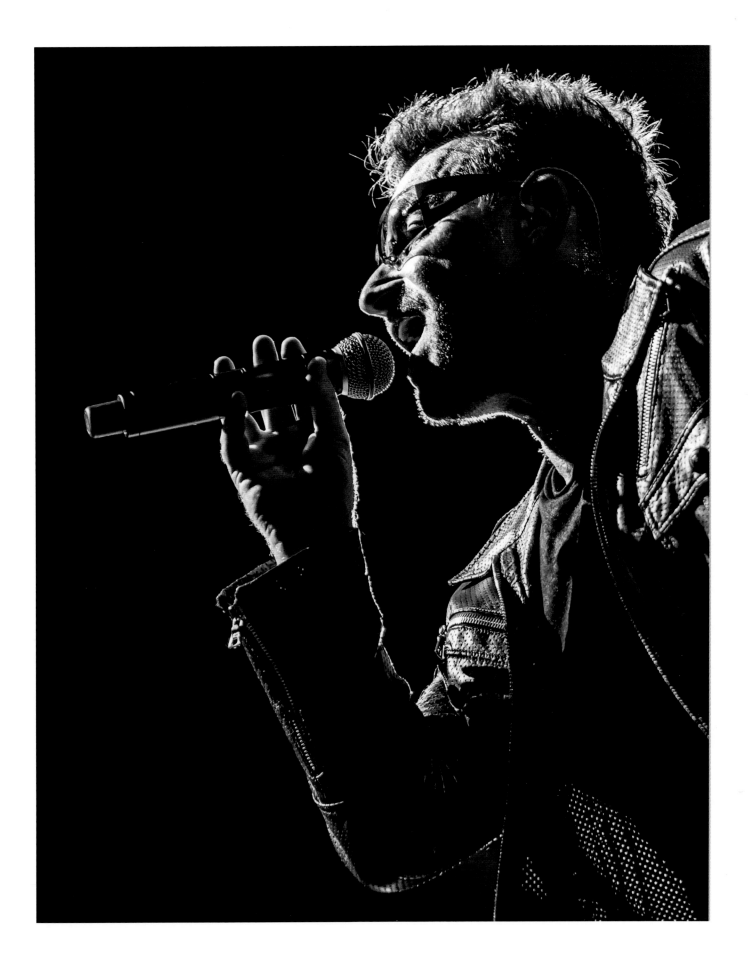

Now more than worried, the next day Bono sent himself off for an MRI scan, the results of which were sent off '... to these geniuses in Munich. And they came back and said, "You are in real trouble." They asked me if I'd lost the use of my left leg. Yes. Are you losing the use of your right? Yes. Don't move! Because two pieces of disc have broken off or gone down your spine, and if they sever your nerves you're in real trouble. The doctor made me aware that I needed a very serious operation, and that it wasn't without risk. I was terrified. I asked if there was a way of avoiding the surgery, and he said no, so I was in real jeopardy. It wasn't like it was just a slipped disc.'

It turned out that as well as a torn ligament, he also had a herniated disc and partial paralysis of his lower leg as well as sciatica. Days later he had emergency spine surgery at the Ludwig Maximilians University Hospital in Munich.

'I was asleep at my home in LA and I was woken by a call from Paul McGuinness at 5 a.m.,' said Arthur Fogel. 'He gave me the news. I was somewhat in disbelief for a period of time, then sort of calmed myself down and went into crisis management, got various people on the phone. We were already building one of the stages in Salt Lake City, which was where [the next leg of] the tour was going to launch. We had to put the brakes on at all kinds of levels; people were getting on planes, the Claw was being built, and we had to shut the whole operation down. And then over the course of a few days it became apparent that we were not only going to have to postpone a few shows, we were going to have to postpone the whole tour. Then came the reality of, "Well, how do we put this thing back together?" because of weather issues we had to wait a year, which is a very long time to postpone. So

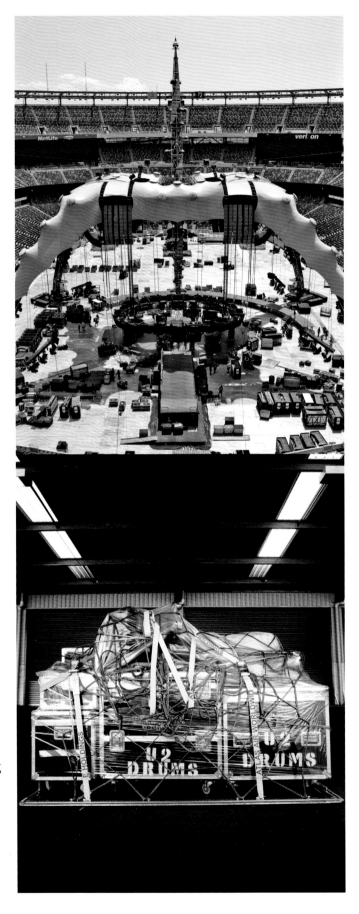

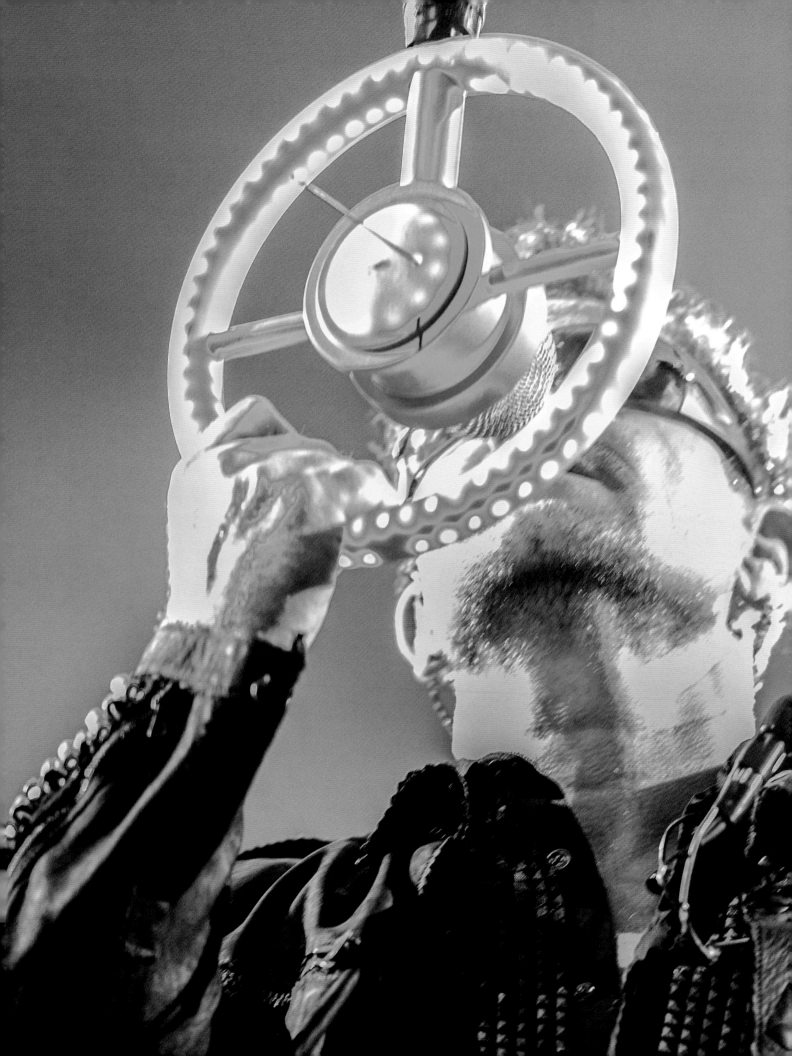

myself and my team put together an itinerary that included all the shows we had postponed. We had to make a few changes based on certain things with band members, but we got it all back together. We ended up putting in six new shows. We wouldn't have necessarily got to South Africa if it hadn't been postponed, so we certainly got the window to go there. But it was a very difficult time, it was Humpty Dumpty time.

'The insurance issues were huge. Obviously the tour was well covered, but it didn't make it any easier to work through with insurance adjustors and brokers and underwriters. Basically, we had to build a claim and then submit it and haggle back and forth. The interesting dynamic was that we have two levels of insurance. One covers all lost cost, and the other is revenue shortfall. So in practice, let's say the show we're playing in New York, let's say last year it would have sold 70,000 tickets and generated a gross of X. This year's show, as a result of refunds, would have ended up at 65,000 tickets. We're able to claim the 5,000 ticket shortfall. So there's a revenue shortfall component and a lost cost. We had relatively little issue on the lost cost portion, and oddly, most bizarrely for me because I've never seen this before, the level of refunds from last year to this year was about eight per cent, which is phenomenally low. The norm would be – if someone cancelled a show today for illness and rescheduled it maybe two months from now, you'd be looking at fifteen to twenty per cent at least. If you assume that people bought their tickets six months before the previous summer, you're talking about someone who's laid out the money eighteen or twenty months ago, and only eight per cent of the people refunded. So there ended up being no claim on the revenue side.'

Crucially, Bono's injury didn't increase the

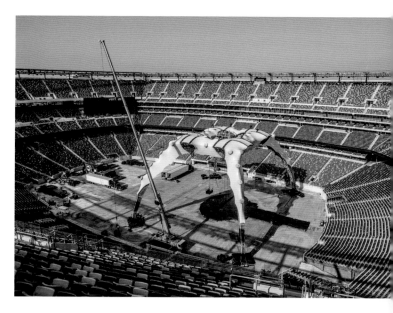

insurance premiums, but it did introduce the reality of additional exclusions. Like having a back problem.

Immediately following the surgery, Live Nation announced that the third leg's opening concert in Salt Lake City, which had been scheduled to take place on 3 June 2010, would now be postponed to a later date, with other dates also potentially being affected. Bono's doctors included the famous sports physician Hans-Wilhelm Müller-Wohlfahrt, a physiotherapist who has worked with Bayern Munich, Usain Bolt, Ronaldo, José María Olazábal and the German World Cup squad, and who said that Bono would need eight weeks of physical rehabilitation. The remaining dates were then cancelled, the entire North American leg postponed, and on 13 July it was announced that the tour would start again in Mexico City on 11 May the following year.

So Bono convalesced, lying in bed, staring at the ceiling. And he got creative. Read books – 'Books I would not normally have the time to read' – books about Iran and Afghanistan. He listened to music. Listened to the National, listened to a lot of Leonard

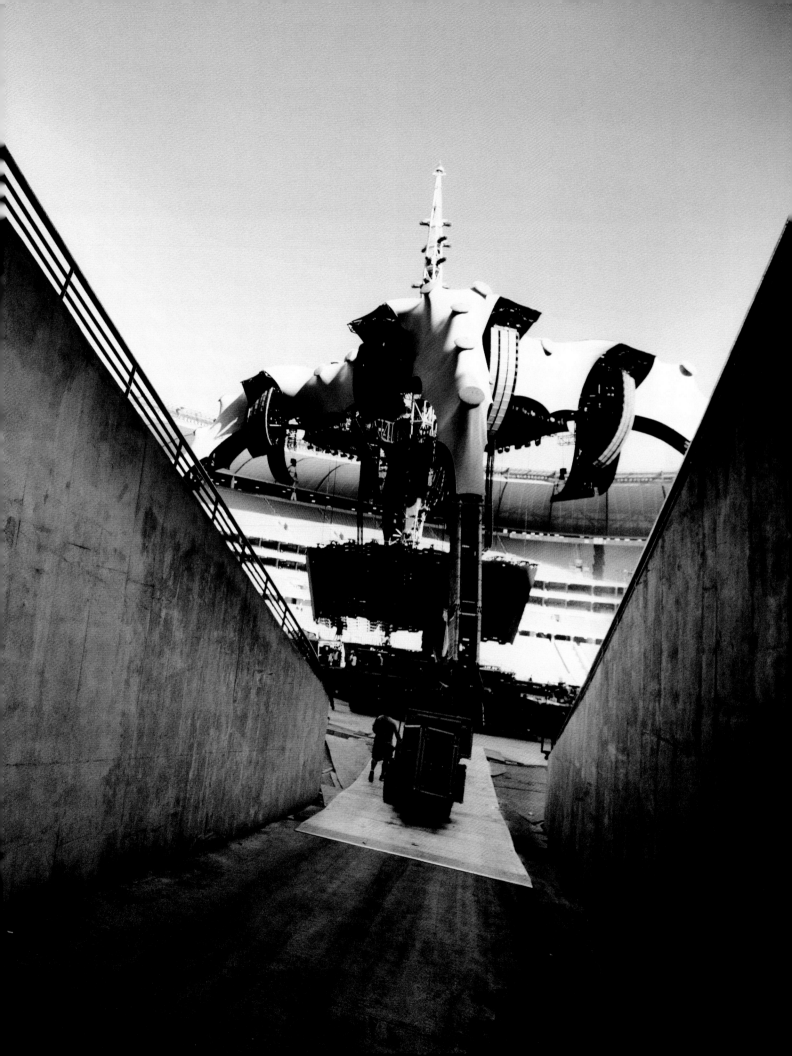

ten beautiful, almost religious songs.

The interruption was also complicated by Spider-Man: Turn Off the Dark's faltering performance on Broadway. The previews were playing to packed houses, yet the critics had grown so irritated at its inability to officially open – when would it be finished? – that they had started reviewing it, even though it wasn't ready. And they hadn't been kind.

'Spider-Man was not supposed to be going on, but it just wouldn't go away,' said Bono. 'It kept changing shape. Weirdly, Spiderman actually improved our songwriting. It was incredibly disciplined. I mean, there's a reason why the Beatles became the Beatles. It was because they were locked up in the American songbook and musical theatre.

Paul McCartney told me they got better paying gigs in Liverpool if they could play songs from musical theatre. Rodgers and Hart, Rodgers and Hammerstein, all of that. You look at the structure of the Beatles' music and you think, how did they know those chords, where did that come from? A lot of it came from musical theatre, and indeed English music hall … quite a ways from rock and roll.'

He was soon back at work, doing three hours of physio a day with Müller-Wohlfahrt, along with one of his team, Klaus Egger, a former ice hockey player who also helped train the German football squad. He gave the singer one of the most excruciating workouts of his life. 'He could break your neck with one finger,' said Bono, flinching at the memory. 'I've been beaten

Cohen. And – crucially – he wrote music. A lot of it.

'It was amazing to be on my own for such a long time, and I really thank God for it. Honestly, what do you give a person like me for their fiftieth birthday? Well, this gift, this blessing, was being given three weeks on my back. It was a great gift. We were living in New York at the time, so Ali took the kids back to New York and I was living on my own in France. And it was a wonderful abandoned place to be. I think these songs, when they're finished, will have been worth all the pain I went through, writing them.'

Ah yes, the songs. Not only did he hit a creative seam, but Bono's resourcefulness eventually resulted in the band recording a lot more songs while on tour than they had ever done before. Much to the band's annoyance, Bono started telling the press they had four albums under their belt, saying he wasn't sure which one they were going to release first. There were at least forty Spiderman pieces, at least twelve songs from the Danger Mouse sessions, and a bunch of sessions recorded with RedOne (eight with words) for a club/futuristic dance album, as well as the partner album to No Line On The Horizon, called Songs of Ascent, containing eight to

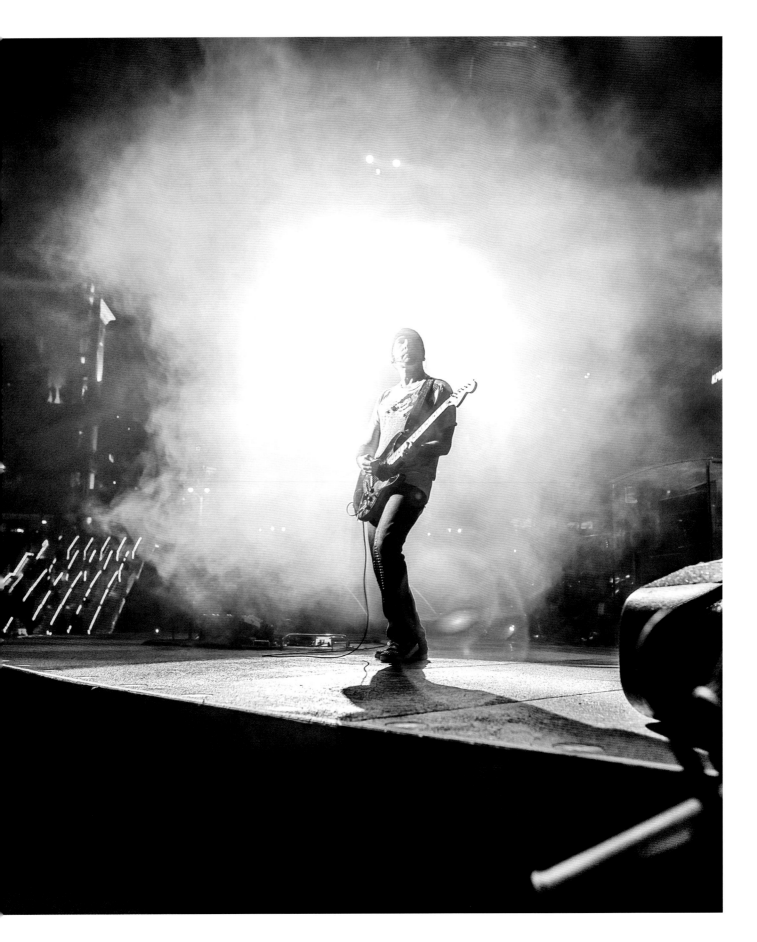

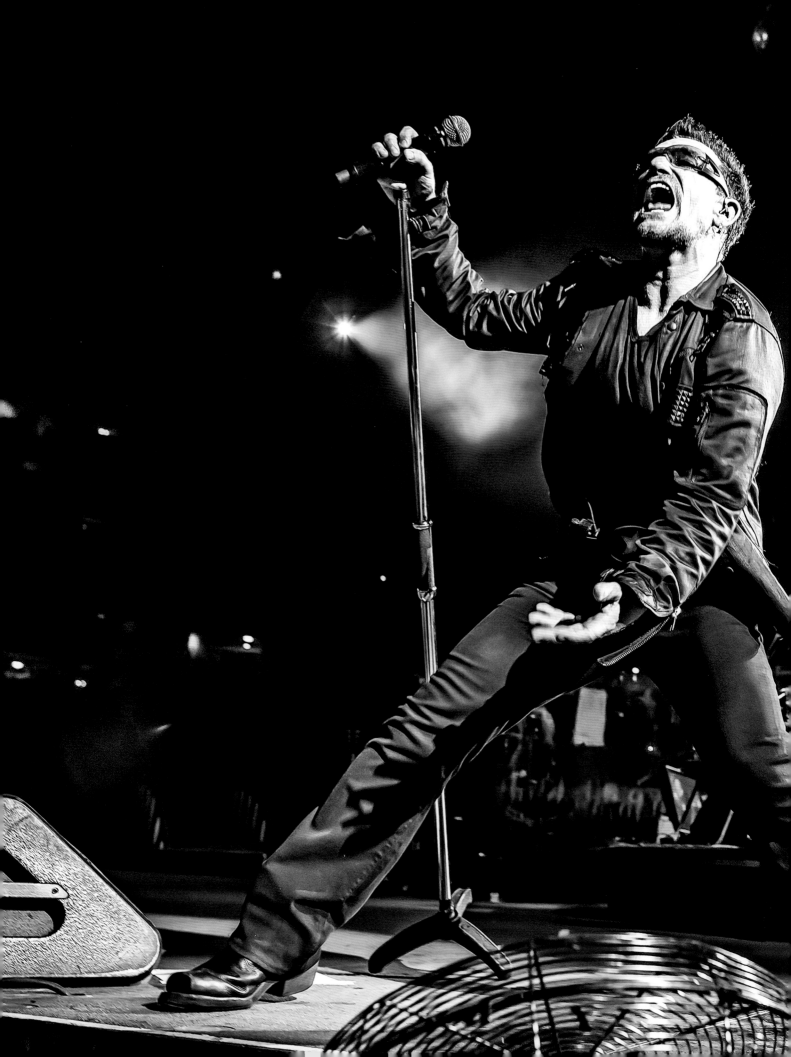

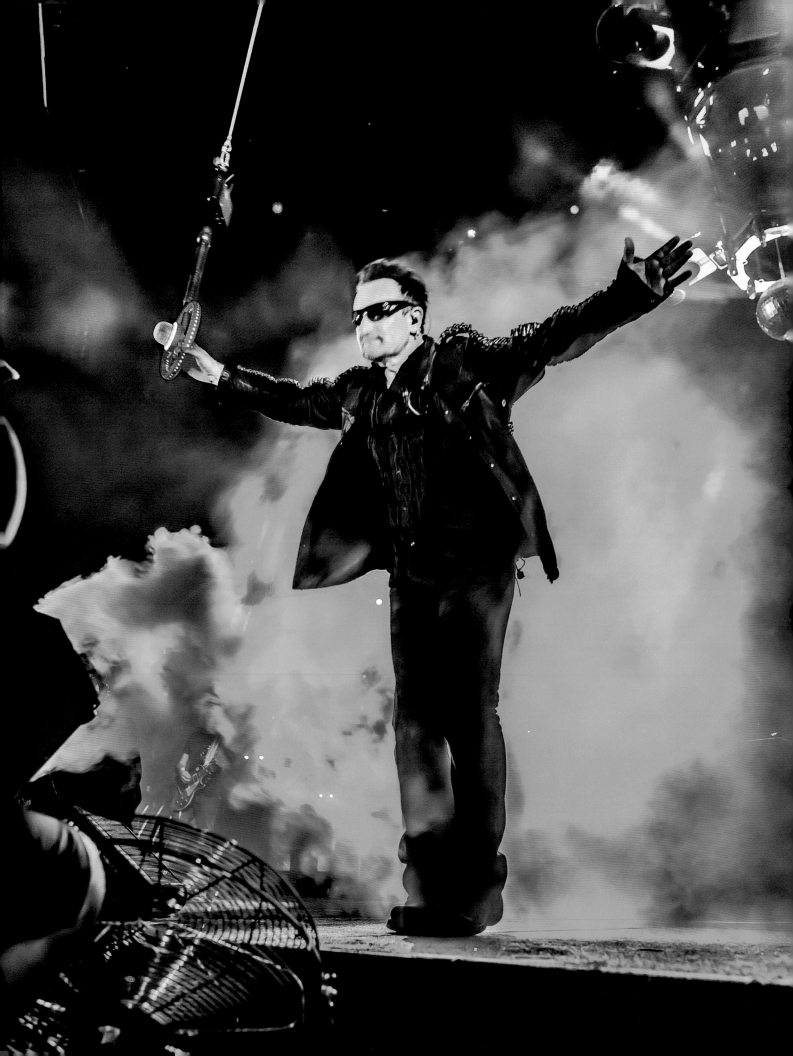

by iron bars, I've been shot at, I've been in a lot of situations in my life, but I've never felt more fear than facing Klaus Egger. Klaus is a genius, probably the greatest physical therapist on earth. When the German football team went to the World Cup they have a heart surgeon with them, a brain surgeon, two psychiatrists, a food therapist, and Klaus. The German football team is unbelievably good for a reason.'

Usually, boxing is one of the few things that can get Bono fit. He needs to get in shape in order to deal with the onslaught of constant travel and performing. And as he gets bored in the gym, the combative nature of boxing keeps him alert. This time was different, though. 'I had to think completely differently about the way I did physical fitness, about how I stood up, walked, sang ... I had to completely rethink the way I perform. When I came back I noticed that I'd become much more rhythmic because of the surgery, the convalescence and the exercise. At the age of fifty I finally learned how to be a Latin American.'

For the rest of the tour he would have an elliptical training machine set up in his hotel room.

He had to practice singing, too, using his diaphragm in a completely different way. He had started to sing 'Miss Sarajevo' on the tour, even attempting Pavarotti's parts, and the exercises he performed when he was off actually helped him get to grips with it. 'You have to sing that song from way down there in your gut. And that's one of the things I did when I was practicing, so hopefully my singing has become a little better than it was before I got broken. It's weird. You think, how can that hurt? Running hurts, not singing. But it does.'

Ten weeks later, on 6 August, U2 were back on stage, in Turin, with only another 65 dates to go.

'I am now Bono 2.0,' said the singer. 'Through the wonders of German science, I'm not just fixed, I'm better.'

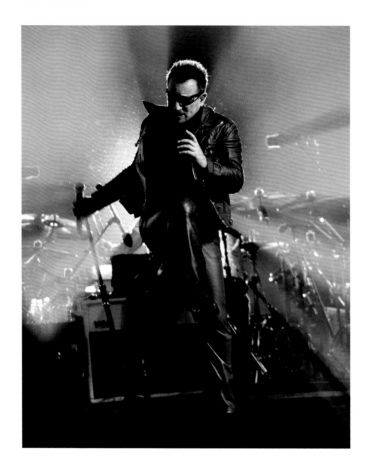

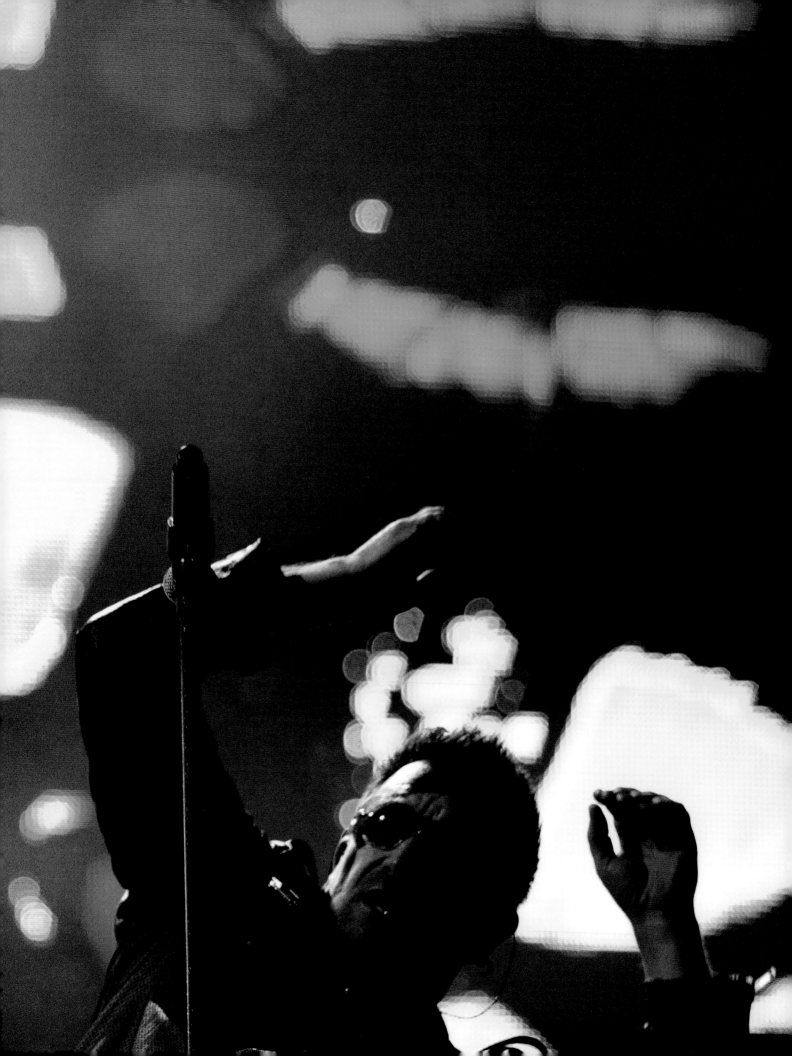

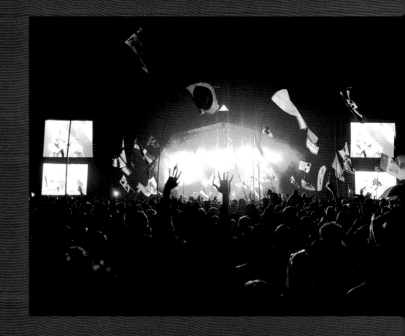

IT'S ROCK 'N' ROLL REDUX:
# GLASTONBURY 2011

Chapter Four

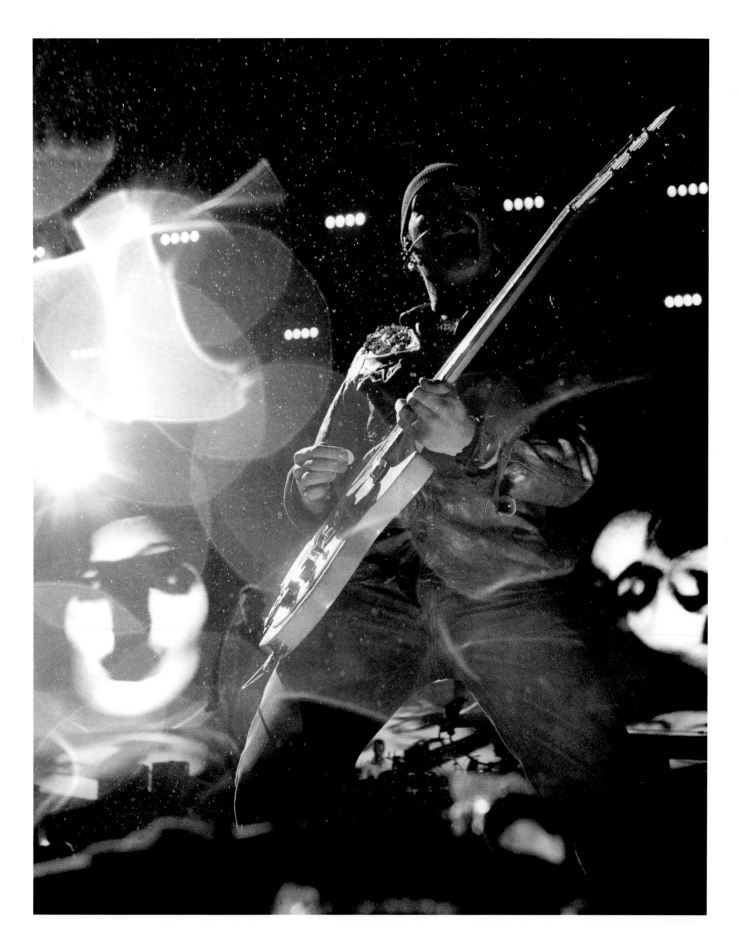

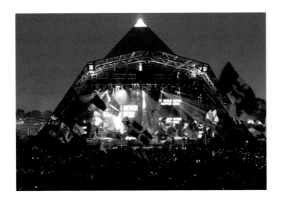

This Was The Three-Birthday Tour, Starting In The Summer Of 2009 And Eventually Finishing In The Autumn Of 2011, Taking In North America, South America, Russia, Europe, Australia And Most Points In Between. In The Spring Of 2011, The Band Played In Turkey, In Istanbul, The City Where East Famously Meets West.

# 'LOOK AT YOU, A WHOLE CITY IN THE RAIN!'

*— Bono*

**Pulling out of the 2010 festival due to Bono's back surgery was never going to be easy, and the pressure of their appearance a year later became all-consuming. Interrupting the last leg of the North American section of the tour, and at a cost of over two million dollars, the band flew from Baltimore to Cardiff, braced for one of the biggest weekends of their careers.**

Friday 24 June 2011: 'Welcome aboard,' said Edge, as we passed each other in the hall. I had come to learn that this is what the band said to everyone who climbed unsuspectingly onto the rocket ship that was 360.

On Friday morning in the Royal Crescent Hotel in Bath, where most of the band, management and crew were staying, Hunter wellington boots started to be distributed. One of the rooms in the hotel basement had its entire floor space covered with black Hunter boxes, which were delivered to bedrooms with instructions as to what to do if they didn't fit.

Ken Friedman, who owns the Spotted Pig restaurant in New York, along with Paul McGuinness and Jay-Z, was having trouble finding boots to fit his size-14 feet, and so he dispatched himself into town to try and find a pair (successfully, as it happened).

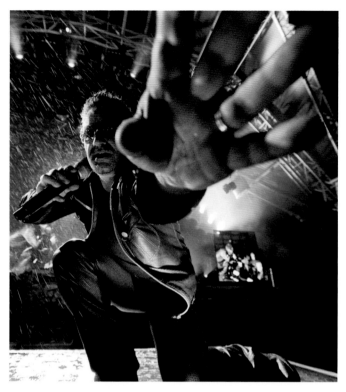

Everyone I spoke to appeared to have an opinion about the weather, as the ubiquity of phone apps allowed everyone to be a secondhand meteorological expert. The consensus appeared to be that it was definitely not going to rain. Unless it did, of course. There had been a party at Alan Moloney's house, the Irish film producer and a friend of Damien Hirst's the night before, outside Bath, and the discussions there revolved around whether or not the band should play 'Get On Your Boots', in case the crowd started belting the stage with them. Edge thought this was a stupid topic, as why would people want to get rid of their boots? Even if Michael Eavis was claiming that there wasn't any mud on site. Bono didn't seem to care either way, as he was too busy go-kart racing while playing air guitar to Bruce Springsteen and Iggy Pop

records: 'Born to cycle, born to recycle!'

At breakfast, band and crew members were still discussing the importance of President Obama's much-anticipated prime time address in Washington two days before, in which he had laid out the beginning of the US drawdown in Afghanistan, assuring the nation that 33,000 US troops would be pulled out by the autumn of 2012 – with 5,000 being pulled out immediately, and another 5,000 leaving at the end of 2011.

There was a weird sense of calm, yet everyone knew that this was one of the biggest days in the group's career. If the band performed well this evening, their equity would rise, the papers would be kind, and the previous year's cancellation would be considered an irrelevance. If they didn't, even though

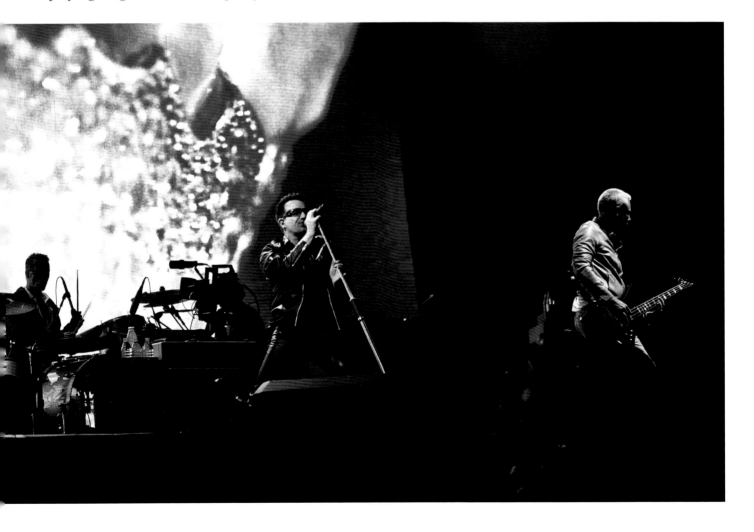

it was costing them two million dollars, well ...

'The shortfall is huge, but it's a special occasion,' said Paul McGuinness, in one of the hotel's living rooms. 'We're doing it for the love of it, or something like it; for complex reasons. In the early part of the band's career, in the eighties, we used to do festivals in Europe quite frequently, and we were very good at them. And then in later years the festival phenomenon altered, it changed. Festivals are the antithesis of everything we do normally. We build an environment sonically, visually, with video, and we produce an amazing show. The idea of going into a situation where you're using someone else's lighting, the same ones as all the others acts, the same sound system, well, the aesthetics of festivals are pretty poor. So we spent two decades playing to people who like U2, and then we've gone to all this trouble to find some people who might not.'

At 2 p.m., everyone began descending on the front desk, ready for the drive or the flight into Worthy Farm. John Cleese and wife, who sometimes live next door to the hotel, got caught up in the melee, but appeared oblivious to the Star Chamber around them. The band was driven to a nearby cricket pitch, where the helicopter was waiting to ferry them in. Once aboard, Bono sat wearing his trademark shades and customary green peaked cap, sandals and stubble, looking like a *Saturday Night Live* interpretation of a South American revolutionary. He sipped Perrier while Adam read the *Daily Mail,* Larry flicked through the *Daily Telegraph,* and Paul devoured the *FT.* 'I hate commuting,' said Edge to no one in particular, lounging on his leather baby shit brown seat. Although he has a Kubrick-like attention to detail with all things sonic, he often has the air of

a dreamer about him, which makes him very good company.

As they arrived, a cricket match was in full swing, but stopped as the heli loudly moved off the ground. 'That's just not cricket,' said Bono. As we

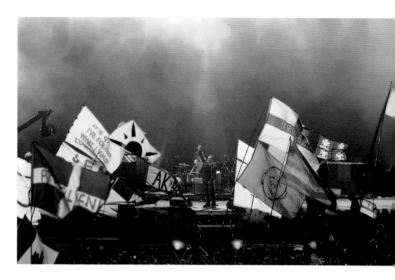

swung across the fields I turned to Paul McGuinness and asked him if he ever worried about the band all flying together, and he looked over his glasses, gave me an old-fashioned look and said that it had crossed his mind. 'My father, who was an RAF officer, asked me once if I used helicopters when I was a film assistant director before U2, and when I said that I actually used them rather a lot, he said that I should be careful as they were only designed to be used in emergencies. So actually I try not to think about it.'

Twenty minutes later they were at Glastonbury, where the band were busied into black Range Rovers, and driven through the mud and the throng to the VIP backstage area. Backstage at Glastonbury is grim, and far more corporate than you might expect. While the so-called VIP area behind the Pyramid Stage was simply half a dozen dilapidated beer tents in a field, the band quarters in the lean-to

adjacent to the stage looked like the reception area of a light industrial centre. It was so nondescript you wouldn't have been surprised to see David Brent make an appearance.

Touring is like travelling without travelling.

it had been assembled, rather quickly, about forty years ago. There was a production room, wardrobe, a Quiet room, a masseuse and a dressing room for each band member, so the amenities were fine, it was just the aesthetics of the place that left rather

The band, as well as all the crew, have to clear their mind at every new venue, as the backstage matrix is always so very different. You see crew members thinking they've walked into a parallel universe as they walk to catering only to find an empty cafeteria. At each venue the backstage is exactly the same but completely different. But not Glastonbury. No, the backstage area at Glastonbury looked as though

lot to be desired.

Backstage, promoters, record company executives, agents and managers sat around in catering, drinking the stale coffee, sheltering from the rain, and bitching about being there in the first place. Most of the derogatory comments were reserved for Morrissey, someone who appears to be universally loathed in the industry, although

mostly the conversation was full of tacit respect for many of the groups playing over the weekend. 'The great thing about Glastonbury is the way that it can change a band's fortunes,' said one promoter. 'One day you're a new car, then you become an old car, and then, a few years later, if you haven't died, or split up, you become a classic car. If you stick around long enough you'll become a legend. There are a lot of legends here this weekend.' The BBC's Alan Yentob was mooching about, as entertaining as ever, collecting as many different backstage laminates as possible (so far he'd managed to acquire a backstage laminate and three wristbands, yellow, green and blue, which allowed him access to different parts of the site). Stella McCartney and her husband Alasdhair Willis had been driven down from their home in the Cotswolds for the gig, as had Kate Moss.

Paul McGuinness spent half an hour in his office making calls to the US, firming up certain points regarding the dates at the end of the tour. As always he used his trusty Nokia, a relatively ancient mobile that a lot of people use because of their almost brutal functionality (Sir Philip Green uses the same phone for the same reason). 'It's so simple,' said Paul. 'It dials numbers, it remembers numbers, and it texts. And that's it.' So many people in the music industry use them that Paul had his name stencilled on the back to stop it being pocketed by mistake at meetings.

And it was still raining heavily. One of the defining characteristics of any tour, let alone a tour of this size and length, is boredom, which is when gallows humour rears its severed head. Whenever the wet weather came, and the 360 world got even more surreal than it already was, so the walkie-talkies would be full of references to a totally new

set of songs. This was certainly true at Glastonbury: 'Even Wetter Than the Real Thing', 'I Will Wallow', 'Get On Your (Wellie) Boots', 'Mudnificent', 'Moisterous Ways', 'Portaloo', sung to the tune of 'Waterloo', etc. (Ironically, when I had asked Adam what the salient difference was between playing at a stadium today and a stadium twenty years ago, he said, 'Twenty years ago it was much more like a festival; people weren't that familiar with them and they didn't have high expectations. And now they want production values.')

Bono often says the goblin in him comes out when it really needs to. But would he come out for Glastonbury? 'There is a script and a plan and I hope they stick to it,' said Paul McGuinness. 'But Bono has a habit of not sticking to it. But as one of those times was Live Aid, we tend to forgive him, as he usually gets away with it.' 'It will have been worth it if the vibe turns out to be good,' said Arthur, 'but we have to wait and see. The press give them a hard time in Britain.'

'I've been chasing that lot since 1979,' said Glastonbury organiser Michael Eavis excitedly the day before. 'I thought I was going to get them to play all those years ago – until I realised the man I'd been talking to wasn't their tour manager as he claimed to be! So when Bono phoned [my daughter] Emily to say they were in for last year, we were all over the moon. But then with his operation, he phoned me from his hospital bed and said there was no way he could perform. He sounded genuinely sorry. We were upset for him and upset for everyone too. I asked him would he be up for it this year but he said, "We'll see." He wasn't sure what U2 would be doing then or if they'd be touring so when he got on the phone to say he'd love to do it, we were all thrilled.'

Weeks before they were due to appear, Larry said, 'Everybody has a view on how it should go. There's the "Where The Streets Have No Name" camp and there's the more subtle approach – the Achtung Baby dynamic approach where you build slowly. Then there are those who think we should open with "40".'

However the set list was being worried about years previously. Eighteen months before Glastonbury a set list was devised which was basically a three act play. Act I was all the eighties stadium hits, so ostensibly they would come out on stage and do Glastonbury on Glastonbury's Terms. It was going to be 'Streets' into 'I Will Follow', 'New Year's Day', 'Still Haven't Found', 'Pride' etc. Act II was going to be Zoo TV. They were going to re-stage the first half hour, with all the video sequences on big screens, so the audience wouldn't quite be able to believe what they were witnessing. The final half hour was the present, the chunk of the 360 show, with 'Beautiful Day', 'Elevation', 'Vertigo', etc. As time went by the band began to question the format, partly because they had got used to the idea and also

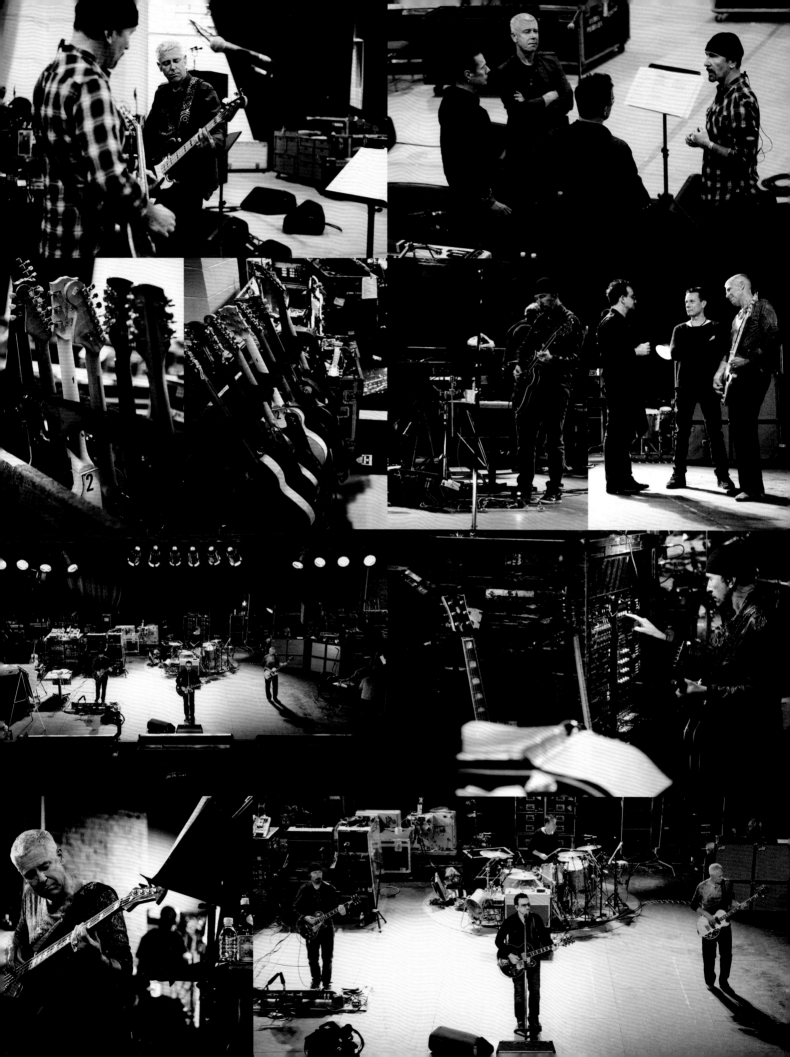

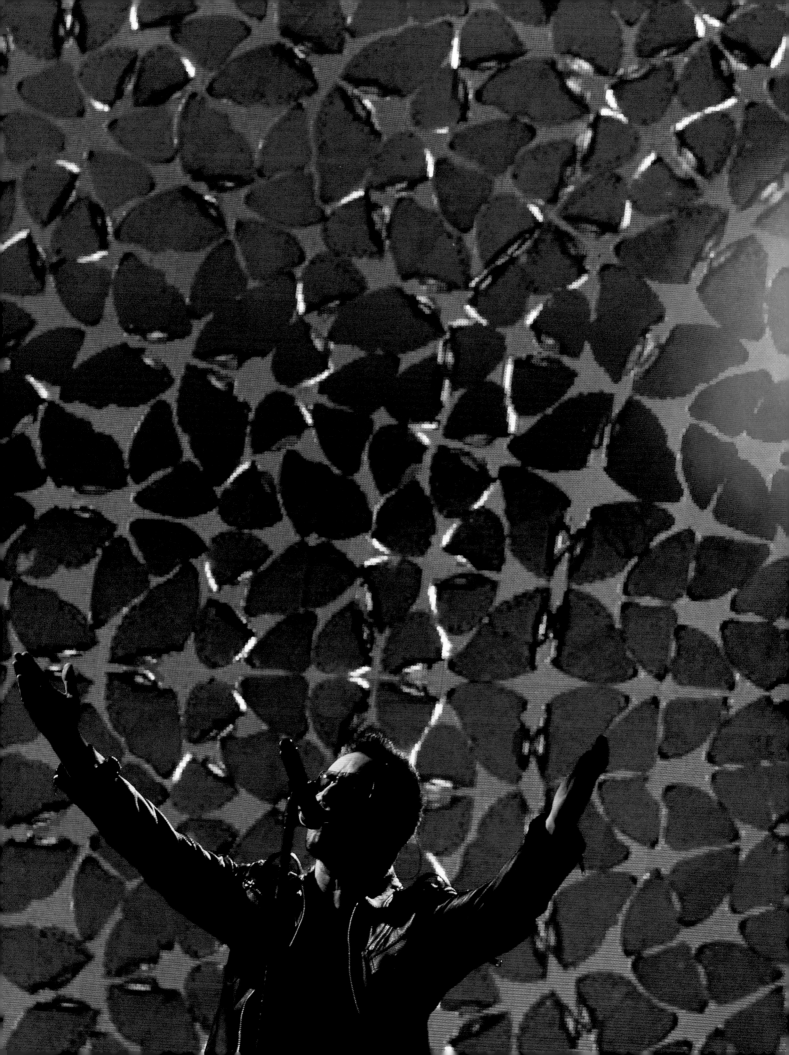

the rumour mill was working and there was a strong suspicion they might open with 'Streets'.

Uncertainty reigned for about six months, largely because they were on tour and Glastonbury was very much in the background. And then during the course of the 360 tour various things happened. Not least the reworking of 'Real Thing', which was so strong that it ended up opening the show. Then the question came up, 'Well, if it's good enough to open this show, maybe we should open Glastonbury with it?'

But they also realised that if they were going to open with 'Real Thing' they needed a very strong visual for it. And so Bono said, 'I'll text Damien.' The phrase 'Even Better Than The Real Thing' could be Damien Hirst's motto and he was up for making a video piece for them. The process was a bit of a roller coaster ride but in the end he delivered in spectacular fashion.

They work with a lot of artists and designers in making video content but working with an established fine artist is a very different dynamic. They present their vision as a self-contained idea so altering it to work within the parameters of a live show can be very difficult.

Eventually Hirst delivered an extraordinary piece of video. What was wonderful about the piece was that he clearly understood the structure and narrative of the song and the edit is fantastic.

In the end one of the power cables blew on the night, meaning that the live feed from the camera shooting the band wasn't working, which meant that the Glastonbury audience could only see Hirst's work and no IMAG, which, ironically, probably made the whole thing more powerful.

The set turned out to include everything from the irony-free stadium rock of the eighties, and the 'French-disco-variety U2' of the nineties. All of it.

This was Glasto Baby, Achtungberry.

At 9.30 that night, after Morrissey's set, under gun-metal grey clouds, and in front of in excess of 50,000 people, the band took to the Pyramid Stage and bashed through a greatest hits collection almost without blinking, beginning with five songs from Achtung Baby and including their debut single, the post-punk 'Out Of Control'. The lean, combative set was a truncated version of the 360 show; shorter, more aggressive, and more reliant on stagecraft than pyrotechnics or light shows, and was interspersed with snatches of Destiny Child's 'Independent Woman', Primal Scream's 'Movin' On Up', Joy Division's 'Love Will Tear Us Apart', Coldplay's 'Yellow' and an a cappella version of 'Jerusalem', followed by some Grade-A 'Bongolese,' the unique form of scat-improvisation spouted by the singer when the band are sketching out songs. 'It's not often you hear an Irishman singing "Jerusalem",' said Bono. 'Could be the ley lines, could be the jet-lag, but it's a very special feeling being here.' He introduced the band variously as Sir Galahad, a sorcerer, and Friar Tuck. Behind them the specially commissioned Hirst video added to the surreal nature of the show, although their performance was a black-and-white short compared to the Technicolor epic of their stadium show.

Tonight, as on most nights, Bono had been running his banter by some of the crew. This has stood him in good stead. At the Perth show, for instance, in December, Bono had wanted to say something about the Ashes, but as he knows as much about cricket as he does about under-statement, some research was needed. Against the odds, it worked, and the audience appeared to love Bono's chat, even if he had no idea what he was talking about. On stage in Seattle in June, in an eloquent and unscripted moment, he said the city looked as though it had just come out of the washing machine and been hung up in the sun to dry.

'We had bottle at Glastonbury,' said Bono, when I asked him about it a few weeks later. 'Even though it was really tense, we had bottle and we threw ourselves into it. It was slippery and raining but we went for it. You go to Radiohead for melancholy – it's beautiful, with lovely purple passages, blues, violets … and you go to Oasis for something earthier. But we've got as much bottle as anyone, we've got as much intimacy, as much delicacy … and it's the dimension that I'm most pleased about concerning Glastonbury. It was a little heavier on the attitude than we're normally used to delivering, but the place required it.'

Even those members of the press who find it hard to indulge the band agreed that it was a fierce, and largely successful performance. After the weekend was over, some felt that Coldplay's Saturday night performance had been more exuberant, and that Beyoncé's show was more surprising, although no one could fault U2 for their passion and energy. Watching from the side of the stage, what was most impressive was the way in which the band interacted with each other, spurring each other on, looking not unlike they did thirty years previously, huddled together on small stages, desperately trying to appear bigger than they were.

Adam was sanguine about the event. 'I've been to better Glastonburys in terms of weather, and nothing really prepares you for the effect of that sort of weather on everyone,' he said. 'It makes everything so much harder. Whereas I was going into Glastonbury with that spirit of, "This is going to be great fun, everyone's going to have a wonderful party weekend," it sort of turned into the Battle

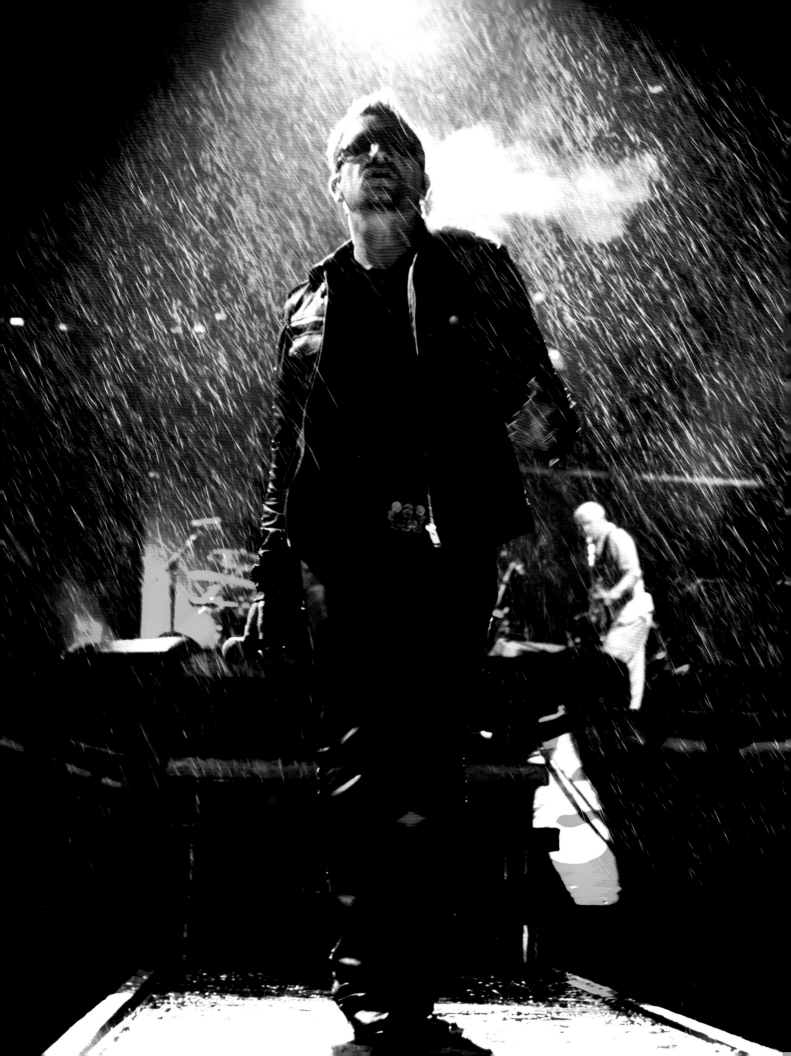

of the Somme. That was a dampener, but then if I think about it we've always been pretty good in the rain. We've done a lot of our best work in the rain, so maybe of all the bands that were going to have to deal with those conditions maybe it was the best spot for us. It was nerve wracking; Larry's already gone on record saying that the stage was a long way from the audience, or the other way round. There was a big gap because of all that TV production stuff and that was a bit of a shock to get used to after our own stage where we're really very close to our audience. It was hard to go straight from our own American tour, but you just adjust to it; you do the best that you can.

'As for the performance, I think we were a little bit on the back foot because of all those things that I've said and that really made it difficult to connect with the audience, so it felt like there was a bit of a void.'

Edge had performed the previous year with Muse, guesting on their version of 'Streets', so was slightly more aware of the different dynamics. 'You really go very much on instinct in a situation like that. You can't really prepare when you're suddenly on a completely new stage ... everything's different, it's not even your audience, so it is a little bit gladi-atorial. You have to try and find a way to connect, keep the energy level at maximum – in doing that you break through some of the barriers. You never know in a situation like that whether the sound is going to be optimal ... certainly the lighting and the video reinforcements can't possibly be as good as they'd normally be because everyone is flying by the seat of their pants. So you have to assume the worst and go in there to try and blast it out with the energy of the performance. I think that Bono was a little uneasy. Normally at the end of songs, he'd vamp for a while. There'd be longer gaps. There'd be a slightly cooler tempo to the show. But

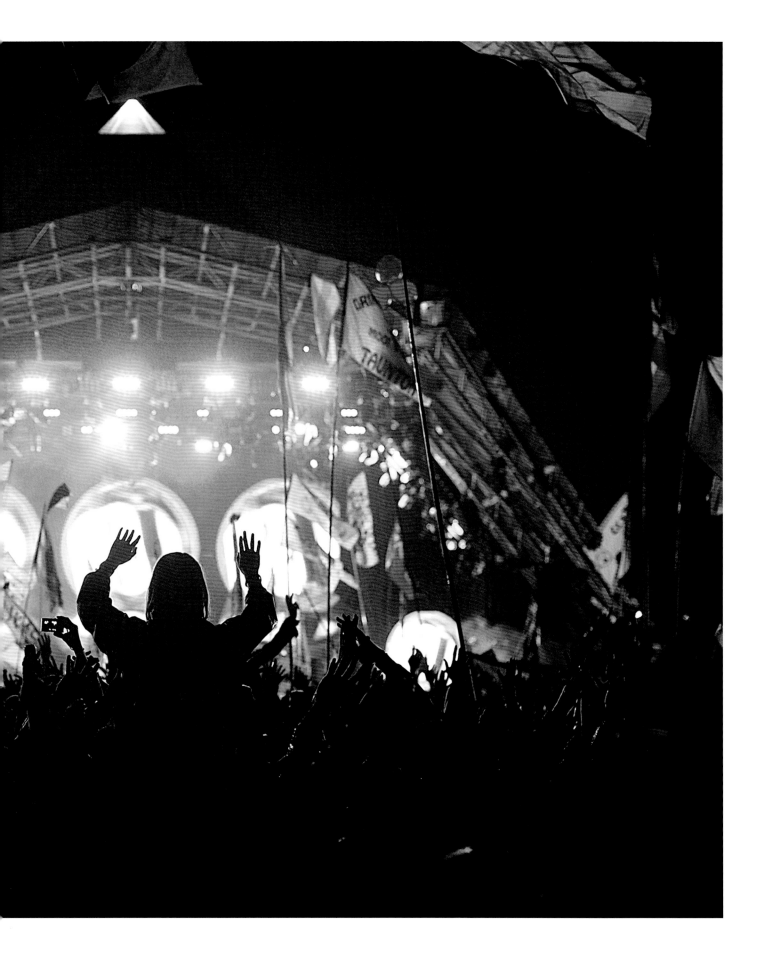

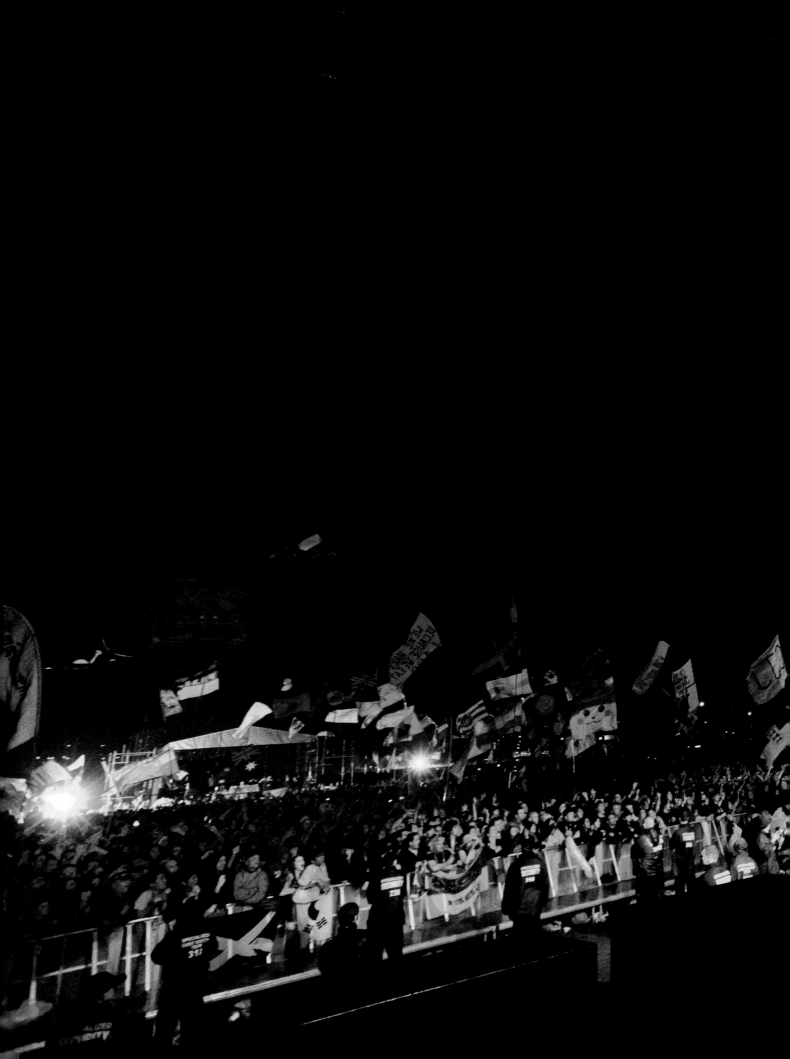

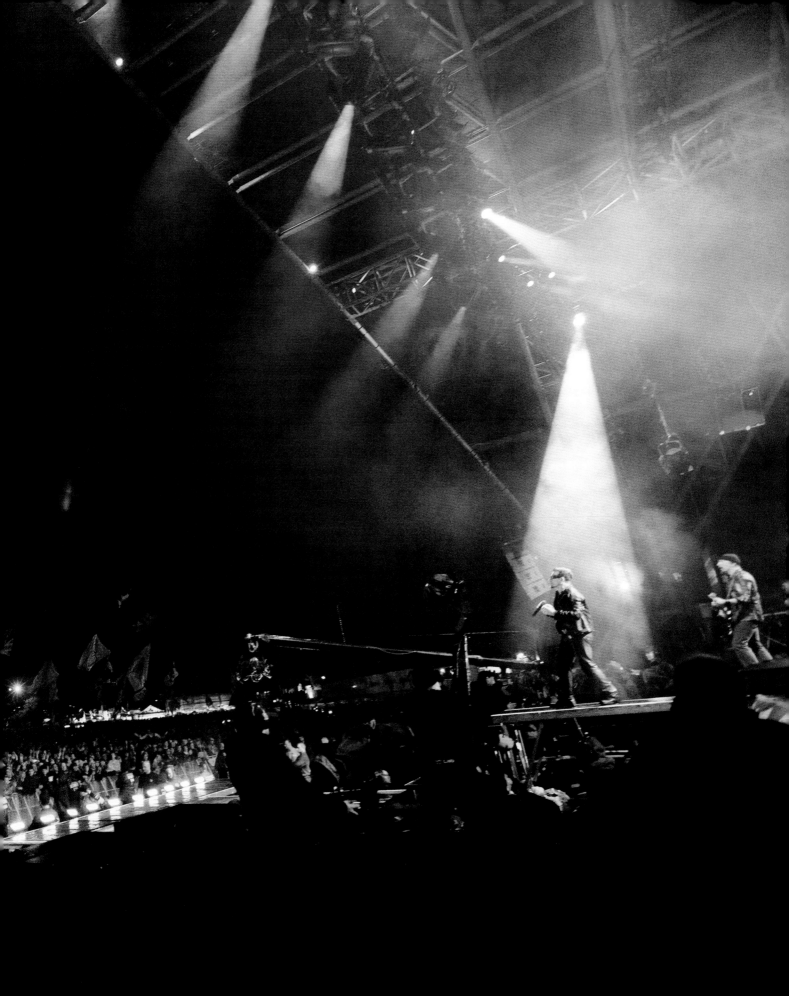

at Glastonbury it was "Bam! Bam! Bam!" He just didn't want to take a second to allow the energy to drop, and I think it was great.'

Long-term U2 producer Steve Lillywhite gave the performance a seven out of ten. As he scooped roast hog off a paper plate at the tented aftershow party he said that their biggest mistake was not playing 'New Year's Day' instead of 'Get On Your Boots'.

When the Rolling Stones first toured North America, they were striving to make gymnasiums flower with passion. With U2 the experience for both band and audience was always about communion.

For the band, Glastonbury was one big connection. The reason they were here in the first place. 'Ever since the eighties we've been trying to change the live experience,' Bono told me. 'All of that climbing on the speakers, that's all about me. About smashing the barrier between the audience and us. It's about a definition of performing, but what is a performer? When I go to see a play, or a gig, the great performances for me are the ones that involve getting down in the aisles, walking among the crowd, who get in your face, make love to me, you know – getting involved. They're not content with this space on stage. They try and get rid of the distance between the audience and the stage. You want people to walk off stage straight into your head. And it's about emotional proximity as much as physical proximity. It's about the emotional connection.'

One of the most exhilarating parts of any U2 show is the moment following the finale, when the band – having finished their pas de quatre – rush from underneath the stage to their cars, which then rush at speed back towards an airport or hotel. These moments, when you're surrounded by dozens of security guards, with the heightened

and occasionally fearsome roar of 100,000 fellow travellers in the background – spent, hoarse, momentarily sanctified – are when you get a true sense of the bubble that the band live in, when the real and metaphorical distance between them and everyone else – the audience, the crew, even their families – is most apparent. This is a sensation amplified by the motorcade and the sirens of the outriders that follow. For a civilian it is nothing short of visceral, so imagine what it feels like for the band. Not only is all this fuss just for them, but also

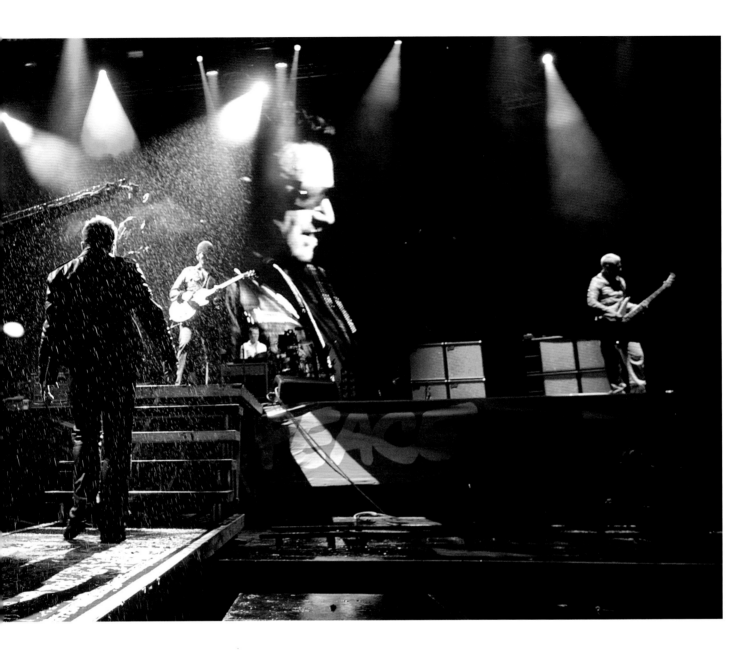

they experience it three or four times a week.

After the Glastonbury performance, some of the band were choppered back to Bath, one was driven, and Bono stayed the weekend, helping to celebrate his wife's birthday (she had a Winnebago for the entire festival, and was having what could only be called a VIP, laminate-only, access-all-areas girls weekend).

The filmmaker Davis Guggenheim was also at Glastonbury, shooting footage for *From the Sky Down,* the documentary celebrating the twentieth anniversary of Achtung Baby that Paul and the band had commissioned. Best known for Al Gore's *An Inconvenient Truth,* and *It Might Get Loud,* the music documentary starring Jimmy Page, Jack White and Edge, Davis had spent well over a year on the project, interviewing the band, following them hither and thither, and trawling through a vast amount of unseen archive footage. U2's appearance at Glastonbury was going to top and tail the show, and he had been here for days.

His abiding memory was 'My son and I trying to

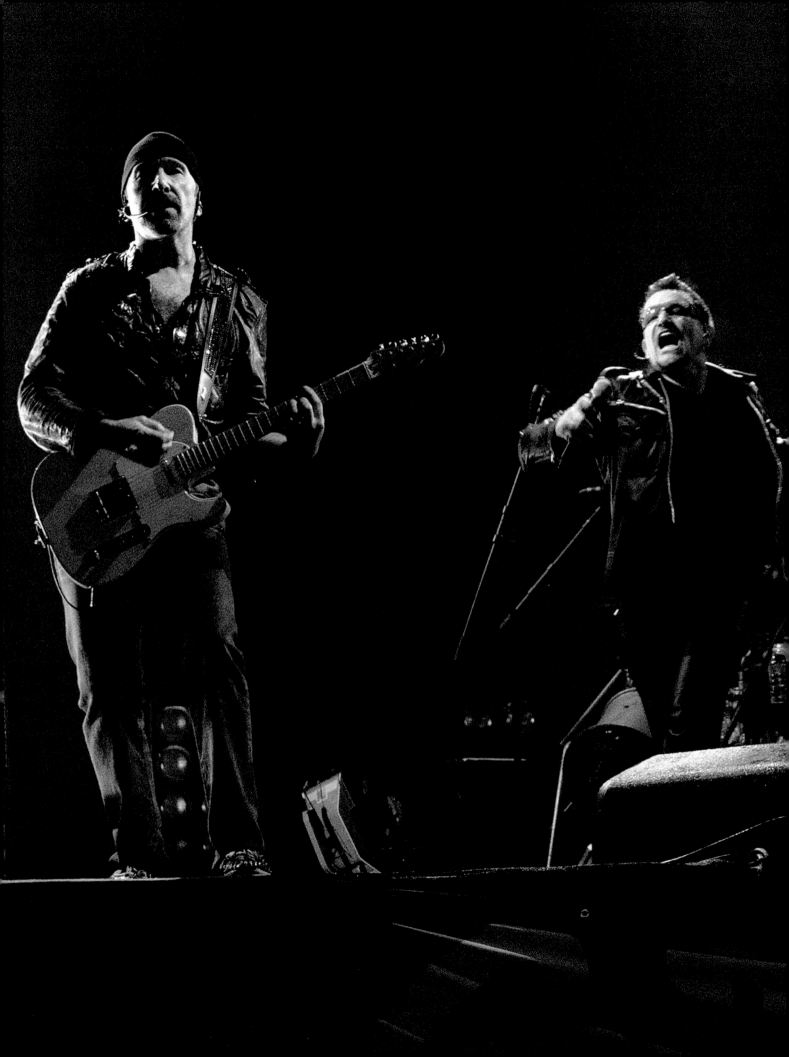

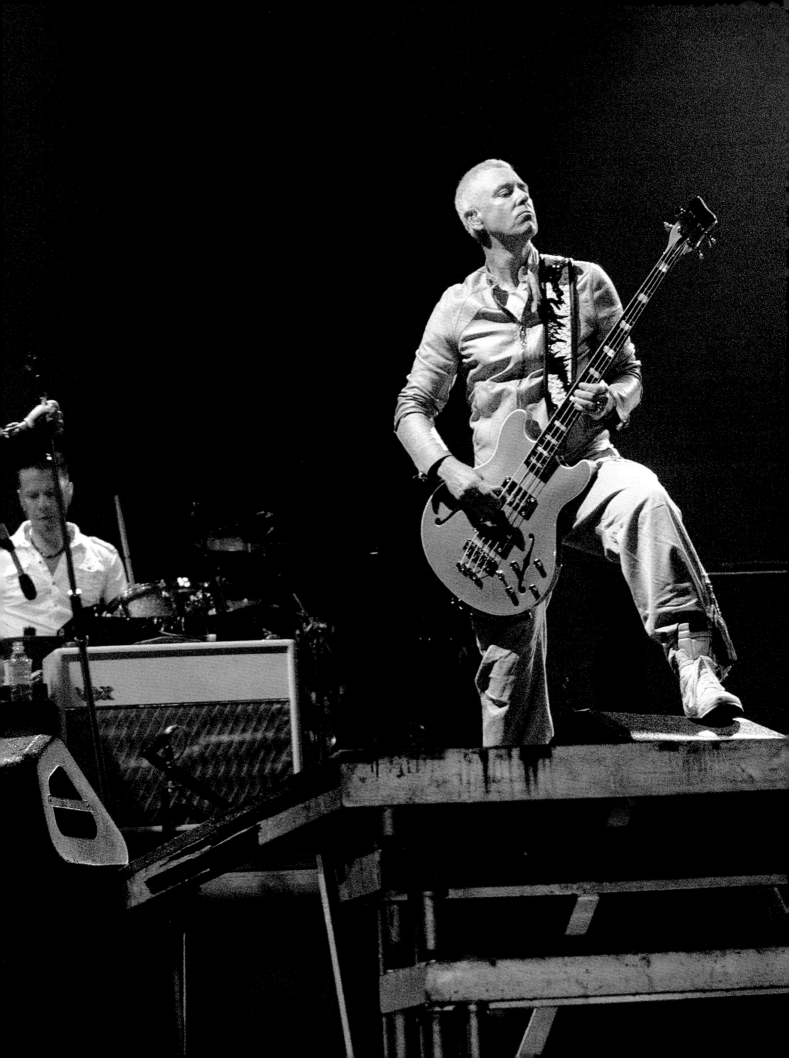

go from one tent to another in twelve inches of mud that could have been glue. Mud in America is not nearly as adhesive. If you took the wrong step, your foot would come right out of the boot. Also they had a backstage area and my son was eating lunch next to this very quiet unassuming African American eating his potatoes – then I realised that it was the lead rapper in the Wu Tang Clan who was just about to go on stage and talk about banging hoes.'

And what did Paul McGuinness think of the Glastonbury sojourn?

'Well, it was a great script, perfectly executed.'

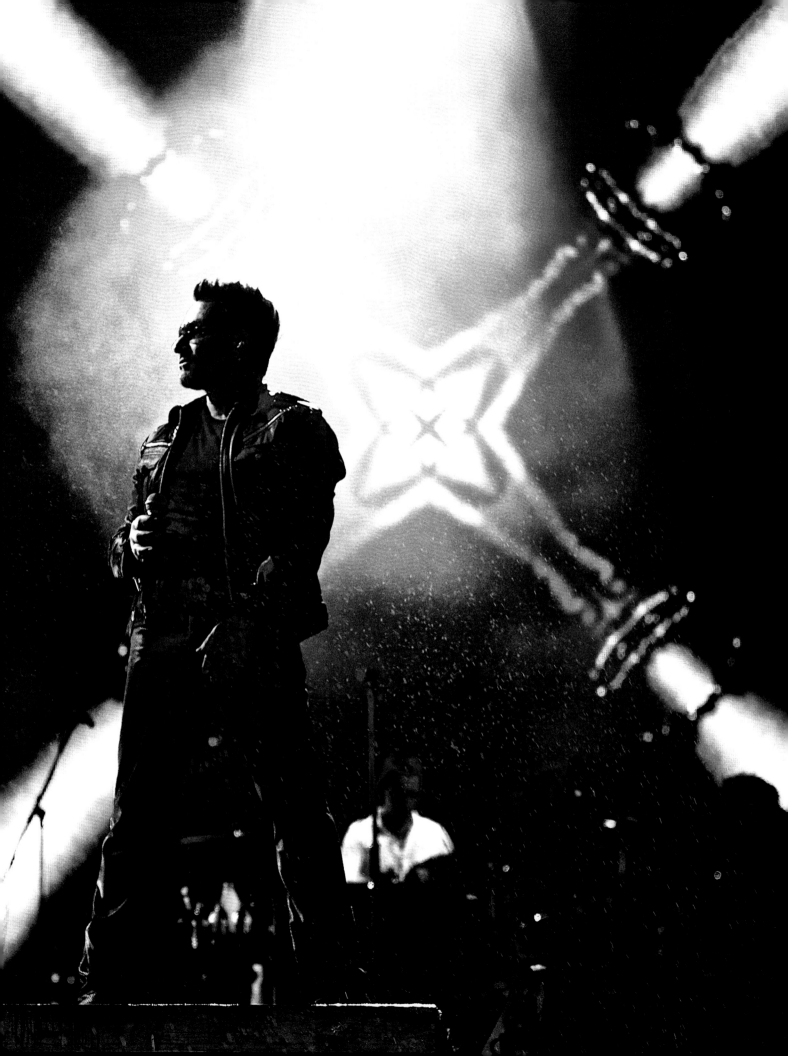

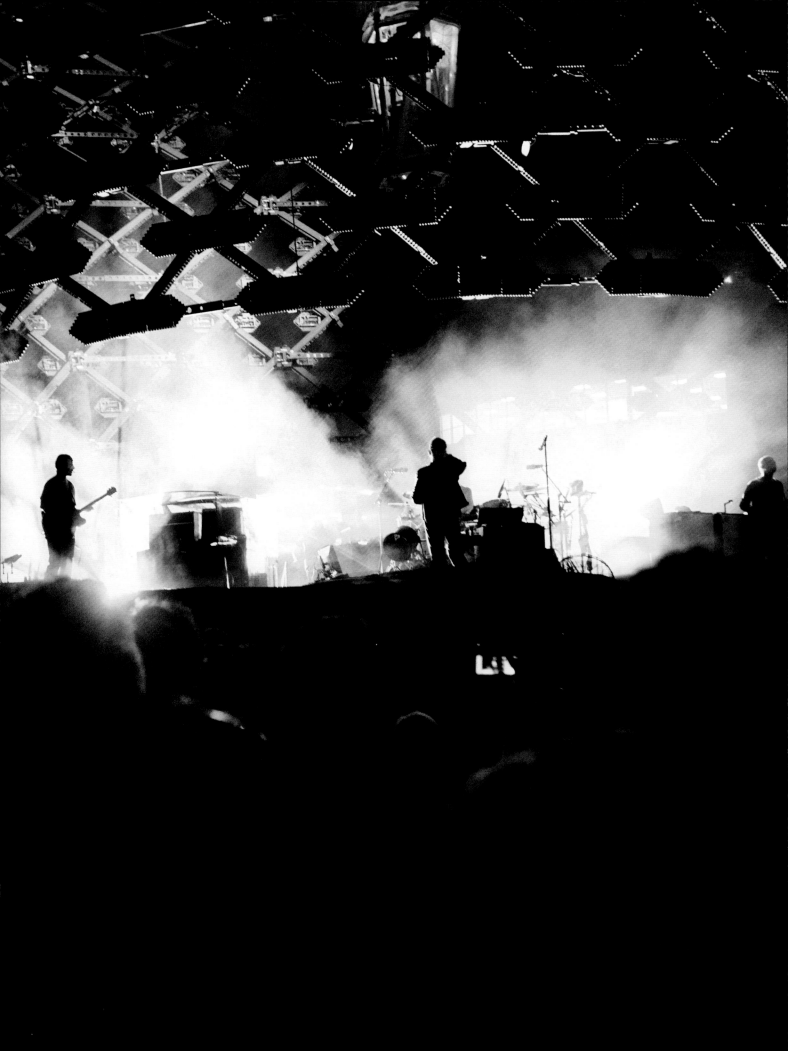

# THE LONG RUN:
# FROM MONTREAL
# THE END UNTIL

Chapter Five

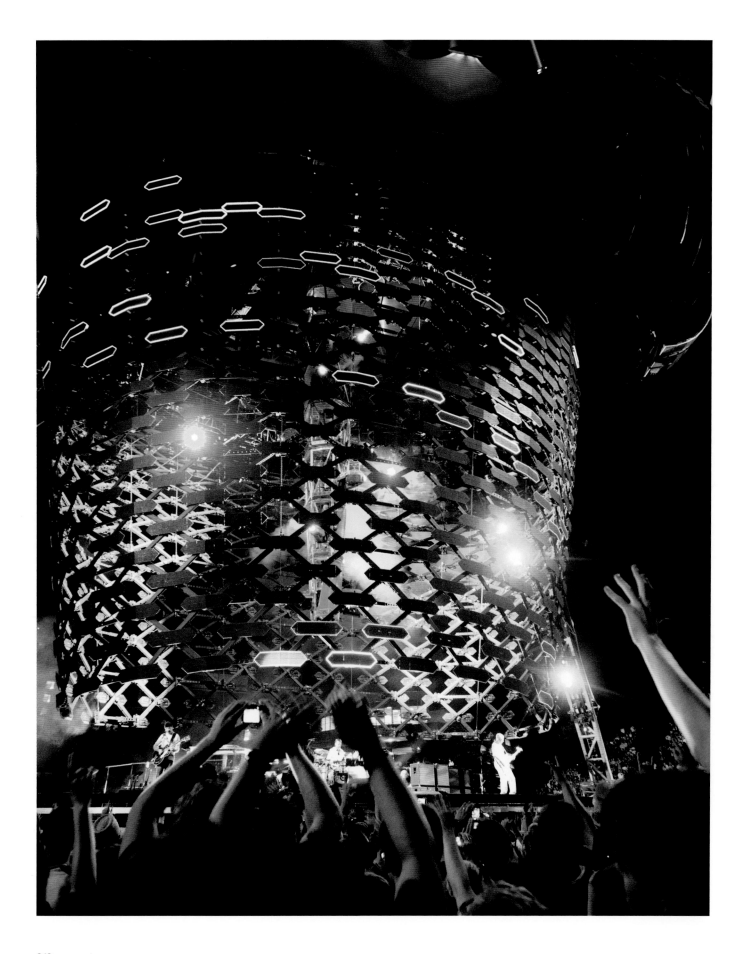

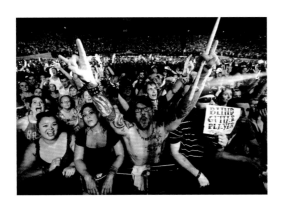

# 'WHAT TIME IS IT IN THE WORLD? SHOW TIME'

## – Paul McGuinness

### (quoting Bono quoting Edge)

When the band got to Montreal for two shows at the beginning of July, they could see the finishing line. With Bono and his family holed-up in Guy – Cirque du Soleil – Laliberté's country house, and with the rest of the band scattered all over the city, the media went into overdrive, anticipating what were meant to be two of the greatest gigs in the group's history. And afterwards? Well, what on Earth were they going to do next?

7 July 2011. If you looked across the enormous disused Blue Bonnets Raceway on the outskirts of Montreal, you could see several hundred men and women hurriedly building a Stickle brick city to a deadline. If you squinted at the dilapidated outbuildings, and the expanse of bleached barely-there grass, the racetrack could be the setting for a sixties B-movie. Stare for a while at the gargantuan contraption being built in the middle of the field and you'd think the film was definitely of the sci-fi genre, although actually maybe it wasn't a B-movie after all. Bought by the municipal government in 1991, and grandly renamed Hippodrome de Montreal, by 2008 the racetrack was bankrupt. Some city officials had been lobbying for this enormous great field to be redeveloped for residential social housing, although all plans had been put on hold when the

site was booked by U2 for two nights as part of the second leg of their initial 360 tour. The last time the band had played Montreal they'd appeared at the 16,000 capacity Bell Center, but needing to cater for a larger crowd this time, they had decided to build a venue on the site of the old Hippodrome racetrack on the outskirts of the city. They were going to play the Olympic stadium, with the retractable roof, but the roof apparently didn't work, so they were here instead. And now it was being turned into an Irish city of blinding lights.

As I stood in the bleachers, an anthropo-morphic metallic beast was being constructed right in front of me, a spacecrab of sorts, part-insect, part-spacecraft, part-cathedral. Elvis Costello called it a city constructed on a nightly basis, and as I peered across a field that by tomorrow would be filled with 80,000 undulating fans, I could do little but stare in awe. The 360 tour made Pink Floyd's Wall look like a village fête.

The Montreal gigs were going to cost the city – specifically the société de transport – between $700,000 and $900,000 to hire 600 extra transit workers on each of the concert days and to put 200 extra buses in service – but then Daniel Bissonnette, Montreal's associate director of events planning, said the shows would bring in over $4 million in economic spin-offs, as an estimated twenty-five per cent of the concertgoers would be from out of town, and would be using the city's hotels and restaurants. Which is why the city lobbied to have the concerts in the first place (at Boston's expense). There were posters of the band all over the city, but bootleg merchandise outside the site was nowhere to be seen (when they toured places likes Mexico the band were used to seeing entire villages full of hawkers; in 1992 the band were horrified to come across a Zoo TV coffee table).

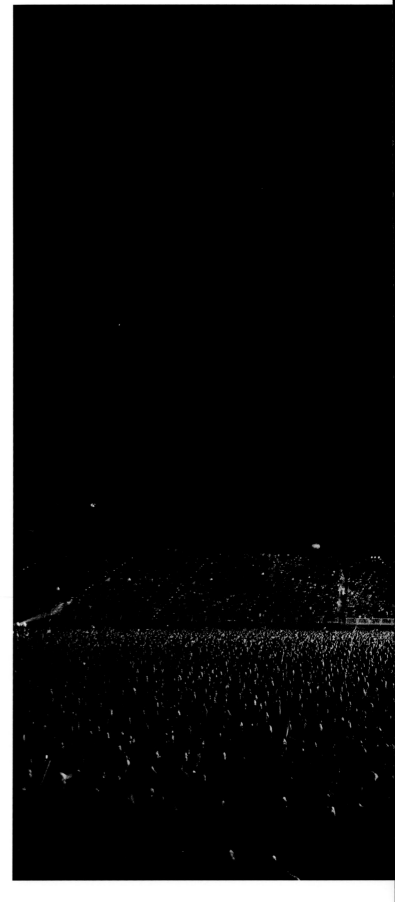

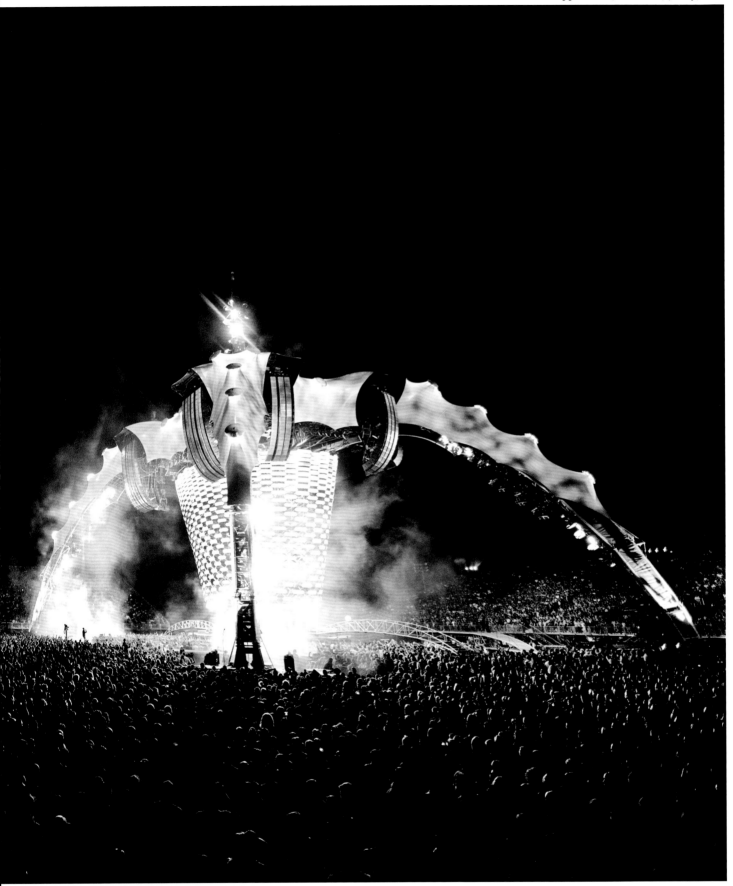

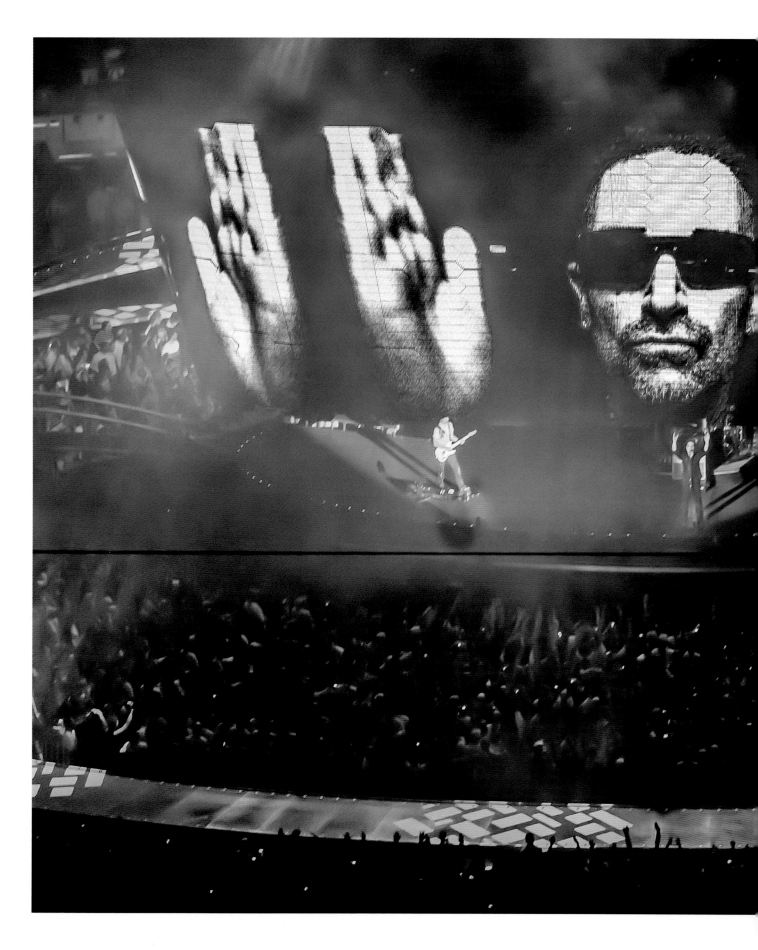

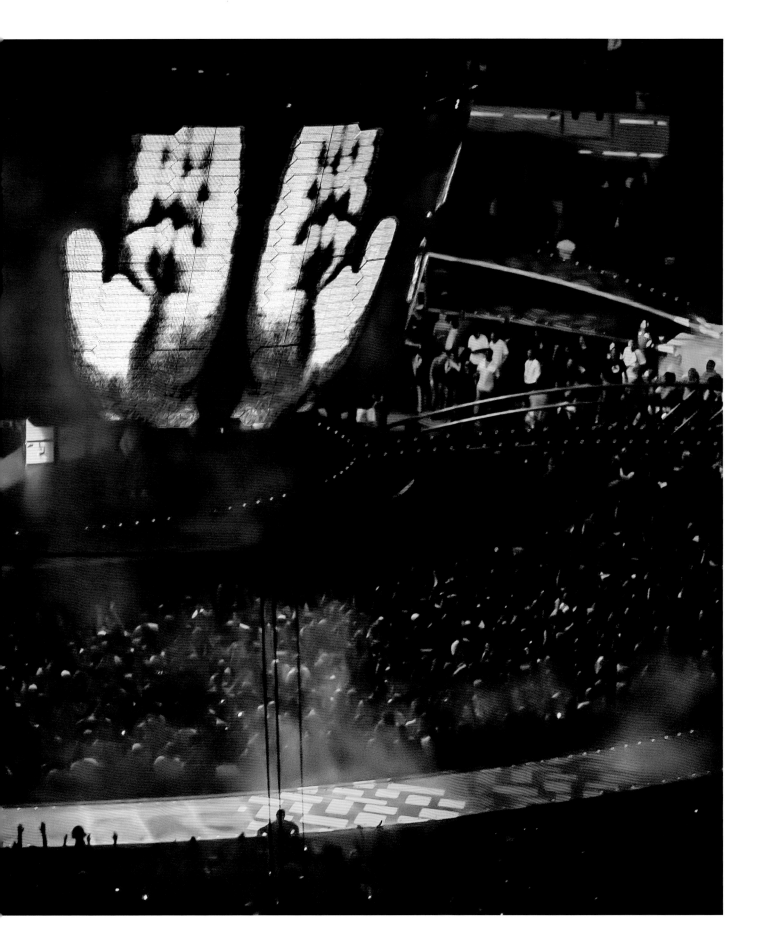

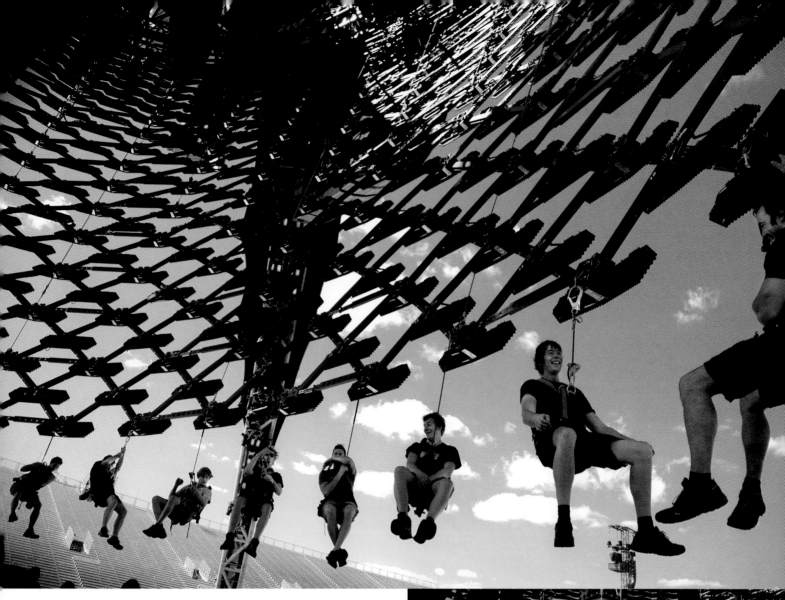

The night before the Montreal gig, the band and Live Nation decided to throw an end of tour party. In one of the parts of the racetrack that was being used for catering, a bar, disco and makeshift casino were set up, with all crew members being given an envelope full of fake dollars; the $20 bills had the band's image on them, the $10 bills had Arthur Fogel and Paul McGuinness, while all the $1 bills had members of the crew. This had become something of an accepted industry-wide ritual, although many of the crew wondered why it was being held on the eve of one of their most important shows, especially as Paul McGuinness had been flown home to Wicklow after the Nashville gig due to pneumonia.

'Dear U2 360 World tour staff member,' read the enclosed letter, 'We are nine shows from completing this incredible and historic journey together! Clearly the success of this tour has taken

the full dedication and efforts of you, and all of your touring associates. Because of the coordinated efforts of all, everyone can take pride in being part of concert touring history. As we are all aware, the demands of touring hours are immense and we do not have the opportunity to share our thanks and appreciation for everyone's sacrifice. We are happy to provide each of you with a touring gift and to share the success of the tour with a tour bonus that should be added to your next pay period. Tonight we celebrate you, we celebrate the many places and people that have made up this tour, and the path that the past two years have taken us. We hope you enjoy the evening and this opportunity to share time with your friends. With Love, and Great Respect, Bono, The Edge, Adam Clayton, Larry Mullen Jr, Paul McGuinness, Arthur Fogel. Please note: The dollars in this envelope ARE NOT your bonus. They are FAKE! Use them to play tonight and the person who turns in the highest winnings by 1.30, will receive a $1,000 cash award (with real US dollars).'

The band all came, and Bono stayed until the silly hours, partying with an adolescent sense of zeal. Even though he had been on the tour since God was a boy, the sight of the finishing post was giving everyone an extra fillip. Maybe they could get to the end without falling over. There was gambling, there was beer, and there were sliders – the requisite constituent parts of an end-of-tour knees-up (there were even cups of Starbucks for those who wanted it – oh, and bagels: the word is that in the bagel community, Montreal now had the edge on New York). And the crew had actually dressed up, not that any civilian would have noticed. 'This is black tie for us!', said one of the girls from RMP.

In the early hours of the morning, one crew member took a cab back to his hotel and actually

U2360 Moncton crew party casino fake dollar bills.

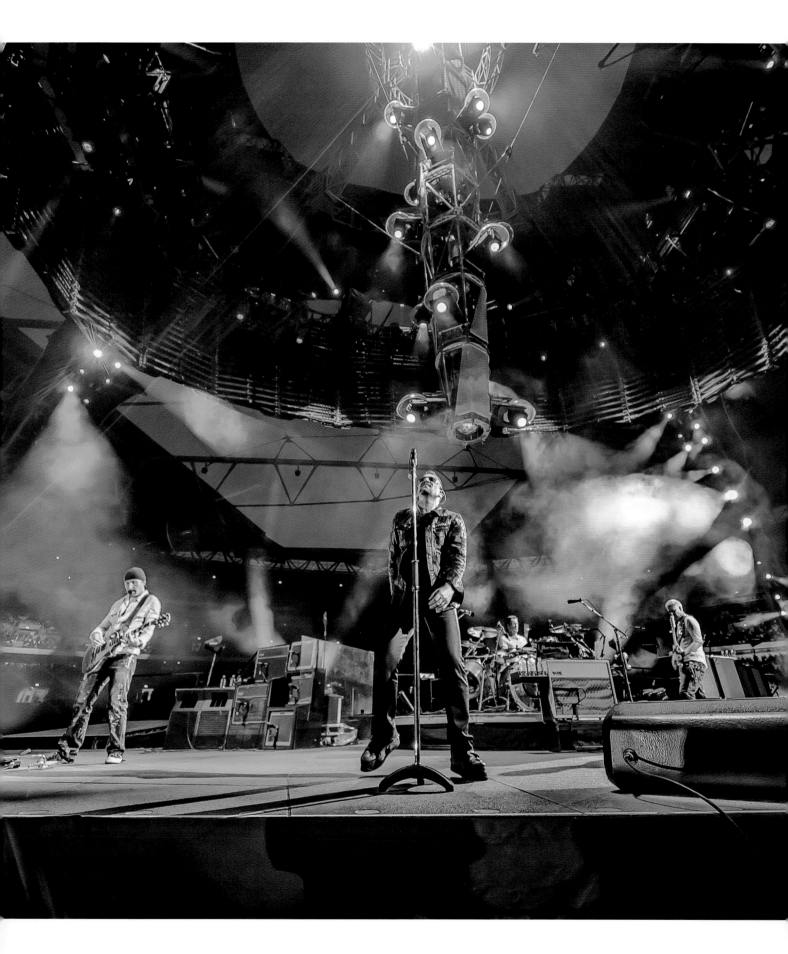

paid for his ride in Bono dollars. He got $2 change.

Everyone was in work the next day, as they tended to be throughout the tour. No one was ill on 360, as they simply weren't allowed to be. According to Willie's blog, there was a standard approach to dealing with illness on the road. For the first three days you completely ignore all symptoms and, whilst feeling quietly sorry for yourself, just carry on. Day four: consume all the random medication you can find in your own washbag/suitcase/workbox. Day five: consider stopping drinking alcohol and staying up late. Day six: consume all the random medications you can find in anybody else's washbag/suitcase/workboxes. Day seven: see the doctor if one shows up at the gig.

For Bono the last six weeks had been relentless. Along with Edge he had to deal with changes to the Spiderman show, he had three days in Washington lobbying to try and stop various budget cuts, two days on the West Coast in Seattle with the Gates Foundation, and some tech meetings in San Francisco for the ONE campaign (nearly 350,000 new members signed up during the tour, the record for one show being 8,134 at the São Paulo). And Glastonbury. He had also been helping Paul McGuinness celebrate his sixtieth birthday, hiring a mariachi band for a special lunch at the Chateau Marmont in Hollywood, which had been attended by over fifty guests. At Angels Stadium in Anaheim on 17 June, the band had tricked Paul up on to the stage, in order to sing 'Happy Birthday' to him. This was the first time he had ever been on a U2 stage during a performance, and came as a complete surprise to him. As he walked off, Bono picked up a glass from a monitor and said, 'He doesn't usually walk off stage and leave his champagne behind ...'

The support band in Montreal was Interpol.

During the tour, the band had been supported by a total of twenty-six acts, including Snow Patrol, Kaiser Chiefs, Glasvegas, Damien Dempsey, Republic Of Loose, Bell X1, the Script, the Hours, Elbow, Muse, the Black Eyed Peas, Kasabian, Razorlight, Ellie Goulding, Aviv Geffen, Douglas Vale, Springbok Nude Girls, Amadou and Mariam, Vampire Weekend, Lenny Kravitz, Moonalice, Florence and the Machine, Carney and Arcade Fire.

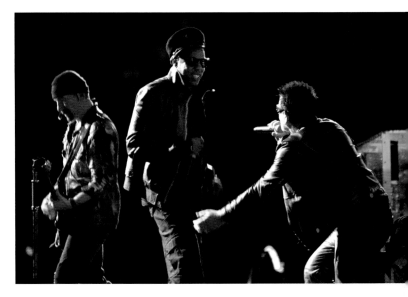

On the Australian leg of the tour, the band was joined by Jay-Z, who Bono thought 'was chasing the big rock bands out of the stadiums' and who was popular with the entire crew. Snow Patrol were another favourite, and during their last performance on the tour, in Istanbul in September 2010, the crew chose to show their appreciation by prostrating themselves on the stage during the chorus of 'Chasing Cars' ('If I lay here ... if I just lay here...').

In Montreal, as soon as Interpol finished, the digital ticker tape on the 'chip pan' sprang into life, bludgeoning the crowd with a succession of facts and figures: 'U2 songs performed on 360 tour: 52 ... Abortions this year: 21,749,815 ... Show number: 102 ... HIV/AIDS infected people: 33,630,026

'... Montreal Elevation: 764ft ... Net Forest Lost This Year: 2,692,849 hectares ... Tour Generator Capacity: 3,500,000 watts ... Countries in the UN: 192 ... Unemployment Montreal: 8 per cent ...'

And then 'Space Oddity' began, and the crowd instantly moved as one, cheering and hollering and working themselves into a fervour, a fervour they'd been looking forward to for weeks, months, some for years. Guys carrying trays of beers hurried back to their spot, and girls started jumping up and down with even more abandon. Julia Roberts was standing on the mixing desk platform, managing to look even more beguiling than she did on film. Paul McGuinness' partner Trevor Bowen, nodded along to the set, sipping a beer and occasionally looking up at Joe O'Herlihy.

The Montreal set was fairly representative of the shows towards the end of the last leg of the tour, starting with the glam rock urgency of 'Even Better Than the Real Thing' and followed by 'The Fly', 'Mysterious Ways' and 'Until The End of the World', moving through 'I Will Follow', 'Get On Your Boots' and 'I Still Haven't Found What I'm Looking For', and then on to 'Stay', 'Beautiful Day', 'Elevation',

'Pride' and 'Miss Sarajevo', before 'Zooropa', 'City Of Blinding Lights', 'Vertigo', 'I'll Go Crazy/Discotheque', 'Sunday Bloody Sunday', 'Scarlet' and 'Walk On' (the song that lyrically always makes me think of Pink Floyd's 'Eclipse') and then finishing with 'One' and 'Where The Streets Have No Name'. Tonight the encores were 'Hold Me, Thrill Me, Kiss Me, Kill Me', 'With or Without You' and, as usual, 'Moment Of Surrender'. At one point Bono sang a snippet from 'Miss You', which may have been a reference to Margaret Trudeau running around with the Stones back in 1978, or maybe he used it just because it scanned. He had forgotten how many oldies he had sung portions of on the tour, although even he was proud of his eclecticism: 'Stand By Me', 'Blackbird', 'Singing In the Rain', 'Fool To Cry', 'All You Need Is Love,' 'Rock 'n'Roll High School', 'Oliver's Army', 'Thank You (Falenttinme Be Mice Elf Agin)', 'Don't Stop 'Til You Get Enough' and 'Man In The Mirror' to name but a few.

Throughout the tour the set list proved to be of such interest – with Willie continually tweaking the set – that changes often trended on Twitter. The band had played over half a dozen new songs on the tour, including 'Glastonbury', 'North Star', 'Return Of The Stingray Guitar' and 'Boy Falls From The Sky' from the Spiderman: Turn Off The Dark soundtrack. When Bono and Edge sang 'North Star' at the Munich gig, a bunch of people in the mosh pit started singing along. 'That'll be the Internet, then,' said Bono afterwards.

In 1976 Martin Amis reviewed the Rolling Stones at Earls Court for the *New Statesman*. 'The ante-hall of the Earls Court Arena was a Brobdingnagian underground car park of remote and overcrowded bars, sweet shops and dirty hot-drinks machines. Normally a token homogeneity obtains at

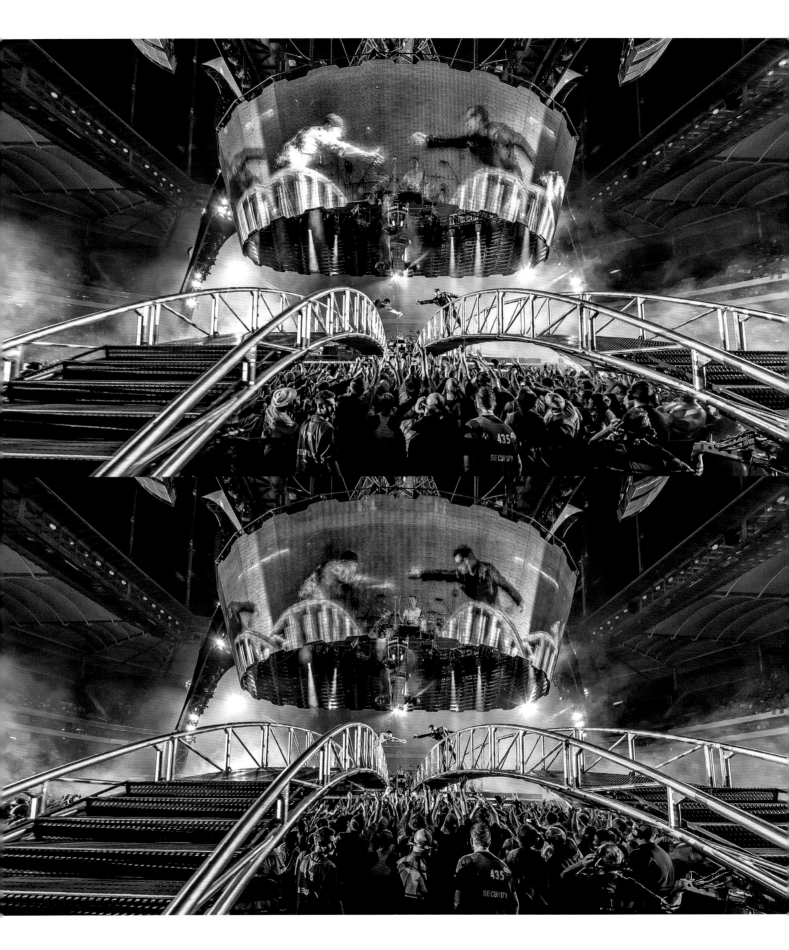

the average rock concert: David Bowie fans all look and behave like David Bowie, Bryan Ferry fans all look and behave like Bryan Ferry etc. But everyone is a Stones fan.' Not everyone is a U2 fan, but not only do they appeal to U2 fans, they also appeal to people who don't necessarily like any other sort of music, and the people who make up the crowd at a U2 show might not normally go to another concert all year. Because each time U2 go out on the road, they attempt to reinvent the rock experience, and each time they succeed. With the 360 tour, however, they produced one of the most extraordinary, one of the most extravagant live experiences in the history of rock 'n' roll, and one that is unlikely to be repeated on this scale again. The seven million people who saw it will never forget it.

'I suppose in some sense a U2 tour is a little like a movie franchise,' said Willie Williams, 'where if you go and see the latest Bond you will expect that there will be that scene where they show you the gadgets and all that sort of thing, so similarly there's an expectation that certain things and certain songs will be in the show. But then the audience always expects more, as do we.'

As Paul McGuinness described it, U2 was the equivalent of a football team that wins the World Cup not just this year but does it again four years later, and again four years after that, and again four years after that.

'Biggest is something we've had for a while; best is something else, however ... In a way, good enough is easy to get to. Great is harder; maybe not every day, but I think they are clearly the greatest rock and roll band of the day, and of the age, and maybe of all time. And the longevity of the group produces commercial ambition to do great shows, great recordings, and better things than they've

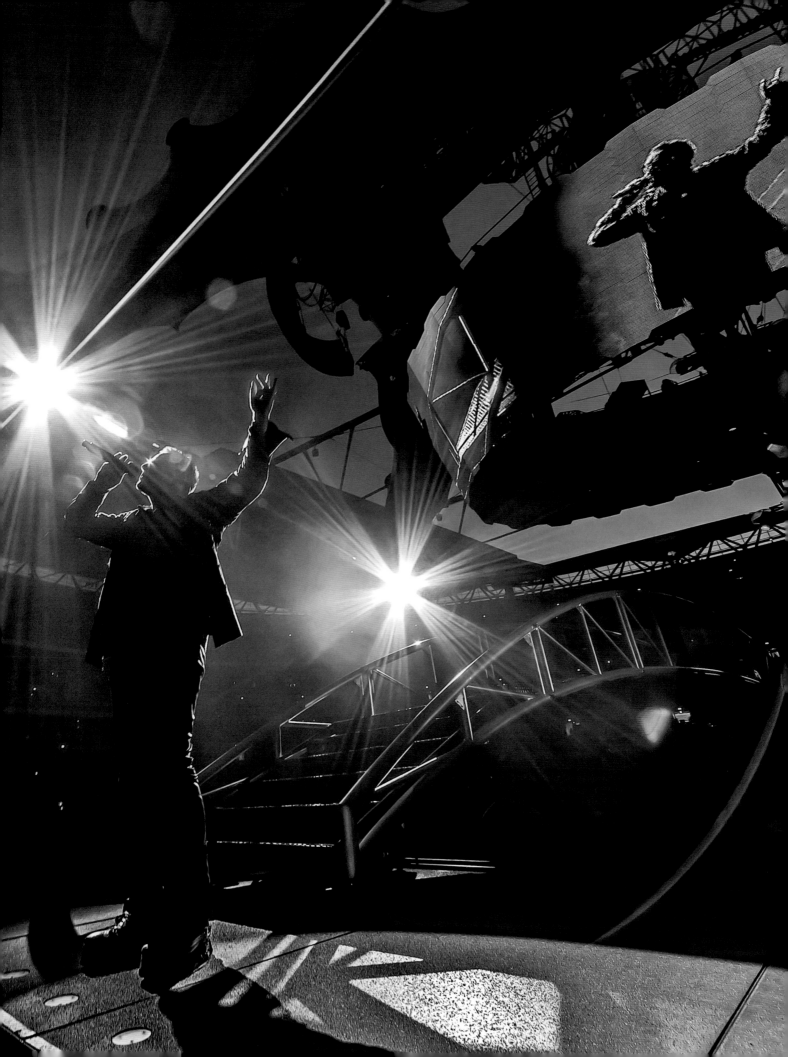

done before. Bono's other life as an activist and as a politician is problematic in some ways; it draws fire, a lot of people don't like it. And to some extent Bono has to put up with that nowadays and he does it quite gracefully, but not always. I think he finds it hurtful when his motives are questioned, and when he is held to account in the same way that politicians are used to, he can sometimes be a bit thin-skinned. And it does come with the territory.

'There was a guy we met once in the eighties – Bobby Colomby – who was the drummer in Blood, Sweat and Tears and he later went on to have a successful career as an A and R man and also as a TV personality in Los Angeles. He introduced Bono and Adam once for a television show in the early eighties in Los Angeles. After the interview he said, "Do you mind waiting for another minute? I've got something personal to say to you, not on camera." And we all thought, "Oh shit, he's a religious nut; what is it going to be?" And he said, "I was in a big band myself once and I loved it, and not ashamed to say that, but I'm saying this to you now because I think you can benefit from it. Try to enjoy every moment of it, because it won't last forever; every time there's a limousine or an enthusiastic audience, just remember that it doesn't go on forever, and relish it." It sounded like the truth, so we tried to observe that. So for a few years whenever somebody might mention the limousine's late or something, we'd say, "Bobby Colomby!" And we'd think of Bobby.'

By common consensus the best gigs of the tour were the Spanish and South American ones that had the feistiest, most expectant crowds. In those parts of the world the audience really does come to be part of a communal event, rather than just to come and 'see a show'. 'I would say South America,' said

Adam. 'The other ones I remember for pure determination were the ones where we had torrential rain – Zurich, Brussels, and one of the Austrian ones where we just had insane rain. The audience, they didn't give up on it, they stayed there and they

went right to the end of the show. I think every crowd is slightly different depending on what their cultural touchstone is and what their experiences are. I think American audiences are very familiar with the pace and the language of the concert; they understand the beginning, middle and end, they understand the narrative. And because they see a lot of shows, they go to a show a week in the summer or a show a week in college, they don't ever go manic. They're fairly well educated, if you like, in terms of the concert. When you go into places like South America where you might get one big show like us through every two years, they must see a concert that a lot of people turn out to as a cultural event. In South America, as soon as you get on stage, it's like lighting gunpowder.'

Willie found it hard to choose the best shows, 'As Bono has to be Father Christmas for 70,000 people every night.' But he eventually plumped for

Barcelona 1, Mexico City 2, and Dublin 2.

For Paul and Live Nation, perhaps the gigs with the most resonance were the São Paulo dates in April 2011, as they marked the point at which the tour overtook A Bigger Bang to become the highest grossing tour in history.

'The first shows were much more of an exercise in taming the beast,' said Arthur Fogel. 'The notion of designing this 360 contraption, building it, putting it there, creating all these seats, but then the dynamic of using it and getting comfortable with it. Certainly with respect to the band and their performance, certainly with respect to the crew and putting it up and down. Because in the early days, everyone was sitting there going, "Oh God, what have we created?" Because of the logistics. As time moved on and the tour started rolling, the beast was absolutely tamed in terms of the logistical challenges, and fast-forward to the end where it was an incredibly well-oiled machine and people were amazed by how well it went up and down and how efficient it was for its size and scale. And similarly for the band, they mastered it, and it was an incredible transformation from Barcelona to the end of the tour. I think it ended up being the greatest show of this kind I've seen and can almost imagine seeing.

'The show had that unique characteristic of using its size in the largest of venues to create intimacy, which is a remarkable achievement. Stadiums are certainly a challenge in that respect, and frankly over the years I think there have been very few artists that have mastered that particular art form. U2 have. But this, I think, goes that step beyond; they've taken their mastery of the art form of performing in a large stadium, but at the same time made it an incredibly exciting and enjoyable

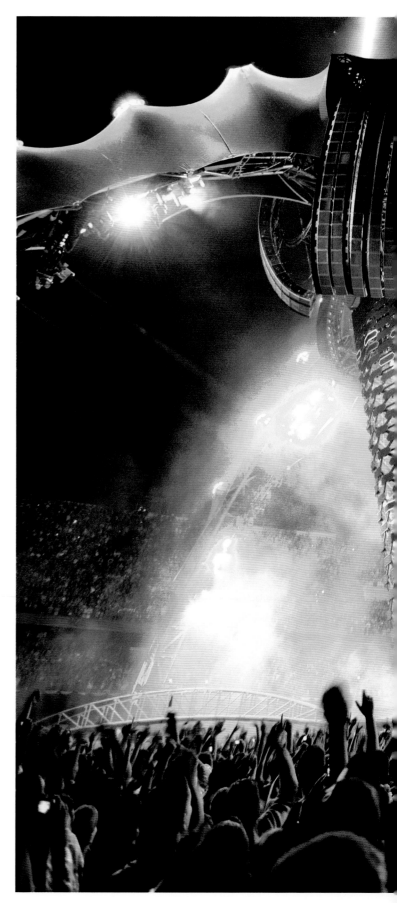

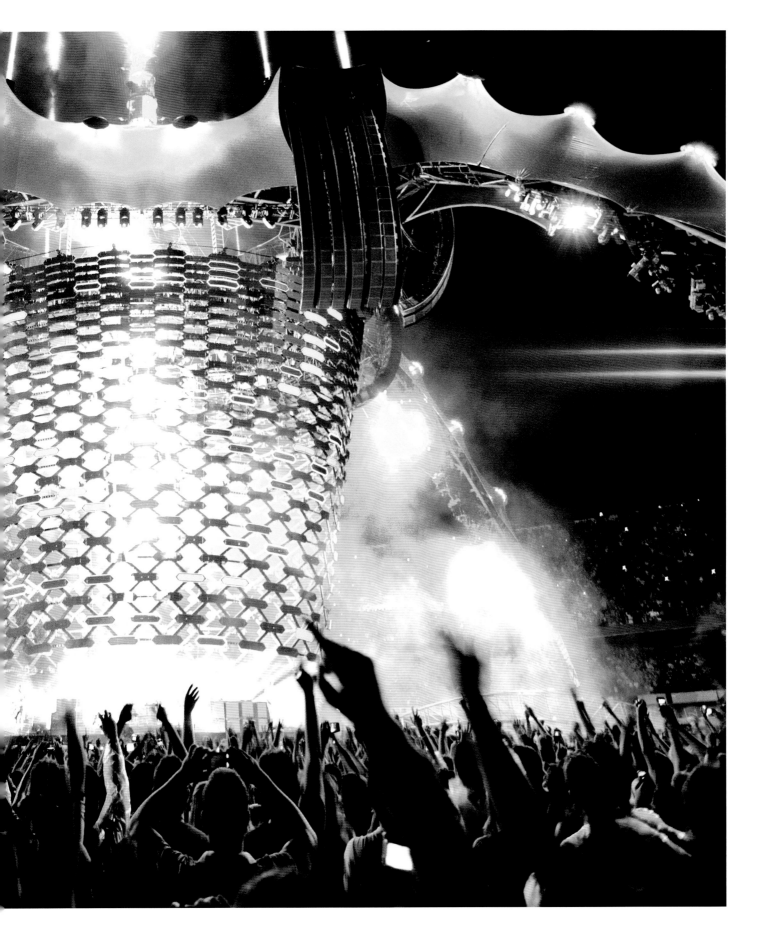

experience for the people who are coming. And that, I think, is the ultimate magic that has made this such an unbelievable result. It's like the circus had come to town. And in today's world I think that's ultimately what people want; they want to be entertained, they want to feel a part of something, they want that connection with their favourite artist. And so on so many different levels this show delivers that; it's like the perfect storm of what a live concert should be.'

How did Adam feel about the tour – the length of it, the enormity of it, the extravagance?

'I think once I got used to the energy it takes to do these shows on big stages and travel the distances, once I got used to that I really enjoyed it. I've always felt that the best job in the world is working outdoors in the summer. And that's what I do! I've been coming to these cities for thirty years. And most of the buildings we've been in, this would be our third of fourth time in that building, in all the hotels; so there's a sort of familiarity to it. Never would I have thought I would know all the capital cities of the world as well as I do now.

'I certainly take a lot more care of myself than I used to. I don't think it's essential. But I just like to wake up each day feeling like I got to bed at the right time, and feeling like I'm going to do a bit of a workout. And then I know whatever happens throughout the day is going to be fine. When you look at bands on their first or second tour, you see them getting caught up in having late nights, having a great American breakfast every morning, and at the end of the tour they've put on ten pounds and their eyes are down here and they're just wrecked. I've done that, and I don't want to do it again. To be honest I would have loved for it to have been over within a year or a year and a half. I like the

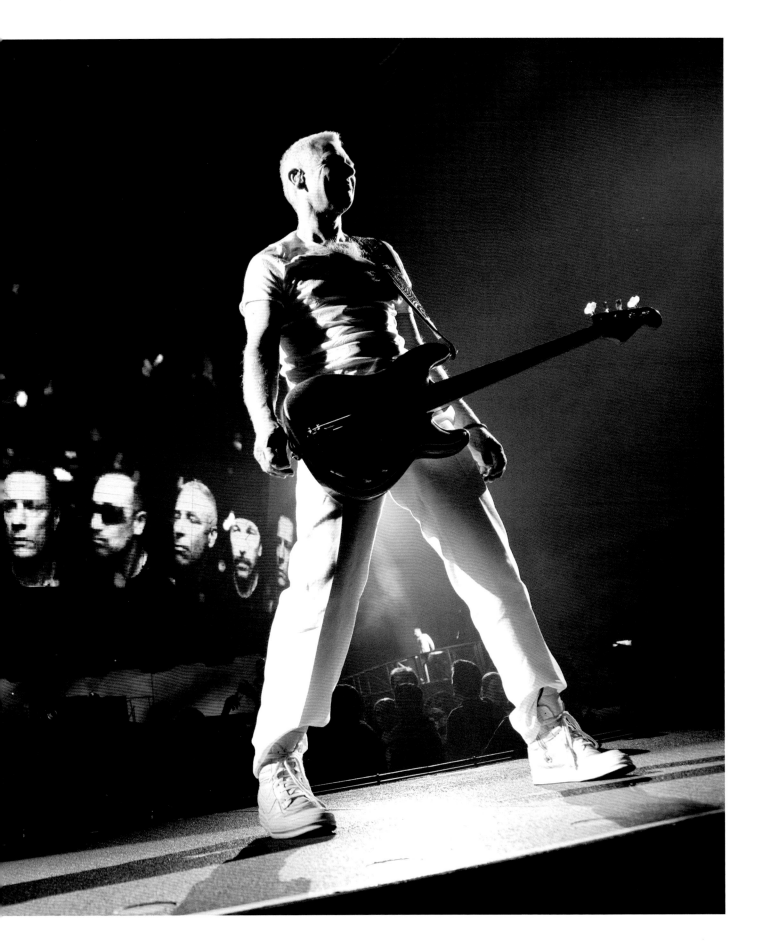

momentum of doing the tour over a year; you get on to the next project. The fact that this went on over three summers, I felt a little bit stuck in the material.'

Tonight's crowd was almost as enthusiastic as they had been in Barcelona or Mexico City. Everything tonight was fresh, even old songs such as 'Sunday Bloody Sunday', which had been recontextualised by adding a montage of footage from the Arab spring (when the Egyptian leader Mubarak finally stepped down in February, Bono suggested they use photographs from the demonstrations and celebrations in the intro to 'Sunday Bloody Sunday' in place of the Iranian ones that had been in the show for the previous two years). The Aung San Suu Kyi passage had also been substantially reworked. She was finally released from house arrest on 13 November, after nearly twenty years, which meant that they had to update that part of the show. It seemed that playing 'MLK' would no longer be appropriate, and so after digging around in the back catalogue for a while, Willie came up with the notion that perhaps they might replace this with 'Scarlet' from the October album, a piece of music that U2 had never performed in concert before. And there it had stayed, wedged comfortably between 'Sunday ...' and 'Walk On'.

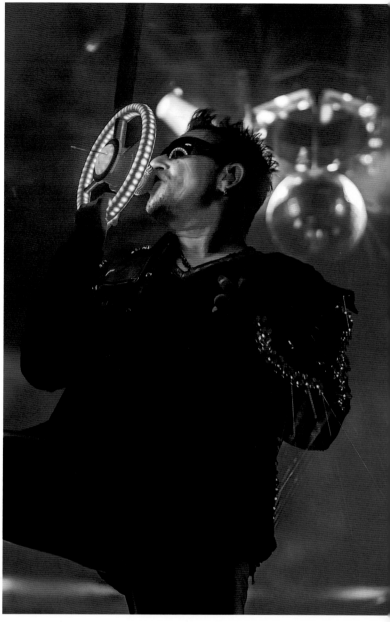

After the show, Bono, Ali and I took a helicopter back to Guy Laliberté's house, twenty-three kilometres east of Montreal, in Mont Saint-Bruno, in the beautiful Monteregian Hills. His children swirled around him, grabbing his legs, slapping him on the back, asking him how the concert had gone. Ali called him 'B', which is what those close to him seem to call him all the time.

'Is there a glass of red wine for an ageing rock star?' he asked, as he wolfed down a plate of steamed chicken, greens and pesto butternut. The tour was coming to an end, and he was in a typically reflective mood (it comes naturally). How did he feel about this tour of tours?

'Many of these people on the tour have been with us for thirty years,' he said. 'And I can assure you it's not sentimentality – we don't keep people because they're old friends. All these people are the very best at what they do. We want it to be good for them too. We don't want to let them down.'

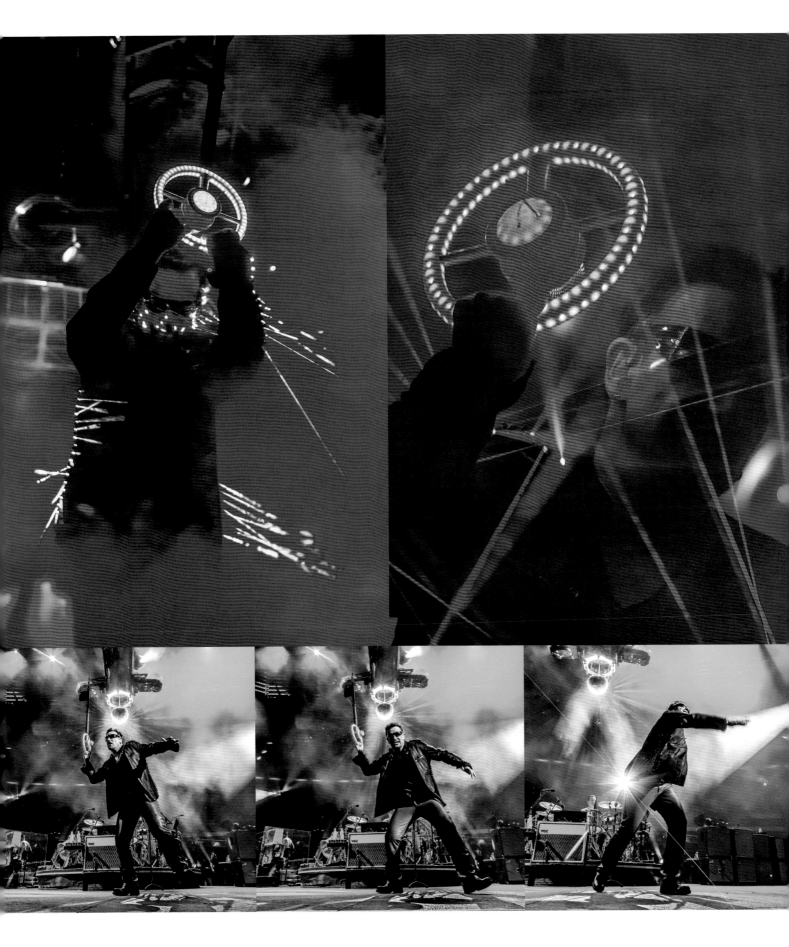

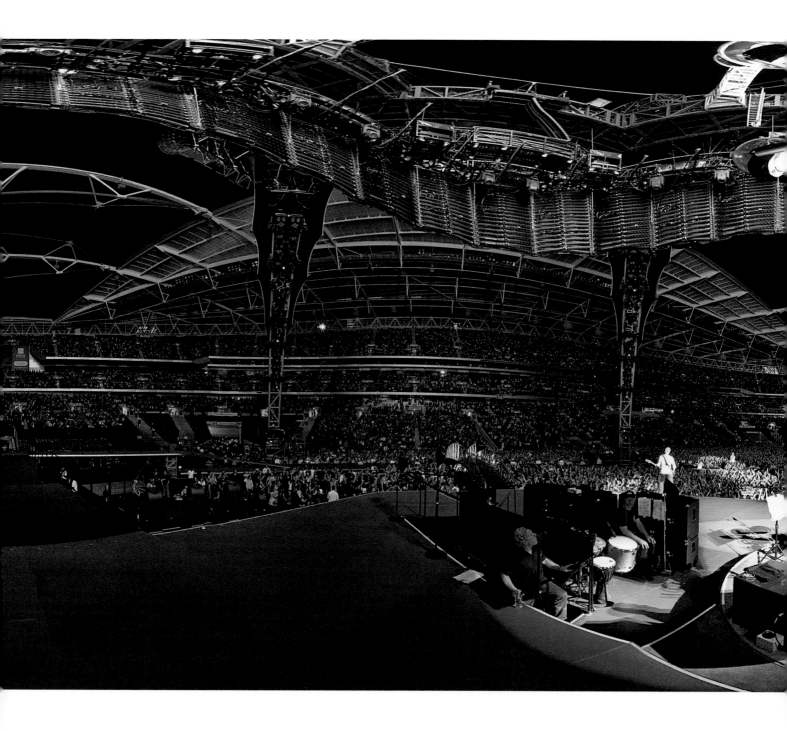

And it is so very obviously a community. There might only be four stars above the parapet, but having dropped in and out of the tour for two years, it was impossible to imagine the 360 tour as anything other than a kind of benign circus, with everyone working for the common good.

'My mother's family was so big and so joyous, and that sense of community has stayed with me all my life,' said Bono. 'They were so inclusive. With everybody. I remember being in this old railway carriage that was on the dunes in north Dublin, and everyone singing. And I remember when community disappeared from our family, when people left, and I remember thinking, this is bad, this is not as much fun. Community is so important, and I suppose we look on everyone who works with us as family, and

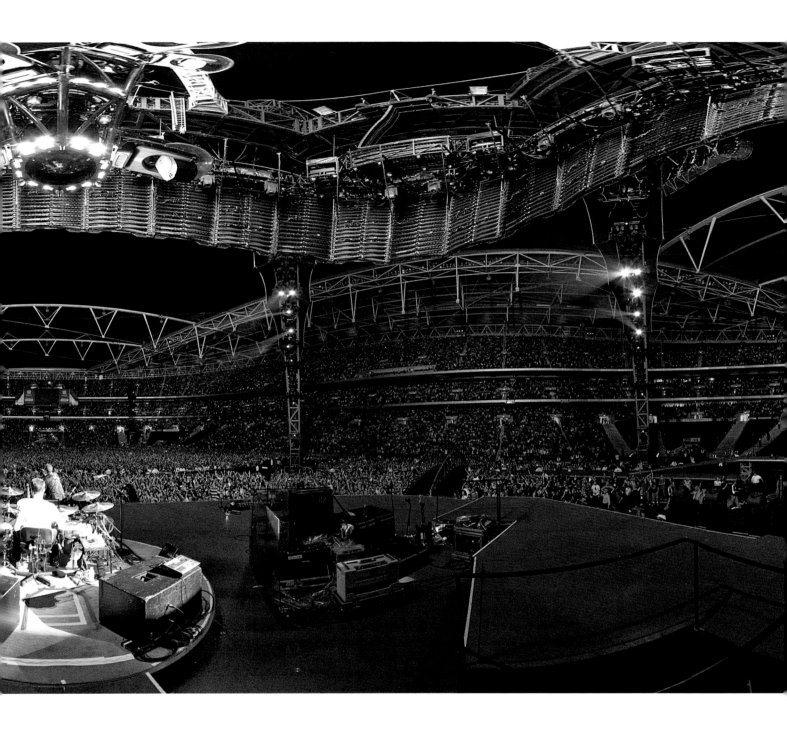

as a way of not being corporate.

'We keep this community going because we are a family. If we were Jamaican nobody would question the way we operate. Oh yeah, they make this kind of spiritual music, a bit political, they all hang out together. Yeah, got it. But then I suppose there's always been a Jamaican vibe to a lot of what the Irish get up to. I'm sure Joe O'Herlihy's

Jamaican. His accent is totally Jamaican. Lots of one, two, trees and t'ing. He's the blackest Irishman I've ever met.

'This band is about joy, it's about community, it's about loyalty. And it's very powerful to be with the same people for such a long time.'

In Chicago Bono had celebrated the city's 'majestic skyline', as well as the audience: 'We're

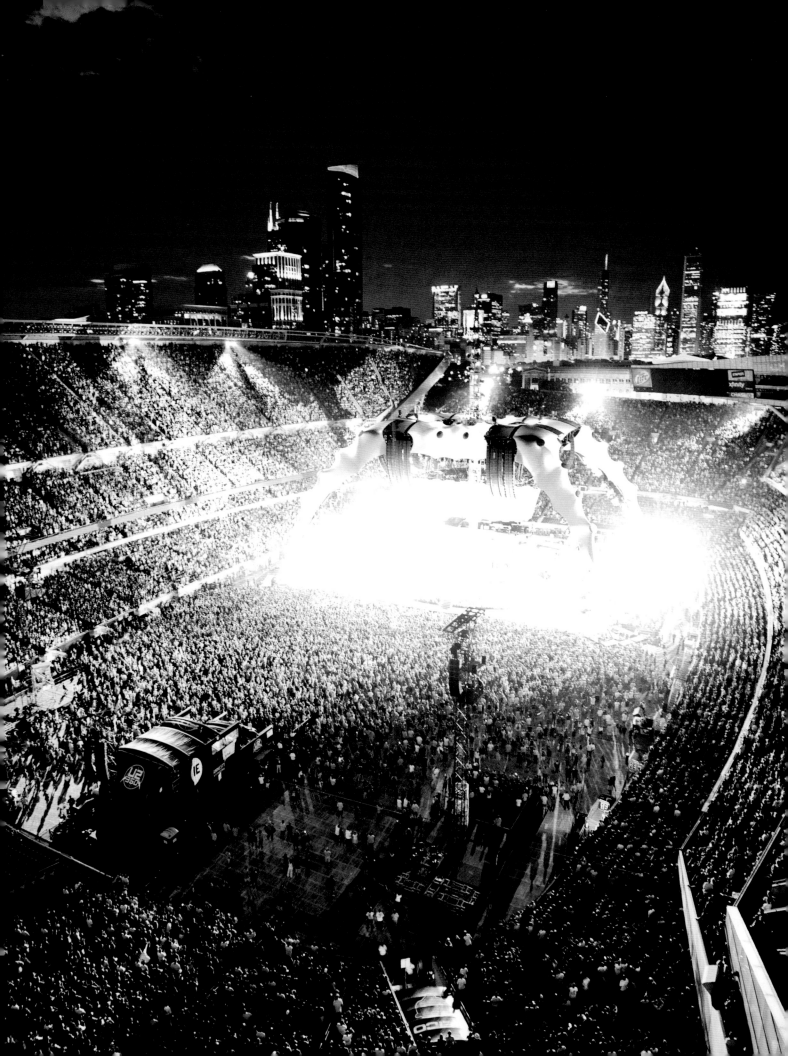

the wind in the windy city. When you put this band with this crowd, there is no room for modesty. Anything is possible.' It was a sentiment that almost everyone on the tour appeared to share. With U2, anything really did seem possible. Which begged the question: what in the world were they going to do next? Would there ever be a more extravagant tour? There was a feeling amongst the touring party that, enormously proud though they were of their achievement, a further extravagance might be too much, and that anything bigger than this might be impolite and self-aggrandising. Paul McGuinness was already arranging to sell the Claws as permanent event space around the world ('Six million a piece, free assembly, postage and packing!'), and there was an unspoken assumption that nothing of its type, or size would ever be built again. Not by anyone.

Arthur Fogel actually thought the next U2 tour would be a lot less stressful than 360, principally because it almost has to be less ambitious. 'Personally I think the encore is going to be easier,' he told me. 'I think that the pressure was much greater to bring this home as an ultimate success. Now that they have done it, it opens up a whole realm of possibilities in terms of what to do next.

As they've gotten to the top of the mountain, they can scale back, go back into arenas, and do a different type of show. In terms of size and scale there's nothing to prove. And therefore I think it offers up that flexibility to go in different directions;

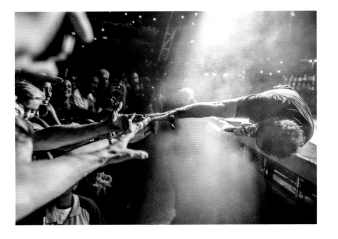

to mix it up and maybe do something in a few places, rather than touring it. Having said that, there are territories in the world that the band is still to visit; they've never been to South East Asia. And so I think next time we have that opportunity to create a more flexible production that can go smaller if we want, bigger if we want. And because of the flexibility get to places that we couldn't get to on this tour because of economic realities.'

Adam concurred: 'I think we're psychologically prepared for not playing outdoors next time. We'll do an indoor tour, but until the songs and the identity of that project come together we won't have an idea of what the production will be. We tend to go indoors after a stadium tour and we tend to strip it down, and we want to make it more about the music and less about the production. That's my instinct, anyway.'

'In many respects the tour has been made possible by technological advances, and the quality of the constituent parts was incredible,' said Arthur. 'The sound was superb; the video elements awe inspiring. And so each layer of the physical production rose to the standard of the concept. The real question is, "Can anybody do this again? Is there anybody that can go to stadiums around the world and sell them out, with a production that generates that kind of capacity and that kind of interest?" And it's a hard question to answer, but if someone insisted that I answer that today my feeling would be, "No." It's not likely to happen again. This band was already at such a

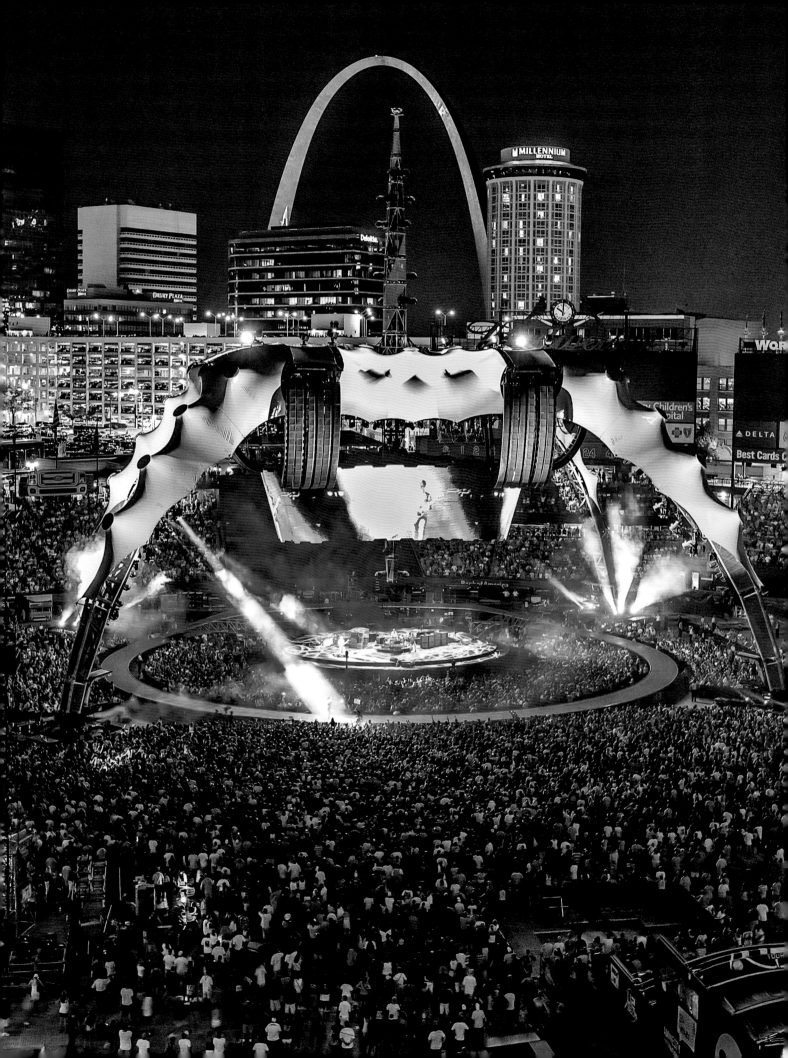

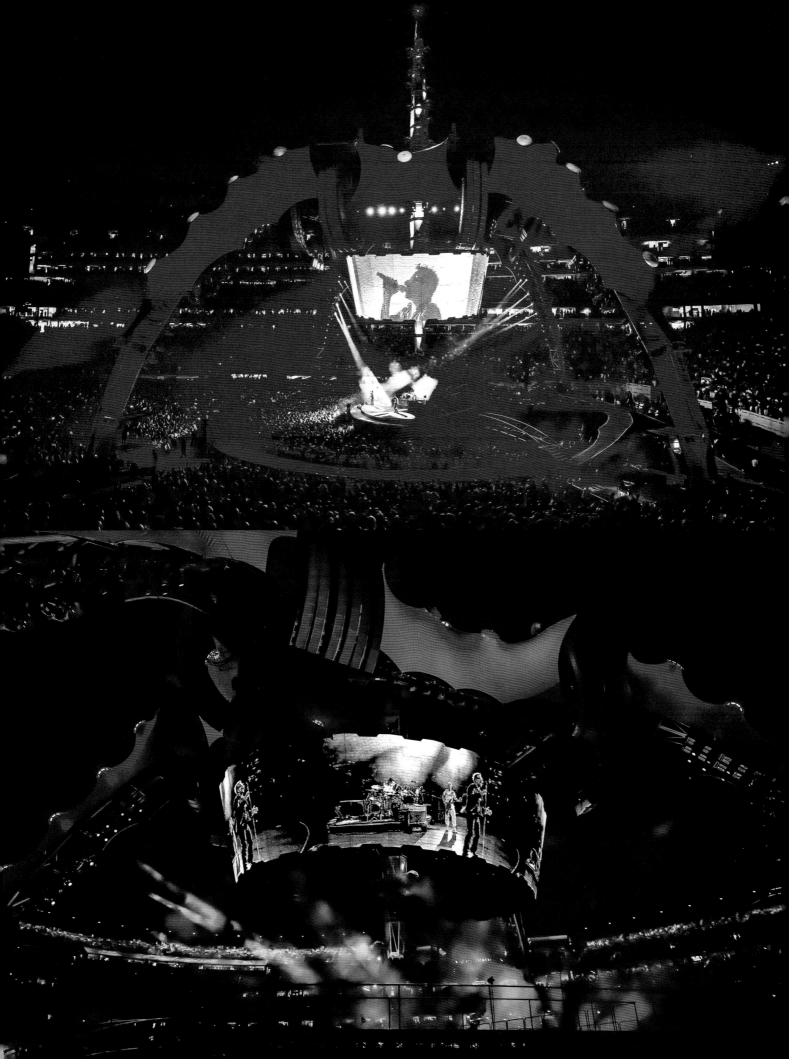

ASIA |

level, and this has propelled them to the very top of the mountain, and deservedly so. And I have a hard time envisioning anyone else coming along to top that.

'They're certainly not going to stop themselves. I promoted Frank Sinatra once, and he was still going in his seventies. There's no reason why artists have to stop touring these days, as there will always be an audience for them. Sinatra proved that.'

'Thirty years for five men is a long time,' said Paul McGuinness. 'We know each other quite well, and I suppose we don't live in each other's pockets but we spend a lot of time together. We're proud of what we've achieved. And we all understand that if Bono didn't have this other side to his life, which I know annoys many people, he probably wouldn't be as good a songwriter. That's what he says; that's where his inspiration comes from. He wouldn't have anything to write about. And he's a spoilt rock star, but at least he says that. We're all sort of spoilt. It's been quite a ride.

'We have a proverb that every tour is a month too long. Right at the moment I suspect there are certain members of the band who would love to be in the Rolling Stones and take seven years off, but there's no chance of that happening.'

'Maybe we'll do what Bono said at the start of the nineties, maybe we'll go away and dream it all up again,' said Joe O'Herlihy to me one night in Montreal, as we sat at the mixing desk twenty minutes before show time, as the Claw cast its shadow

over the Blue Bonnets Raceway. 'Because now we have the tools to do it. Technology is on our side now.'

Technology and ambition, a collective emotion the band have rarely been without. Bono in particular tends to think about the next tour at the end of the one he's on, while everything's fresh. 'It's important to think about while you're doing it. The feeling you get performing in front of thousands of

people gradually wears off, so to fully understand it you need to make decisions when you're actually in the middle of it. When you're away from it, you actually forget what it feels like.

'It's like our songs. The best music always comes from playing them live, testing them out, seeing how the crowds respond. The way we've toured for the last twenty to twenty-five years is a really bad idea. Big long tour. Big long album. Repeat till fade. At the end of the tour you've forgotten how to make recorded music, the recording process, and by the time you've

finished making a record you've forgotten how to go on tour. So each time you have to go and start it all again. The Beatles did all their best stuff when they did nothing but make records, all the time.

'So increasingly we try and record while we're on tour. There is a word used in the studio – it should be a pejorative, but it isn't. And that's "interesting". Edge always says, that's really interesting.

I'll say, that's interesting. We sit round making music that's "interesting". The only music you won't play in front of 80,000 people, or 18,000 people, is interesting music. Because that's the only kind of music they don't want to hear. They want dramatic, melodramatic, angry, joyful, raw music. Just don't play fucking interesting music. No jazz funk, nothing odd, because people can't get into it. We were working on some songs during the last few months of the tour, and it's great making the decisions as you go along. And the same thing is true when you're constructing a tour. You have to pay attention. The time to think about it is at the end of a tour, not when we've finished making the next record.'

The ideas that Bono had for the next U2 tour sounded as though they had been percolating for some time, ideas that were given more credence from being discussed during his convalescence. That percolation would be ongoing.

'A lot of bands have exactly the same show every night, and if it's a big dance production I suppose that's the way it needs to be,' said Willie Williams one night in Baltimore. 'For a rock band, the thought of just going through the motions is boring. So with U2 we have to find this middle ground where there's enough movement for them to stay alive whilst being able to carry this massive choreographed production.'

Choreography, architecture, philosophy. And emotion. 'Part of our manifesto is topping what we've already done,' said Bono. 'We're about communication to large crowds, that's what we do. We're about the big music. If you're not, then why would you want to be in those environments? So I don't know what we'll do. We've to write some really serious, fuck-off tunes though. We've got to write some tunes not just for those people who don't like U2, we've to write tunes for people who don't like music. That's what is happening in the industry now. We've got to grab people's attention, not just for us, for U2, but for everyone. We've got to write tunes so we can get on the radio and people

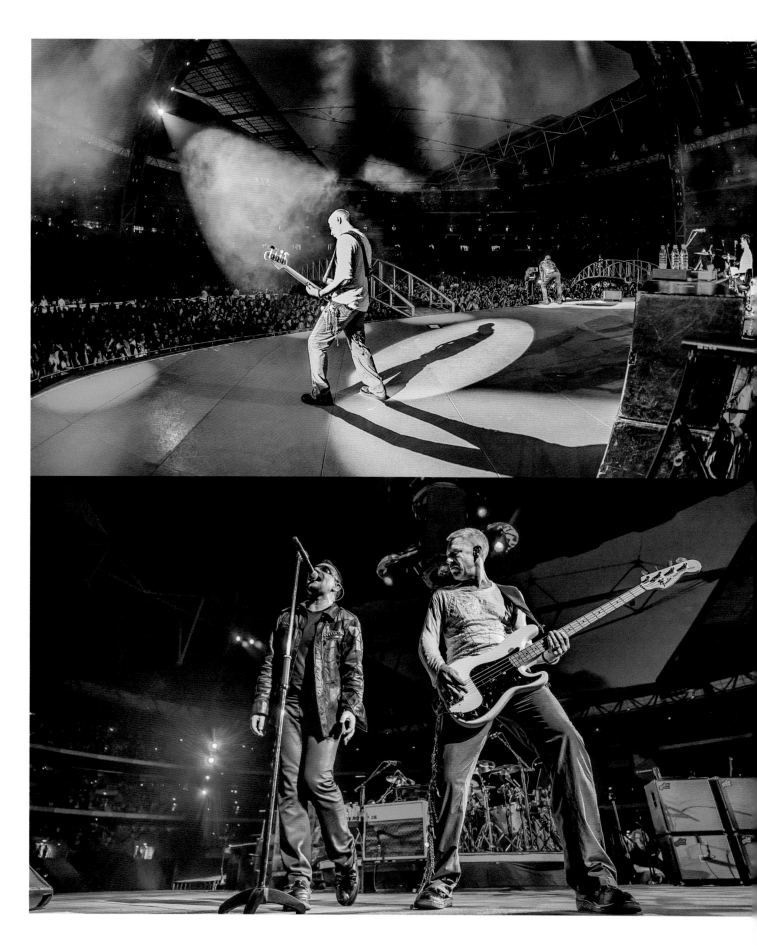

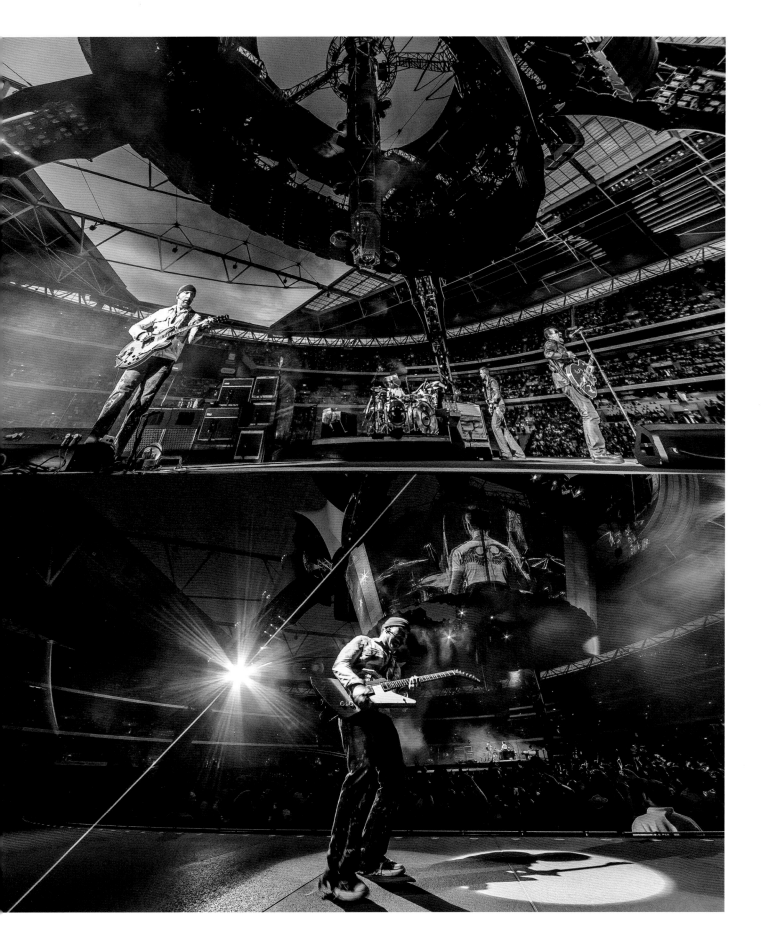

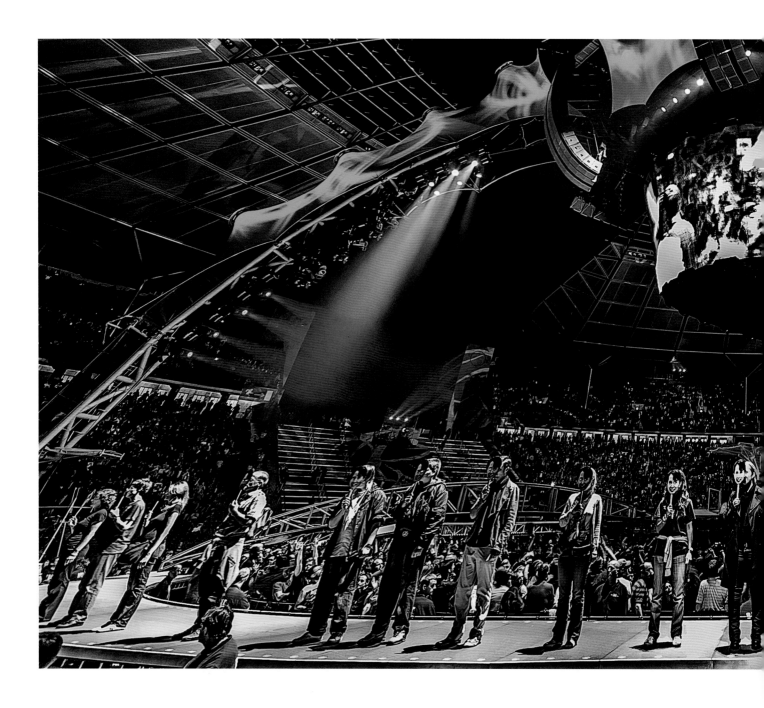

say, "What is that?" We're still struggling with the same things we struggled with twenty-five years ago, which is we're on the verge of irrelevance. Why should we think anyone wants a new U2 album? That's the challenge.'

Whatever it is, it will fit cleanly into the narrative arc of the U2 legacy. 'This here, this thing that we do, is old school,' said Jake Berry, on our last day in Montreal. He was in his office backstage,

having just spent twenty minutes berating one of his suppliers. 'We have to play our music for over two hours because that's what we've done all our lives and that's what our people expect, and we're not going to cheapen that. Not for anyone. What will we do next? Well, we shall see what we shall see ...'

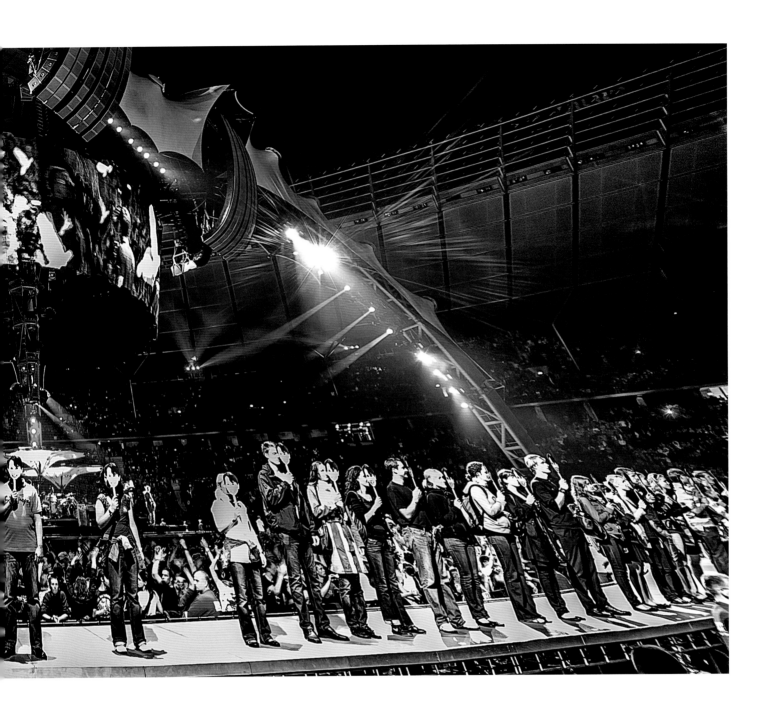

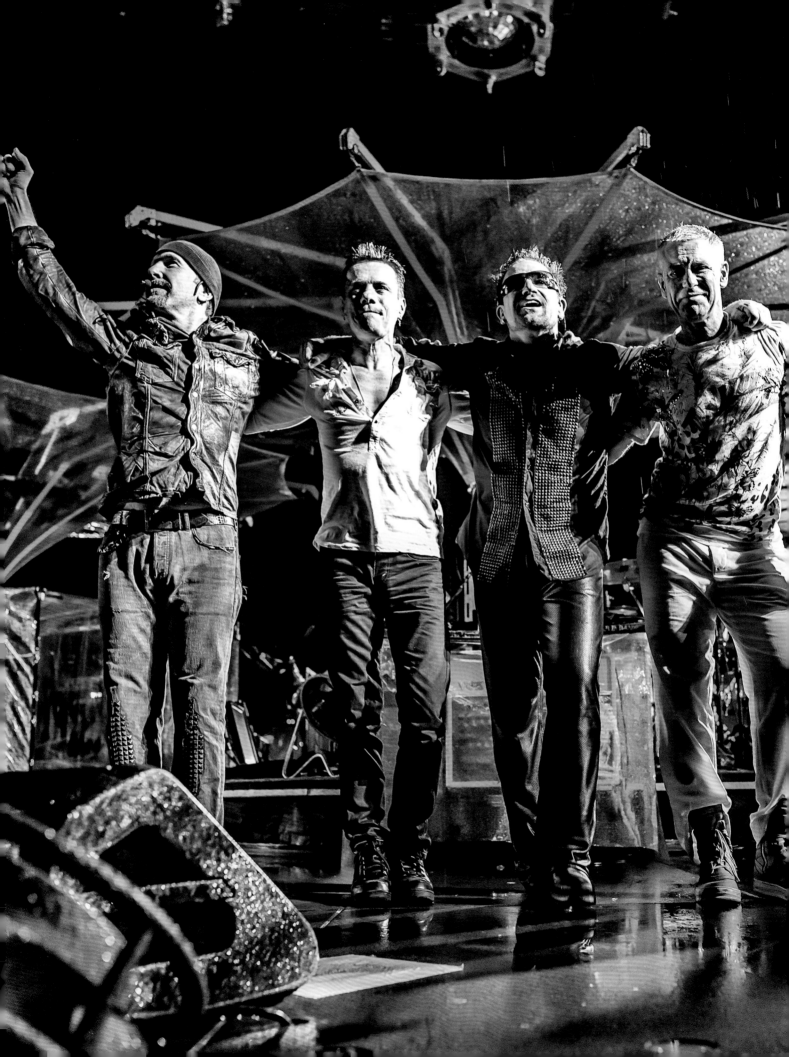

## ACKNOWLEDGEMENTS

I'd like to thank Nicholas Coleridge, Jonathan Newhouse, Ed Victor, Paul McGuinness, Trevor Dolby, Susan Hunter, Willie Williams, Bono, Edge, Adam Clayton, Larry Mullen Jr., Arthur Fogel, Brian Celler, Trevor Bowen, Chuck Hoberman, Mark Fisher, Joe O'Herlihy, Frederic Opsomer, Régine Moylett, Sharon Blankson, Gavin Friday, Dennis Sheehan, Jake Berry, Frances McCahon, Brídín Murphy Mitchell, Stephanie Sleap, Luciana Bellini … and Sarah Walter, Edie Walter Jones and Georgia Sydney Jones.

DYLAN JONES

## PICTURE CREDITS

INDEX

Page numbers in *italics* indicate references to picture captions